19-99

Designer's Guide to Typography

EDITED BY NANCY ALDRICH-RUENZEL
AND JOHN FENNELL

PHAIDON · OXFORD

Jacket art: Proprietor of the Philadelphia-based design firm that carries his
name, William Longhauser used collage to create a cover design that not only
makes "new connections" but also sums up his feelings about typography.
"There is a lot of soul in this piece which is based on past information and
knowledge," says Longhauser.

A Step-By-Step Publishing Book

Phaidon Press Limited, Summertown Pavilion,
Middle Way, Oxford OX2 7LG

First published in Great Britain 1991
Copyright © 1991 by Step-By-Step Publishing,
a division of Dynamic Graphics, Inc.

ISBN 0–7148–2706–1

A CIP catalogue record for this book is available
from the British Library

Manufactured in the United States of America

First printing, 1991

1 2 3 4 5 6 7 8 9 10/95 94 93 92 91

Acknowledgments

The staff of *Step-By-Step Graphics* wishes to thank the many individuals and organizations who made valuable contributions to this reference guide when it was first published as the "Designer's Guide to Typography," the 1990 special annual edition of *Step-By-Step Graphics* magazine, and who subsequently gave us permission to reprint that material for publication in this book: Russ Bannon; Neil Becker; David Berlow; Roger Black; Neville Brody; Kevin Byrne; Matthew Carter; Rob Carter; Graham Clifford; James Craig; Michael Doret; Gene Federico; Louise Fili; Robert Fleury; Peter Fraterdeus; Dwayne E. Freeby; April Greiman; Allan Haley; Steven Heller; Wayne Kosterman; Jerry Kuyper; William Longhauser; M & Company; Phillip Meggs; Debby Mendoza; Felipe Michelena; Mary Millar; Lulu Morgan; Greg Paul; Alan Peckolick; Nancy Rice; Rolf Rehe; Douglas Scott; Leslie Segal; Donna S. Slade; Martin Solomon; Jack Stauffacher; Sumner Stone; Kathleen Tinkel; Joe Treacy; Simon Tuckett; John Weber; Wolfgang Weingart; Richard Weltz; Joan Wilking; Michael Winslow; Cindy Wrobel.

Nancy Aldrich-Ruenzel
Editorial Director
Step-By-Step Publishing

Contents

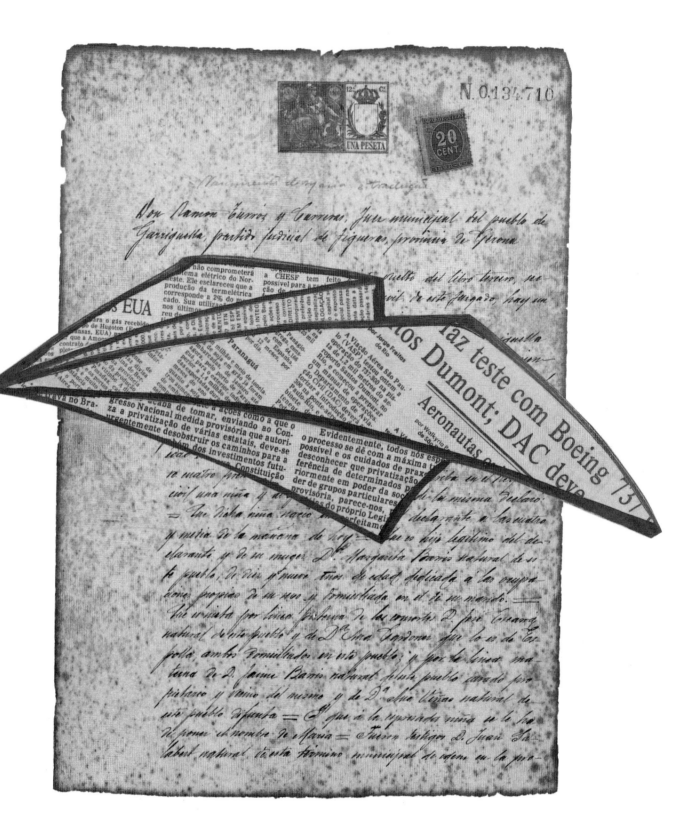

PREFACE

Aside from *desktopping*, typography is surely the hottest topic in graphic communications today. And considering the enthusiastic reports we continue to hear from the subscribers of *Step-By-Step Graphics* magazine, users of the first edition of this *Designer's Guide to Typography* (the issue sold out the first month it appeared), we are confident that this hardbound book version will not only help you with the immediate, hands-on tasks of designing better and more cost-effective typographic communications, but that it will also help you in your ongoing quest to become an ever more expressive and sensitive creator, art director, and specifier of good typography.

This practical and inspirational guide to the effective and expressive use of typography in graphic design focuses on the many typographic challenges you struggle with every day as professionals working on budget, and facing a deadline, in creating typographic communications. For easy reference, this book is organized in five sections, from introductory chapters covering some of the more general design and production topics to more genre-specific articles addressing design problems and solutions inherent in the various design disciplines, including corporate graphics, signage, print and TV advertising, and type in magazines, books, and newspapers. An entire section of the book is devoted to the challenges of "Digital Typography and the Desktop," where you'll find practical techniques and advice for producing and evaluating good typography on your desktop computer. And in our fifth and final section, "Type as Information, Expression, and Business," you'll experience fresh new ways of looking at and designing with type, including experimental approaches, a look at "de-constructing typography," a review of some of the quirky faces of the past, and tips on the business of designing and licensing your own typefaces. Leading international type designers, experts, authors, and educators have contributed articles and materials to all of these sections, and we have interviewed the best practitioners in the field for tips, techniques, and unique working methods. It is our hope that you will use this guide's roster of talented contributors and featured artists as your own private stable of typographic mentors for the 1990s.

Nancy Aldrich-Ruenzel
Editorial Director
Step-By-Step Publishing

Felipe Michelena of Curitiba, Parana, Brasil, principal of MM Programacao Visual, used existing materials—a newspaper page and an antique document—to create this typographic expression. Michelena, who feels that the newspaper page is one of the most expressive typographical forums, says, "Shaping the newspaper into the shape of an airplane suggests, in a subdued way, the concept of time. The plane on top of the written document completes the evolutionary thought." (Photo by Daniella Michelena.)

Why Study the History of Typography?

Knowing more about the history of letterforms and the technology that has created them helps us judge the qualities of type and its composition.

By Douglass Scott

The history of printing and typography has long been a source of inspiration for designers and typographers. In the late 19th and 20th centuries, authors such as Theodore Low De Vinne, Daniel Berkeley Updike, Frederic Goudy and Douglas McMurtrie wrote about the history of typography. Their books were required reading for those working in printing and design.

With a few exceptions, the history of typography has not been taught in art and design schools as a separate course until recently. The teaching of history usually has been discussed as a part of a studio course or workshop class. It was the fortunate student who either discovered or who was directed to that part of the library which contained books about Aldus Manutius, John Baskerville and Jan Tschichold.

Why study the history of typography? Here are four strong reasons why.

1: HISTORICAL MODELS
Learning about the form of letters is directly related to the technology used to make them. Our alphabet has been derived from writing systems developed by the Phoenicians, Greeks, Etruscans and Romans; and was further improved in Europe during the Middle Ages by scribes who copied manuscripts. Guttenburg's innovation, letterpress printing, used letterforms that were based on Northern European blackletter scripts. Aspects of typography, such as lower case letters or miniscules, space between words, and punctuation were developed over centuries. Renaissance types were based on letters drawn with a wide-nib pen. Eighteenth-century types were derived from models drawn with compass and straightedge on gridded paper. The form is also affected by the type's material. A one-foot-high wood letter looks different from a four-point letter cast in lead or a 72 point digital letter printed on a laser printer. Observation of historical models teaches us that there are certain proportions that are pleasing, types which are easier to read in blocks of text, and types that are appropriate to specific content.

With the flood of typefaces that are available and the opportunities to make our own types on a computer, how do we judge the qualities of a type or a typographic composition? Ruari McLean, in his "Manual of Typography," wrote, "In music, in wine, in drawing, in typography, words like 'good' or 'very good' or 'superb' do not have meaning until you have some experience of the best that exists–for instance, until you have listened to Beethoven, drunk some Mouton Rothschild, looked at Dürer, handled the printing of Jenson, Whittingham, or Bruce Rogers."

2: FUNDAMENTALS OF THE CRAFT
We learn both the fundamentals of typographic craft and the heritage that printer and designer share. Terms such as "kerning," "leading" and "em space" which are used by the typographer, come from metal-type technology. As letterpress printing has given way to offset lithography and the typographic designer has become further separated from the craft of printing, the burden of teaching the craft of typography is shifting from the studio instructor, who no longer has metal type, to the history lecturer.

3: CONTENT, FORM & FUNCTION
From good typography we learn that content, form and function are inseparable. The best examples are based on ideas, are clearly organized and are appropriate to the subject matter. Typography is linked not only to its technology but also to its time. We can be influenced by Caslon, Bodoni, William Morris, Heartfield and Sandberg–but should not blindly mimic their work. At the same time, we should not be led by the latest trends. Emil Ruder, in his book "Typography," eschews "the excessively modish and the whims and fancies peculiar to our day and age."

4: CULTURAL LINKS
We learn that the history of typography is linked with the histories of art, architecture, commerce, science and technology, literature, and politics. In his "Five Hundred Years of Printing," S.H. Steinberg wrote, "The history of printing is an integral part of the general history of civilization. The principal vehicle for the conveyance of ideas during the past 500 years, printing touches upon, and often penetrates, almost every sphere of human activity."

In summary, the study of the history of type enables us to reflect on our role as designers and communicators—it teaches us about form-making, aesthetics, craftsmanship, technologies and criticism.

Several teachers of the history of typography are worthy of note: Daniel Berkeley Updike's lectures at the Harvard Business School in 1911–16 which resulted in his book "Printing Types"; Ray Nash's Dartmouth College course on the history of the book, 1937–70; Alvin Eisenman and Bradbury Thompson, at Yale University since the early '50s, combine the study of history with studio projects; and Louis Danziger, who in the early '70s began teaching semester-long courses in the history of graphic design at several schools in California. Design history has now become an important part of many graphic design curricula and lecture programs of organizations such as the American Institute of Graphic Arts (AIGA), Society of Typographic Arts (now the American Center for Design), and the Cooper-Hewitt Museum in New York.

RESOURCES

The following is a list of books or authors that I have found helpful both in teaching and professional practice. This is certainly not a complete list, but will lead to other resources.
• "Typography, A Manual of Design," by Emil Ruder;
• Any book by Stanley Morison;
• "El Lissitzky," by Sophie Lissitzky-Kuppers;
• Any book by or about Jan Tschichold;
• "A Designer's Art," by Paul Rand;
• "Bradbury Thompson: The Art of Graphic Design," by Bradbury Thompson;
• "An Essay on Typography," by Eric Gill;
• "Paragraphs on Printing," by Bruce Rogers;
• "Grid Systems in Graphic Design," by Josef Müller-Brockmann;
• "Pioneers of Modern Typography," by Herbert Spencer;
• "Design With Type," by Carl Dair;
• "Printing Types," by Alexander Lawson.

Douglass Scott is a senior designer at WGBH Radio and Television in Boston. He teaches at the Rhode Island School of Design and at Yale University.

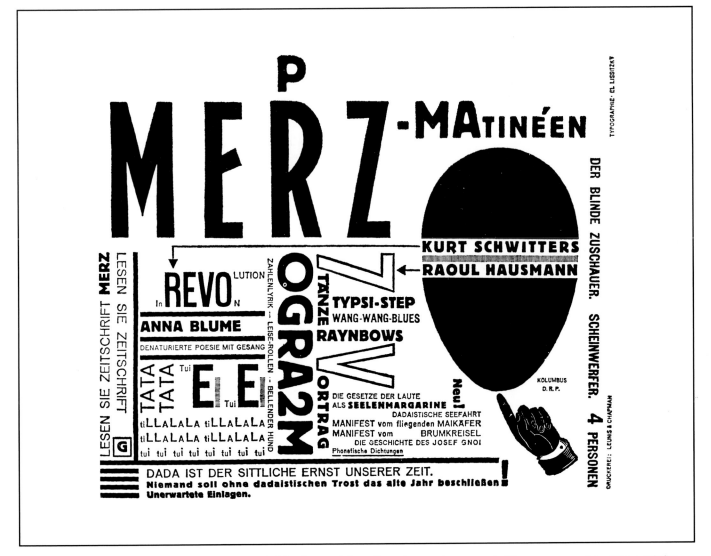

A Rich Heritage Typography is the art of planning and giving form to information using words, as seen in this announcement for Merz-matinéen, designed by El Lissitzky (c. 1922).

DESIGN AND PRODUCTION TECHNIQUES

From guidelines for quality print reproduction, readability and legibility, and basic headline retouching to text typeface selection, layout considerations and combining type and color in your layouts, this section is a working professional's guide to producing better type.

Columbus, Ohio-based designer John Weber (of design: Weber) says he likes to take found objects, like the ones used in this collage, and place them in a new context. "I feel expressive and beautiful typography is everywhere," he says. For instance, Weber, who also scans found objects for use on his Mac, found the letter "P" in his local hardware store. (Photo by George C. Anderson.)

Producing Consistently Readable and Beautifully Printed Type

How ink and paper can affect the reproduction of type.

By Joan Wilking and Russ Bannon

The trend toward setting type with lots of white space is a relief for eyes which have been squinting at tightly-set text and headline type for years. As with all typographic trends, when it is good, it is very good, and when it is bad, it is horrid.

As designers, we all share a responsibility for legibility in the work we present to the viewing public. Even when we take advantage of the healthiest trends, our job is not well done if through the vehicles of ink and paper we do not present readable messages. When we sacrifice readability to a "look," we thumb our noses at the reading public.

For years members of our trade worried and complained that the digitization of type would force designers and in turn the public to accept a lesser typographic standard; and, of course, the contrary has happened. High-resolution digital type provides a more incisive image than was thought possible even at low resolution; it provides readable typographic images that are available to everyone—the six-year-old with a home computer, the secretary typing up the winners' names in the office baseball pool, and the chief executive officer noodling his numbers for a board of directors meeting.

And, unlike the predictions of some of our peers, ink on paper has not become obsolete; it has taken a new form, which in some ways is more personal and more immediate. Modes of setting type may change. Printing technology may change. Papermaking may change. But the basic concerns inherent in producing readable, beautifully printed typographic images remain the same. The demonstration sections on ink, type and paper to follow will help you present exquisitely printed typographic images time after time—as will these three golden rules:

1. Design for the press. Understand what can be controlled and what cannot, and be able to talk to printers intelligently about what is doable and what is not.

2. You do not have to sacrifice the print quality of the type in four-color work. Take densitometer readings of the black from page to page and maintain the same number throughout the run. Talk to the printer about the imposition in the planning stages. Remember, type maintains better edge definition when run head into the press, rather than side-in, which

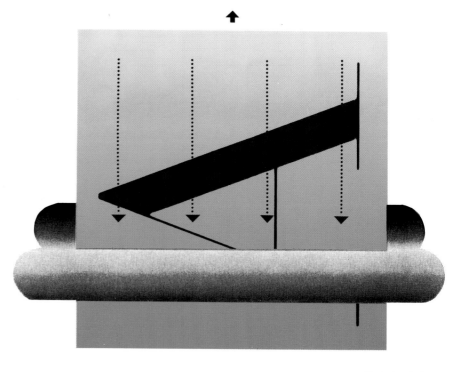

Figure 1 As indicated by the diagram above, type should be run head into the press because excess ink will distribute itself along the verticals of the typographic characters. When printing type side in (as shown at left), there is a danger that excess ink will tail off the back side of the characters.

Figure 2 Increasing linespacing can dramatically improve readability. In the example at top left, set tight with tight linespacing, the text could be difficult to read for some people. The example at lower left, set loose with loose linespacing, is much easier to read. The larger example at right, tight set with loose linespacing, is a natural compromise between the two.

tends to fatten the characters. (See Figure 1.) Color and paper selection can enhance or detract from readability.

3. Not minding the shop can cost you money and clients. The times you have missed the press run, have not reviewed mechanicals, or have neglected to recheck galleys will be the time the black is run too heavy, the ruby is cut crooked and that one little change critical to the client slips by without having been made. It also means that the piece which should have been a source of pride and joy can become an ugly reminder of what can happen when one allows the printer, the typesetter or the paste-up person to be the last eye on any critical job.

INK

1. Check your black densitometer read-ings at the beginning of the press approval. When the "color" of the type is optimal, make note of the number (usually between 160 and 180), and mark it on the signed-off press sheet. This way, you and the printer have a documented number to achieve from press sheet to press sheet.

2. Check with the printer about the imposition of the job. Type should be run head into the press, rather than side-in. By running head-in, excess ink distributes itself along the verticals of the typographic characters. When run side-in, you run the risk of the excess ink tailing off the back side of the characters. (Refer to Figure 1.)

3. If the job includes delicate type in combination with a lot of four-color photography, you may want to consider running black as a fifth color for type alone. Taking advantage of this option allows you to maintain a consistent densitometer reading for the type, and enables you to push or cut back on the black in the four-color work without worrying about its effect on the look of the type.

4. Ink drying time can have a profound effect on the look of typographic images. We like to print our most sensitive typographic work with heat-set inks. This process, which utilizes an infrared dryer at the end of the press, ensures the ink will not spread as it would in the course of a longer drying time. It also maintains a glossier surface.

TYPE

1. Very light typefaces (like ITC Garamond Light) can be difficult to read at

Excellence in typography is the result of nothing more than an attitude. Its appe comes from the underst used in its planning; designer must care

In contempo appeal co standir

Excellence in typography is the result of nothing more than an attitude. Its appe comes from the underst used in its planning; designer must care
 In contempo ing the appe the under desig

Excellence in typography is the result of nothing more than an attitude. Its appe comes from the underst used in its planning; designer. ✪ In cont porary advertisi ner must und its plannir peal c

Figure 3 There are many options to use when separating one paragraph from another: extra line space between paragraphs with no indents (upper right); use of end slugs in deeply line-spaced texts (left); and traditional indents with no space between paragraphs (lower right).

small sizes. We like to spec them at 11 point and up, and go to the book weight in the smaller sizes.

2. An extra point or two of linespace and a looser intercharacter setting can significantly improve readability. (See Figure 2.)

3. There are many different ways to separate one paragraph from another. The three we particularly like are settings with no indent in the first line after the head; no indents at all with a full or half linespace between paragraphs; and the use of end slugs in deeply line-spaced texts. (See Figure 3.)

4. We live in a society full of aging eyes. Consequently, you should always be vigilant about readability. More and more, we set text at 12 rather than 10 point. Six, seven or eight point captions are usually

set bold or deeply line spaced.

PAPER

1. If you must use stock with poor opacity, use lightweight type to minimize the show-through. Another technique which works very well is to plan the design around alternating pages of text and full-bleed color. The solid match color or four-color images block the show-through. (See Figure 4.)

2. If you are planning to print shells and imprint text on them later, think twice about running full solids, especially dark matte colors with matte varnish over the folds. The paper, ink and varnish, which are still pliant immediately after printing, become brittle and crack when folded if held for too long.

3. Uncoated papers act like a blotter.

Ink is soaked up by the untreated fibers. Coated papers allow ink to pool on the surface and dry to a more even finish. Because ink on uncoated stock may bleed into the fibers and fatten the type, you may want to consider a lighter weight of text or headline when you are trying for delicacy in a piece. (See Figure 5.)

4. White paper comes in many colors and finishes: antique white, blue white, creams, eggshells and pinkish whites. We often substitute a color or even a subtle PMS black for process black text to highlight a particular white stock. ∎

Joan Wilking and Russ Bannon are principals of Cartouche, a design and marketing communications firm in Rowley, Mass.

Figure 4 If forced to use paper with poor opacity, use lightweight type to minimize show-through (as shown at left), or plan the design around alternating pages of text and full-bleed color. Solid match color or four-color images block the show-through (right).

IN PURSUIT OF Q
_{SM}

Since the sharpness of type is an essential element for the legibility and attractiveness of the printed page, a crisp, sharp character image has always been the goal of the fine compositor.

To be sharp, typographic characters must be reproduced so that the strokes forming each letter are clean and smooth. Straight lines must be straight and clearly defined, without raggedness or breaks. Outside corners must not be (unless so designed) rounded, nor inside corners "filled in." Curves must be smooth, and fine lines must reproduce cleanly. Above all, the type must faithfully reproduce the original design.

IN PURSUIT OF PERFECTION

Until recently, all true typographic processes were capable of producing sharp images, although perfection was far from guaranteed without considerable effort to avoid the many kinds of pitfalls and gremlins that can beset the composition process.

In hot metal composition, great care was taken to produce a surface which was free from imperfections, such as those that might be caused by physical scratches or nicks in foundry type or rounded edges caused by wear. With linecasters, the type metal alloy proportions, possible contamination of the molten metal with foreign elements, temperature and casting pressure all had to be controlled carefully, as did the condition of the matrices from which the type was cast. In addition, the casting machine had to be properly adjusted.

Even with the type as close to perfect as could be expected, the proofing of it required a delicate balance of ink, paper and "heaviness" of impression on the press to yield a final proof of optimal sharpness. Nevertheless, in good shops, high quality, sharp repros could be and were produced daily.

NEW PROBLEMS

With the advent of photocomposition, other factors began to affect the question of typographic sharpness. A speck of dust any place could cause a "broken" character. Under- or overexposure, improper time and temperature control in processing, dirt on lenses or mirrors, or a poorly designed optical system could yield fuzzy or broken characters or undesirable rounded edges. Of course, the fonts themselves had to be sharp and unblemished from the start.

ANOTHER DIMENSION ADDED

Digital technology has added an entirely

Figure 5 Because ink on uncoated stock may bleed into the fibers and fatten the type (left), you may want to use a lighter weight of text or headline type. Or you could consider a coated stock, which allows ink to pool on the surface and dry to a more even finish (right).

new dimension. Type is generated by a series of "dots" called pixels, either on a cathode ray tube or by a laser beam. The sharpness of the type is highly dependent upon its fineness or "resolution," both in the digitization of the character by the font manufacturer and in the capabilities of the output unit. It requires a resolution of at least approximately 1,000 such dots per inch to equal the sharpness possible with good metal or analog (second generation) photographic composition.

The same digital technology which has enabled production of extremely sharp type has also made it possible, and popular in some quarters, to imitate typographic letterforms digitally at far lower levels of resolution, but it is not possible to produce sharp type at low resolutions.

Just as a 55-line halftone cannot reproduce the same fineness of detail that can be achieved with a screen of 133 lines, conventional dot-matrix printers driven by "typographic" software or 300 dot-per-inch laser printers are simply incapable of rendering typographic letterforms with anything approaching the sharpness of genuine phototypesetting. Although the dots themselves forming a halftone or laser printed image are not seen individually by the reader's naked eye, the overall difference in effect is quite apparent in both cases.

PLAIN PAPER VS. TYPESET

The plain paper printers, furthermore, use a toner imaging system much like that of an office copier, which produces a "soft" dot without the crisp definition possible on a photographic emulsion.

Letterforms digitally generated at low resolutions are characterized by ragged edges and a lack of extremely fine lines. Circles and curves, such as in the letters "O" or "Q," cannot be produced smoothly, and the distortion of them is particularly noticeable. Especially in small sizes, as *A+ Magazine* noted, "You may not be able to see the difference on coarse papers or in single isolated words, but there is a visible and appreciable difference between typeset matter and even good laser printer results."

Richard Weltz is president of Spectrum Multilanguage Communications, a firm specializing in translations and foreign language typography. (The stylized "Q" in the headline is a proprietary mark of the Typographers International Association.)

Readability and Legibility in Text

Learning to understand the subtle distinctions of fine text typography will help you specify the most readable type.

By Betty Binns

This article is about type that is meant to be read—whether read for pleasure or information or instruction—and read for more than just a sentence or a few paragraphs at a time. While there are many visually striking and exciting ways of using type in advertising, promotion, packaging and in other contexts, they are simply unacceptable in setting text type.

This specialty has its own set of design guidelines. What makes for good text typography is independent of the typesetting system used to produce it. Whether you are setting on the most sophisticated Linotronic or Compugraphic or using desktop equipment, the principles remain the same, although the best results may be more difficult to achieve on less advanced systems. What is important is to be able to evaluate the type you get. This means training your eye to perceive the subtle ways in which letters and spaces relate to each other. And please note: The fact that the equipment on which type is set is sophisticated (and expensive) is no guarantee that its output is good. What is more important is an understanding of the subtle distinctions upon which fine typography depends. The guidelines discussed here should help you toward that goal.

LEGIBILITY AND READABILITY

A minimum requirement for text type is that it be legible, which means that it should be large enough and distinct enough for the reader to discriminate individual words and/or letters. If type is too small to focus on, or if letters are insufficiently distinct from each other to be easily recognized, then type is illegible. While eccentric letterforms such as a capital "A" without a crossbar can be effective in a display face, this kind of eccentricity makes a text type illegible.

Readability takes legibility a step further. It is the quality that makes text easy to read, inviting and pleasurable to the eye. Text may be legible, but if the reader is unable to read smoothly and easily and becomes quickly tired and bored, the designer has not achieved readability.

LINE WIDTH/TYPE SIZE The major factors affecting readability relate to the relative proportions of the visual size of the type, the width of the line, and the spaces between the lines. How this works becomes clear when we understand something of what psychologists have discovered about the process of reading. They have found that we read in a series of eye fixations; that is, we read a group of words within one eye span and then shift our eyes in what is called a saccadic movement along the line to another group of words. At normal reading distance, a normal eye span is between 12 and 15 picas wide. If a column of text is set too wide—slightly more than two eye spans—we must move our heads as well as our eyes. This is a tiring and inefficient way to read.

The width of line, however, is only the first factor determining readability. Two further elements make for readable composition: the proportion of the type size to the line width, and the ease of horizontal eye movement conditioned by the white space between the lines.

If the size of the type is too large for the measure, very few words will fit on the line, word spacing will become very uneven, and many line endings will be hyphenated. This will cause the rhythm of

The programme was not satisfactorily set up. Apart from several mistakes in the spelling of proper names, the thing with its fancy types, curious centring, and superabundance of full-stops, resembled more the libretto of a Primitive Methodist Tea-meeting than a programme of classical music offered to refined dilettanti on a Sunday night. Though Edwin had endeavoured to modernize Big James, he had failed. It was perhaps well that he had failed. For the majority of

A. 8/10 x 14 Times Roman

The programme was not satisfactorily set up. Apart from several mistakes in the spelling of proper names, the thing with its fancy types, curious centring, and superabundance of full-stops, resembled more the libretto of a Primitive Methodist Tea-meeting

B. 11/13 x 14 Times Roman

reading to become broken and difficult. On the other hand, if the type is too small for the measure, the reader will have to focus more closely, reducing eye span and increasing the number of saccadic movements. This quickly leads to fatigue.

There are certain rules-of-thumb about the proportion of line length to type size. For example, the width of the line specified should be equal to 1.5 to 2.5 times the length of the typeset alphabet, or that line should average eight to ten words. These

Typeset examples by U.S. Lithograph, New York, N.Y. Excerpted from Arnold Bennett's book "These Twain."

The programme was not satisfactorily set up. Apart from several mistakes in the spelling of proper names, the thing with its fancy types, curious centring, and superabundance of full-stops, resembled more the libretto of a Primitive Methodist Tea-meeting than a programme of classical music offered to refined dilettanti on a Sunday night. Though Edwin had endeavoured to modernize Big James, he had failed. It was perhaps well that he had failed. For the majority of customers preferred Big James's taste in printing to Edwin's. He corrected the misspellings and removed a few full stops, and then said:

'It's all right. But I doubt if Mrs Clayhanger'll care for all these fancy founts,' implying that it was a pity, of course, that Big James's fancy founts would not be appreciated at their true value, but women were women. 'I should almost be inclined to set it all again in old-face. I'm sure she'd prefer it. Do you mind?'

The programme was not satisfactorily set up. Apart from several mistakes in the spelling of proper names, the thing with its fancy types, curious centring, and superabundance of full-stops, resembled more the libretto of a Primitive Methodist Tea-meeting than a pro-

C. 8/10 x 26 Times Roman

The programme was not satisfactorily set up. Apart from several mistakes in the spelling of proper names, the thing with its fancy types, curious centring, and superabundance of full-stops, resembled more the libretto of a Primitive Methodist Tea-meeting than a programme of classical music offered to refined dilettanti on a Sunday night. Though Edwin had endeavoured to modernize Big James, he had failed. It was perhaps well that he had failed. For the majority of customers preferred Big James's taste in printing to Edwin's. He corrected the misspellings and removed a few full stops, and then said:

'It's all right. But I doubt if Mrs Clayhanger'll care for all these

D. 11/13 x 26 Times Roman

Figure 1 The visual size of type changes radically on different measures. The type in A is the same size as the type in C, but A, set on a 10 pica measure, is more readable. On a 26 pica measure, the type in C looks very small and would be tiring to read. Samples B and D are also the same size, but on a 10 pica measure, the larger size looks clumsy and hard to read. The 26 pica measure is in the correct relation to the x-height of the type and, therefore, easier to read.

rules are a good place to start, but remember that the design of the face and the nature of material as well as the context in which it will be read should also be taken into consideration. I find that the most common mistake that nonprofessionals make is specifying type that is too large for the width of line. As you can see from the typeset samples, the visual effect of the same size of type is radically different on different measures. (See Figure 1.)
LINE WIDTH/LINE SPACE In our culture we read horizontally, from left to right. Curiously, the design of our alphabet is such that there is a preponderance of vertical strokes, tending to work against the direction of reading. For this reason, we need adequate space between lines of type to help the eye move easily in a horizontal direction. However, there must not be so much space between the lines that the eye cannot make an easy and secure movement from the end of one line to the beginning of the next. How much space is right is partly a function of the length of the line, with longer lines requiring proportionately more space, and partly a function of the design of the face. Faces with small x-heights need less space between lines than faces with large x-heights.
SERIF AND SANS SERIF TYPES Experts continue to debate whether sans serif faces are less legible and/or readable than serif faces. Since serifs on letters are horizontal strokes, serif faces do tend to help horizontal eye movement. Further, serifs are

Figure 2 Examples A, B and C show how different amounts of thick/thin contrast in the stroke weight of a typeface affect the overall color and texture. Example A has a very even stroke weight and creates an even overall texture. Compare this with B which has strong thick/thin contrast and an active overall texture. Example C is intermediate in contrast and creates a texture which is not too busy, but at the same time not totally flat.

The programme was not satisfactorily set up. Apart from several mistakes in the spelling of proper names, the thing with its fancy types, curious centring, and superabundance of full-stops, resembled more the libretto of a Primitive Methodist Tea-meeting than a programme of classical music offered to refined dilettanti on a Sunday night. Though Edwin had endeav-

A. 9/11 x 9 Egyptian Light

The programme was not satisfactorily set up. Apart from several mistakes in the spelling of proper names, the thing with its fancy types, curious centring, and superabundance of full-stops, resembled more the libretto of a Primitive Methodist Tea-meeting than a programme of classical music offered to refined dilettanti on a Sunday night. Though Edwin had endeavoured to modern-

B. 9/11 x 9 Bodoni Regular

The programme was not satisfactorily set up. Apart from several mistakes in the spelling of proper names, the thing with its fancy types, curious centring, and superabundance of full-stops, resembled more the libretto of a Primitive Methodist Tea-meeting than a programme of classical music offered to refined dilettanti on a Sunday night. Though Edwin had endeavoured to

C. 9/11 x 9 Times Roman

Figure 3 Examples A, B and C here show how much letter design, especially the distribution of the internal spaces within the letters, affects the overall color and texture. All the samples have even line weights but A, which has an even distribution of internal space and a much more even texture than B, which has very large spaces in the "o's" and "a's," combined with small spaces in the "e's." Example C is less even in color than A but is not as active as B.

The programme was not satisfactorily set up. Apart from several mistakes in the spelling of proper names, the thing with its fancy types, curious centring, and superabundance of full-stops, resembled more the libretto of a Primitive Methodist Tea-meeting than a programme of classical music offered to refined dilettanti on a Sunday night. Though Edwin had endeavoured to mod-

A. 9/11 x 9 Helvetica

The programme was not satisfactorily set up. Apart from several mistakes in the spelling of proper names, the thing with its fancy types, curious centring, and superabundance of full-stops, resembled more the libretto of a Primitive Methodist Tea-meeting than a programme of classical music offered to refined dilettanti on a Sunday night. Though Edwin had

B. 9/11 x 9 Avant Garde

The programme was not satisfactorily set up. Apart from several mistakes in the spelling of proper names, the thing with its fancy types, curious centring, and superabundance of full-stops, resembled more the libretto of a Primitive Methodist Tea-meeting than a programme of classical music offered to refined dilettanti on a Sunday night. Though Edwin had endeavoured to modernize Big James, he had

C. 9/11 x 9 Gill Sans

an additional means of differentiating letterforms. It would therefore seem that serif types should be easier to read. However, there seems to be no experimental evidence that proves sans serifs decrease legibility. Nevertheless, many people do find that long passages of sans serif type can be tiring. My own feeling is that some sans serifs, because of their overall evenness of color, do not have enough visual interest to sustain the reader's attention for many pages.

TYPE COLOR

Color may seem an odd word to apply to something that is essentially black and white, but it is the word designers use to describe the appearance of the mass of type on a page, the precise shade of gray that is created by the visual mixture of black type on white paper and the visual texture of its mass. Perhaps the easiest way to think about type color is to compare it to various kinds of gray fabric—some light and some dark, some smoothly woven and some rough-textured. Imagine, for example, a gray silk woven of evenly dyed strands, and then compare it to a tweed fabric woven with irregular threads of white and black. The visual effects of these color and textural differences are similar to the effects of different kinds of typefaces and different line, word and letterspacings.

But whatever the type color, the key requirement for good typesetting is that it be consistent overall. Before delving further into this question, we should look at the factors in the design of the typeface that affect its overall color and texture.

STROKE WEIGHT/INTERNAL SPACING Every aspect of the font design affects its color. Of course, the thickness of the basic stroke weight is the primary factor which determines the lightness or darkness of the type mass. A thin stroke produces a light type mass, and a heavy stroke, a dark one. The evenness of the stroke, that is, the degree of contrast between the thickest and the thinnest parts of the letter, is the primary factor affecting the texture. A typeface with an even stroke weight will produce a smooth, "silky" texture, while a face with strong thick/thin contrast will

Figure 4 Linespacing has the strongest effect on type color. Here, example A shows extremely tight linespacing and B shows extremely open linespacing. Both of these styles have their devotees and each can create interesting and beautiful type textures on a page. However, neither is very readable. For prolonged reading, moderate linespacing, in proportion to the length of the line and the design of the type, as in C, is a better choice.

produce a rough, "tweedy" one. A good way to think about such textures is as being more or less visually "active." (See Figure 2.)

The distribution of the internal spaces within a typeface is also very important in determining the evenness of texture. If, for example, the enclosed space of letters like "e" or "a" is very small in comparison to the unenclosed space, the face will be more active than one which distributes these internal spaces evenly. The relative proportion of x-height, ascender and descender also influences overall color and texture. Although these differences in design may seem slight, their overall consequences in the color and texture of the type mass are very obvious. (See Figure 3.)

LINE SPACE Line space has a great effect on type color. As we add space between the lines, a lighter overall effect is created. Even very black faces look less heavy with a good deal of space between the lines, and faces with very high contrast tend to look somewhat less active with added space. Care and judgment are needed, however, to be sure that the space is not too great; otherwise, readers will not be able to find their way back to the beginning of the next line.

Linespacing should also be considered in relation to the other spaces on the page and to the overall space within the face that is used. Typefaces with large x-heights tend to require greater linespacing to balance the internal spaces. Dense, unspaced masses of type with plenty of white space around them pre-

sent a very different effect than the same mass with skimpy margins. The effect of loose word and character spacing is exaggerated by tight linespacing, while a bit of additional linespace might actually correct the appearance of excessive or unequal word spacing. (See Figure 4.)

A few years back, there was a fashion for extremely tight linespacing. While it could be very attractive to look at, it was very hard for the eye to move along the type line. Recently, the opposite has come into vogue: linespacing two and three times the x-height of the type. This also makes it almost impossible to read as consecutive text. In general, one can vary linespace quite widely in the interest of getting the overall color and texture a job requires, but both of these extremes should be avoided.

SPACING IN TEXT TYPE

Perhaps the most fundamental criterion of good and readable typesetting is consistency of color. This is achieved by the apparent equality of the spaces between the words on a line and between each of the characters.

WORD SPACING When word spacing is visually consistent, there are no big holes in the page caused by very large spaces between the words and no dark blotches caused by words that are too crowded. In justified type this apparent equal space is by necessity an illusion. Since characters have different widths, and lines have different numbers of characters, the amount of space available to distribute between

the words must be varied in order to justify the line endings. The typesetting system must provide for sufficient variation in word spacing so that lines can be justified without excessive hyphenation. But the variation cannot be so great that the spaces differ obviously from line to line. (See Figures 5 and 6.)

All computer typesetting systems distribute the spaces between words by keeping track of the width of each input character. When the accumulated width approaches that of the full line, the extra space between the words is distributed according to predetermined rules for minimum and maximum allowable amounts. At this point, the decision is made whether to distribute space, to hyphenate a word or to place an additional word on the line. The process is called hyphenation-and-justification or "h-and-j." Sophisticated systems will try many alternatives to get a good result; other systems will resort to less acceptable alternatives, such as excessive space between words or between letters to fill out the line.

Many people new to typography do not appreciate that some hyphenation is essential with justified type. Because many desktop systems still do not hyphenate well, some people try to do without it and produce inconsistent and poorly spaced type. This is not to say that every line should be hyphenated; professionals stick to the rule of no more than two successive hyphens and no more than three hyphens in a paragraph.

CHARACTER SPACING Spacing between

The programme was not satisfactorily set up. Apart from several mistakes in the spelling of proper names, the thing with its fancy types, curious centring, and superabundance of full-stops, resembled more the libretto of a Primitive Methodist Tea-meeting than a programme of classical music offered to refined dilettanti on a Sunday night. Though Edwin had endeavoured to modernize Big James, he had failed. It was perhaps well that he had failed. For the majority of customers preferred Big James's taste in printing to Edwin's. He corrected the misspellings and removed a few full stops, and then said:

'It's all right. But I doubt if Mrs Clayhanger'll care for all these fancy founts,' implying that it was a pity, of course, that Big James's fancy founts would not be appreciated at their true value, but women were women.

A. 9/11 x 14 Times Roman, justified.

The programme was not satisfactorily set up. Apart from several mistakes in the spelling of proper names, the thing with its fancy types, curious centring, and superabundance of full-stops, resembled more the libretto of a Primitive Methodist Tea-meeting than a programme of classical music offered to refined dilettanti on a Sunday night. Though Edwin had endeavoured to modernize Big James, he had failed. It was perhaps well that he had failed. For the majority of customers preferred Big James's taste in printing to Edwin's. He corrected the misspellings and removed a few full stops, and then said:

'It's all right. But I doubt if Mrs Clayhanger'll care for all these fancy founts,' implying that it was a pity, of course, that Big James's fancy founts would not be appreciated at their true value, but women were

B. 9/11 x 14 Times Roman, justified.

Figure 5 Consistency of type color is the fundamental criterion of good typesetting. Examples A and B show the identical passage set with the same specifications. Example A has very irregular word spacing with some lines obviously very open and some with almost no space at all between the words. Some lines have been letterspaced and others have been over-kerned. Example B shows the kind of evenness of overall word- and letterspacing that should be the minimum standard for good typesetting.

characters must also appear to be consistent. As mentioned above, in the h-and-j process, some space may be added and taken out between characters in order to justify a line. If the spaces are very small, they are virtually imperceptible. The result is an evenness of color that is unlikely if word spacing is visually inconsistent. Often, however, this kind of letterspacing is very obvious. A good rule is that any variation in letterspacing that is noticeable is too much.

A more intractable problem is one which is integral to the design of the alphabet we use. Our alphabet consists of straight-edged letters such as "i," "l," "L," "M"; curved letters such as "o," "O," "c" and "G"; sloped letters such as "w," "A," "v"; and letters with trapped interior spaces, such as "Y," "T" and "L." These contours can appear in any combination. What the eye perceives is the overall spaces between the characters, which differ greatly according to the edge shapes—even if the measurable space between them at their narrowest or widest points is the same.

In any typesetting system, a fixed space is assigned to either side of a character; that assigned to the right of a character and to the left of the following one make up the intercharacter space. Since the beginning of typography, type designers have had to consider the variations in edge shapes in deciding the amount of space to allow on each side of a character. This is done, of course, in order to give the illusion of even space between letter pairs of differing shapes. Inevitably, compromises must be made. Systems which permit the greatest possible number of variations in the spaces between characters will come closest to achieving visually equal character spacing. Systems which have only a few permissible spaces will produce crude results unless further manipulation is done.

Most typesetting systems permit some manipulation of the spaces between characters. This can take the form of adding or subtracting small amounts of space between every character pair, which is called overall kerning; or it can take the form of adding or subtracting space between specific pairs, called pair-kerning. Pair-kerning can be done as each pair is keyboarded or as an overall command which changes the space every time that pair appears. Whatever the capacities of the system, the ideal is the same—spacing which appears to be even. Sadly, there are systems which simply do not have the flexibility to achieve this.

HOW MUCH SPACE IS ENOUGH? Although all professionals agree that appearance of even word- and character-spacing is the first criterion of good typesetting, there is no such agreement on exactly how much space this should be. Highly sophisticated computer typesetting permits much tighter composition than older methods. For a time, this ability to set very tight type encouraged typographers to do so—very often to the detriment of readability. (Very tight typesetting is fine when used in advertising and other applications where the overall texture is more critical than the readability of the text.)

At the other extreme, many desktop systems produce type which is not only very irregularly spaced, but very open. This, too, works against readability. A good standard to keep in mind for word spacing is that it should be sufficient enough so that words appear separately distinct, but not so great that the line ceases to cohere as a visual unit. A similar standard for character spacing is that letters should not be so tight that they lose their distinct outlines, or so open that the words cease to be perceived as words.

Another factor to keep in mind is that these spaces are proportional to each other; if type is set open, word spacing

The programme was not satisfactorily set up. Apart from several mistakes in the spelling of proper names, the thing with its fancy types, curious centring, and superabundance of full-stops, resembled more the libretto of a Primitive Methodist Tea-meeting than a programme of classical music offered to refined dilettanti on a Sunday night. Though Edwin had endeavoured to modernize Big James, he had failed. It was perhaps well that he had failed. For the majority of customers preferred Big James's taste in printing to Edwin's. He corrected the misspellings and removed a few full stops, and then said:

'It's all right. But I doubt if Mrs Clayhanger'll care for all these fancy founts,' implying that it was a pity, of course, that Big James's fancy founts would not be

A. 9/11 x 14 Times Roman, unjustified.

The programme was not satisfactorily set up. Apart from several mistakes in the spelling of proper names, the thing with its fancy types, curious centring, and super-abundance of full-stops, resembled more the libretto of a Primitive Methodist Tea-meeting than a programme of classical music offered to refined dilettanti on a Sunday night. Though Edwin had endeavoured to modernize Big James, he had failed. It was perhaps well that he had failed. For the majority of customers preferred Big James's taste in printing to Edwin's. He corrected the misspellings and removed a few full stops, and then said:

'It's all right. But I doubt if Mrs Clayhanger'll care for all these fancy founts,' implying that it was a pity, of course, that Big James's fancy founts would not be ap-

B. 9/11 x 14 Times Roman, unjustified.

Figure 6 Irregular word- and letterspacing can be avoided by not justifying type. However, this is not a cure for all problems. Compare the right edges of A and B here. Example A has some very short lines, which creates big holes in the texture and almost justifying some lines. Example B shows the identical material with line breaks that create a smoothly varied right edge, with no deep indents and enough variation from line to line to avoid the appearance of poor justification.

should also be open to maintain the integrity of the word. If type is set tight, normal word spacing may appear very large. The internal design of the letters also affects the degree of openness desirable. A type with large internal spaces, for example, will require more word spacing to balance those spaces.

SETTING UNJUSTIFIED TYPE

Unjustified or ragged right setting is common now in a great variety of contexts, although there are still a few people who feel that it goes against the very nature of setting type. There are many design reasons why you might prefer to set ragged right—such as informality of effect or gaining additional visual space—but there is also one very good technical reason which might apply. In the absence of a sophisticated hyphenation-and-justification program to make line break and word space decisions, ragged right type prevents big empty spaces within the line by putting all the extra space at the end. For many desktop systems, ragged right setting is always the best choice.

All typesetting problems are not avoided, however, by simply setting unjustified. You must decide how ragged an edge you want. Some designers prefer rather small

amounts of variation between the longest and shortest lines; others prefer a strongly irregular edge. Getting the result you want requires some method of controlling the line endings. One way to maintain control is to specify minimum and maximum allowable measures. However, to keep within these limits may require some variation in word spacing, which to some degree defeats one of the reasons for setting rag in the first place.

Another method of controlling line endings is by permitting or forbidding hyphenation. If no hyphenation is permitted, the rag will be rougher than if words were hyphenated. If absolutely no hyphenation is permitted on narrow measures, the rag is bound to have some disagreeably short lines, especially if the copy contains very long words. On the other hand, if hyphenation is permitted on fairly wide measures, many lines will appear to be almost justified and the feeling of rag will be lost. There are intermediate ways of handling this, such as never allowing two consecutive hyphens or hyphenating only to avoid lines shorter than a certain specified measure.

The relationship between the degree of the rag to the length of the line and the amount of space between the lines are as

much factors in the final appearance as the shape of the right edge.

LITTLE ACORNS/GREAT OAKS

I know of no other field in which seemingly small factors like these have such great overall effects. The difference between a point of linespace, a half-point of word space or a quarter-point (or less) of character space can make all the difference in the readability and quality of a piece of composition. If you are a designer concerned with setting text type, the most important thing you can do is train yourself to see and use these differences. This way you will be able to control the color and texture of the typeset page and to evaluate the final quality of the composition in order to achieve the expressive effect you want. Although the technology by which type is produced is changing rapidly, the standards of good typesetting remain constant. ■

Betty Binns, proprietor of a firm that specializes in the design of general illustrated books, art books, catalogs and museum publications, is also an educator and author of "Better Type," Watson-Guptill Publications, New York, 1989.

Techniques for Display Type

From letterspacing to retouching display type, these time-proven methods will help make your design optically sound.

By James Craig

"Readers want what is important to be clearly laid out. They will not read anything that is troublesome to read, but are pleased with what looks clear and well arranged, for it will make the task of understanding easier."
—Jan Tschichold,
"Asymmetric Typography"

"You may ask yourself if I ever heard a housewife say she bought a new detergent because the advertisement was set is Caslon. No. But do you think an advertisement can sell if nobody can read it? You cannot save souls in an empty church."
—David Ogilvy,
"Ogilvy on Advertising"

The past quarter century has seen dramatic changes in typesetting. First, metal type was replaced by phototype and now phototypesetting is giving way to digital type. This has been a great boon to graphic designers who enjoy working with display type.

Along with these changes in typesetting technology have come desktop software programs which permit designers to experiment in ways that would have been impossible a decade ago.

One thing has definitely not changed, however, and that is how we read. What Jan Tschichold and David Ogilvy wrote is still true today: There is a limit to how much time and effort the average person will spend on reading, especially an ad.

To ensure that our printed pieces continue to be read, we must treat type for what it is—a means of communication—and not as some kind of decoration. Promotions, ads and product literature that cannot be read do not sell products. While experimentation and a sense of adventure are essential to typographic creativity, the bottom line must be legibility and readability. The following methods should help foster those principles.

LETTERSPACING TNT AND TOS

Designers who do not set their own type on the desktop—and a large group of us still are not—are to a great extent dependent on typographers for type quality. With so many typefaces, typestyles, and letter combinations, are there any instructions we can give the typographer that will ensure we get what we want?

To begin with, there is no universal standard for ideal letterspacing: Some designers prefer their type set normal, others tight or very tight. Having stated a general preference, designers then strive for even letterspacing; that is, equal optical space between letters.

Unfortunately, our alphabet does not lend itself to uniform letterspacing, especially words set in all caps. Furthermore, the tighter the letterspacing, the more difficult it is to achieve even spacing.

When type is specified TNT (Tight, Not Touching), the typographer will attempt to give you even letterspacing with none of the letters touching. This may or may not be successful depending on the words to be set; chances are that some of the letter combinations will be less than satisfactory.

Should you specify the type to be set TOS (Tight, Optical Spacing), the typographer will go to even greater lengths to create equal optical letterspacing, even if it means connecting serifs or overlapping letters. The success of this approach depends a great deal on the taste and discretion of the typographer. (See Figure 1.)

There are a number of problems with specifying TOS. First, should you as a designer turn over your responsibility for good typography to the typographer? Is it enough to mark up the copy TOS and "Touch where necessary"?

Typographers will make these design decisions, but they won't all be to your satisfaction. Connecting serifs is one thing, but overlapping letters may mean replacing two beautiful characters with a single ugly form. (See Figure 2.)

Before specifying type to be set TOS, perhaps designers should ask themselves some questions—for example:
- Is the space between the letters becoming more important than the letters themselves?
- Is the type being set TOS so that it can be larger? If so, just how much has been gained in size and is it worth the price you are paying in legibility and readability?
- How tight is tight enough? Just because type can be set overlapping is that reason enough to do so?
- How much type is being set? A single word or logo may lend itself to special treatment, but longer copy tightly set may turn off the reader.
- Is the letterspacing becoming more important than your message?
- Do you really want your typographer to determine your typographic aesthetic? If not, consider making a very tight, accurate comp resolving all letter combinations for the typographer to follow. Or failing that, send along a printed sample in the specified typeface as a model for the typographer to follow.

Perhaps too much emphasis is being placed on this attempt to achieve the Holy Grail of typography—equal optical letterspacing. Jan Tschichold believed that spacing should not be conspicuous; I do not believe he ever thought it could be equal. That was simply a goal to strive

TNT TOS

Figure 1 Tight, Not Touching'' (TNT) and ''Tight, Optical Spacing'' (TOS) are two letterspacing options frequently specified by designers. With TNT, the typographer will set relatively even letterspacing with none of the letters touching. With TOS, the typographer will go to even greater lengths.

Every Every

Acceptable TOS Unacceptable TOS

Figure 2 It is possible to take TOS too far. Overlapping letters may create a situation where two normally beautiful characters are replaced with one ugly, horsey one.

TYPESETTING Typeset

TYPESETTING Trimmed

Figure 3 It is possible to improve by hand the spacing between capital letters which naturally space poorly, such as the example here where the ''IN'' is too tight for the ''TY'' and the ''TT'' combinations. Using a very sharp blade, carefully reduce the length of the cross strokes on the three ''T's'' to balance the optical spacing.

toward. At some point there is a delicate balance between the letterforms and the letterspacing where the designer realizes that this is as good as it gets. Beyond that lies typographic gimmickery.

LETTERSPACING CAPS
Caps are notoriously difficult to set so that they appear to be evenly spaced, especially words containing the letters "L," "T" and "Y." While careful kerning can help in some cases, at other times more drastic actions are necessary.

The word "TYPESETTING," for example, has very irregular letterspacing; the spacing for the "IN" combination is much too tight for the "TY" and "TT." While some space can be added between the "I" and "N," it would not be enough to balance the space between the "TY" and "TT." There is just no way to achieve equal optical spacing short of opening up the entire setting so that all spaces match the widest space.

There is, however, a partial solution, and that is to reduce the generous spacing between the "TY" and "TT" by reducing the length of the cross strokes on the three "T's." This can be done either with a razor blade or brush. The trick is to remove just enough to improve the letter-spacing without destroying the integrity of the letter, or bringing too much attention to the corrected letterforms. The same treatment can be used for words containing the letters "E," "F" and "L."

It should be obvious that this technique can only be used effectively with sans serif letters, as serif typefaces would require a great deal of retouching. (See Figure 3.)

LINESPACING
When setting display type on more than one line, one has to be careful that the space between the lines appears equal.

25

Figure 4 Only lines set in all caps have mathematically equal linespacing. Some lines with upper and lower case letters will have more ascenders and descenders than others, causing some lines to appear to have more space between them.

Unaltered
Display type set in upper and lowercase may make the leading appear unequal.

Altered
Display type set in upper and lowercase may make the leading appear unequal.

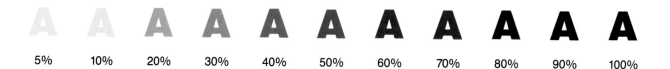

| 5% | 10% | 20% | 30% | 40% | 50% | 60% | 70% | 80% | 90% | 100% |

Figure 5 Choosing the right screen is dictated by a number of factors: the typeface, the size and amount of type, and the background. Using Helvetica Black, notice how the letter's definition changes as the screen percentage is increased.

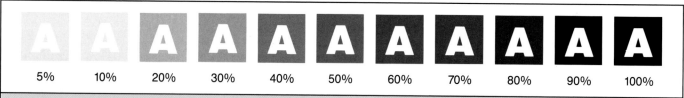

| 5% | 10% | 20% | 30% | 40% | 50% | 60% | 70% | 80% | 90% | 100% |

Figure 6 Reversing a letter out of a screened background can be effective, but it is a technique which must be used with care. Notice how the letter's definition is improved as the background screen percentage is increased.

This is a simple matter when the type is set in all caps, but setting type upper and lowercase can be a problem.

With upper and lowercase settings, it is not unusual to have lines with few or no ascenders and descenders while others have many. Lines without ascenders and descenders will appear to have more space despite the fact that all the lines will measure the same distance from baseline to baseline. To correct this you must adjust the space visually; if it looks right, it is right. (See Figure 4.)

SCREENING TYPE
Screening type is an excellent way to achieve color options without having to pay for additional colors. On the other hand, if the type is not properly screened, it can appear washed out, blotchy or uneven, giving the printed piece a rather cheap look.

Screens generally run in increments of five or ten percent up to 100 percent. Choosing the right screen is more of an art than a science. The designer must determine just how light or dark the type

can be in order for it to be legible. The size and weight of the type will also affect the designer's choice.

Another consideration is the amount of screened type to be read. A single word should not create any difficulty while an entire sentence might.

Bear in mind that when screening more than one color, a common practice when your piece is printed with four-color process, problems may arise. Moiré patterns or ragged edges may occur when screens are overlaid. Although moiré patterns can be corrected by the printer, ragged edges may necessitate a color change. Colors that are made up of low percentage screens tend to have soft edges, but increasing one of the screens to 100 percent may help sharpen the type. Screening is also affected by a number of factors, among them the paper, the amount of ink, the printing process and the press. One printer's 30 percent tint may look like another printer's 20 or 40 percent tint. When it comes to screening type, it is a good idea to sit down with your printer and discuss your goals. (See

Figures 5, 6 and 7.) And for more on type and color, see "Combining Type and Color" later in this section.)

ENLARGING TYPE
Every designer has set type in a particular size only to realize that it is too small and has to be either reset or enlarged. When time or expense does not permit resetting, the type is usually enlarged photomechanically to the required size.

Enlarging type can create problems, especially if the enlargement is excessive. First, the edges of the type can become slightly uneven or soft, so that the type takes on a blurred effect. Second, if you were to enlarge text type, say from 12 point to 36 point, you will notice a great difference in the character of the individual letters and letterspace. (See Figure 8.) Text type is usually designed differently than display type: Counters are larger, the characters more extended, and the strokes finer.

To ensure the highest quality reproduction, it is best to use the photostat for "position only" and then send the original

type to the printer on a separate art board. This will be shot by the printer and stripped into the job, thus assuring a higher quality printed piece.

RETOUCHING TYPE

Not all typesetting systems produce perfect type, especially in the larger sizes. There are times when you get the type back from the typesetter and it just does not look right. The typeface and type size are correct, the spacing is fine, but the type seems soft and unfocused, especially at the end of the strokes.

The problem may be that the corners of the finishing strokes do not carry sharp right angles, but are slightly rounded. To correct this you may want to retouch the strokes with some fine brushwork or carefully recut them with a very sharp razor blade.

The same treatment may be required when the display type is sharp, but the individual characters do not properly align along the baseline. (Some rounded letters, such as "O" and "C," for example, are not intended to sit directly on the baseline, however.)

To ensure fine retouching, you may wish to enlarge the type, say 150 percent, do the retouching and prepare an art board with instructions for the printer to make the final reduction.

INK SQUEEZE AND REVERSE TYPE

As children we all played with small rubber stamps which we inked and pressed onto a sheet of paper. As we pressed down on the letters, excess ink would ooze out along the edges and expand the weight of the letter. This is called "ink squeeze." Although ink squeeze was a greater problem with metal type and letterpress printing, it still must be taken into consideration with offset-lithography.

The effect of ink squeeze can best be seen with typefaces having exceptionally fine strokes or serifs like Bodoni, Didot and Helvetica Thin. When printed black on white the ink tends to make the strokes heavier and therefore more legible. When the type is reversed, the ink is squeezed into the white areas thus making the strokes even finer and in some cases non-existent.

Ink squeeze becomes even more critical when the type is dropped out of a four-color image. If the type is to be legible it must drop out of all four color plates and be printed in perfect register. If one plate is out of register, color will peek outside the body of the letterforms

All this does not suggest that designers should stop reversing type, but it does recommend caution. Many first class printers have no difficulty reversing type as small as six point Futura Light out of four-color screened art. Others may neither have the equipment nor the capability—in which case you should consider using a larger or heavier typeface. (See Figure 9.) ■

James Craig is design director at Watson-Guptill Publications and author of "Designing With Type," "Production for the Graphic Designer," and "Thirty Centuries of Graphic Design."

Combining Type and Color

It is crucial to understand the importance of contrast in the color selection process.

By Bob Fleury

Type and color are two of the most important—and difficult—design elements to use together well. But often the trick to successful design lies not in getting there, but in knowing when you have arrived. And this requires exercising caution and, above all, trusting your own eye. Here are just a few thoughts—tips, if you like—on making type an attractive, compelling part of an overall design, while still paying attention to clarity and readability.

TYPE COLOR CONTROLS

Any rules of legibility that apply to black-and-white type design only become more rigorous when colors are introduced. You cannot get any darker than black, nor any brighter than white, so color typography becomes a spiral of compromise, where readability is to some extent traded for harmony and aesthetic interest.

In addition to the four type controls we use when we adjust and fine tune the texture or "color" of our black-and-white type—size, weight, stress (thicks/thins) and density—there are four additional controls you must consider when working with color. They are: hue (color), value (light/dark), chroma (intensity) and temperature (warm/cool). (See Figure 1.) How you manipulate these four controls in relation to the others greatly af-

fects the legibility and harmony of your designs. (See Figure 2.)

CONTRAST IN VALUE AND HUE

Legibility, especially in text, requires contrast. And the more contrast you have, the more typeface options you have. When contrast decreases, you become restricted to the more medium weights, with less thick-thin stress and larger sizes. (See Figure 3.) To achieve legibility and color harmony, remember that opposite hues are not necessarily as good a solution as a sharp difference in value. A very basic example of such a sharp difference in value is blue on bright yellow. This is usually an excellent combination, since it has good contrast in both hue and value. (See Figure 4.) Its reverse may be just as easy to see, but is simply more tiring to read. Red on black, on the other hand, may not "read" as well, since both contrast weakly in value and hue. Since black has no value to speak of and its hue is totally neutral, you might consider using a high value color with it, regardless of hue. For example, pink on black reads more easily than red on black, because with pink you have reduced the red's chroma (intensity) by adding white, but raised its value (lightness) and so improved the contrast. A classic example of contrast in hue, but none in value or chroma, is red next to blue. The eye cannot see any difference at the edges except in hue, and the result in many cases is an annoying vibration that after a few moments will render any text set in such colors almost invisible.

When using color in type, contrast is important not only between the type and its background, but also between the headline and other subheads and text.

Do not automatically assume you need to put your headline and subheads and/or text in the same color. Frequently, a startling headline needs a restrained or cool copy block to help it stand apart. No color exists in isolation, but only in relation to other colors.

SMALL TYPE

The smaller your type, the more care you must take to preserve its legibility. Remember, contrast usually diminishes when you go to color, and that contrast diminishes further as the type gets smaller. So, once again, keep this golden rule in mind: Contrast in value is more powerful than contrast in hue. For instance, while neither of these combinations is ideal, you would do better with a dark blue on a pale blue than with a medium blue on a medium orange in a smaller size of type.

WATCH OUT FOR THE DOT You must also watch out for the dot. All process color is printed with halftone dots. The smaller the letter in relation to the size of the dot, the weaker the resolution. Black type and flat match colors are printed as line, so the dot problem does not arise. But if you print small type in two, three or four colors on a full-color background, you are likely to get disturbing shadows and vibrations when the registration is anything but perfect. (See Figure 5.) When setting numerals in color, spacing them just a little wider than the accompanying letterspacing is also a good idea. Numbers are rarely read as single words, except perhaps in cases like "1776." Each number is usually perceived in its own right, and so a bit more space here actually speeds up comprehension. Likewise, always allow more letterspacing when planning a reverse of any kind.

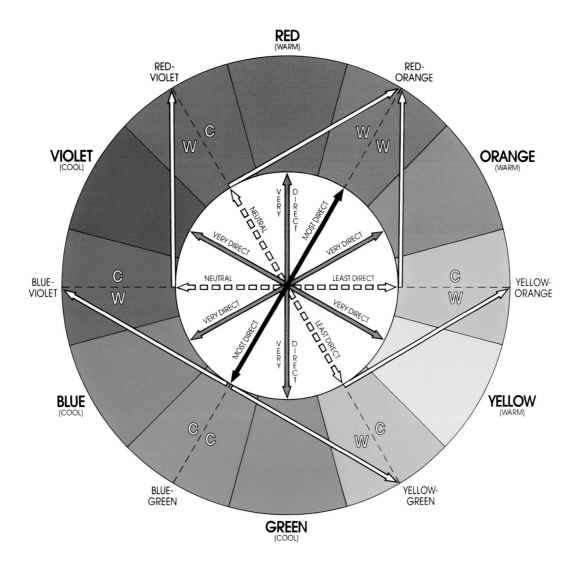

Figure 1 This color wheel demonstrates the opposition and fluctuation in temperature polarities among colors. (W and C indicate warm and cool with WW being the warmest, CC the coolest and WC neutral.) The white arrows within the bands of hue indicate the direction of the rising temperature; the dotted lines indicate the points of relatively neutral temperature opposition, and the gray arrows indicate points of strong, direct temperature opposition. (Chart courtesy Rockport Publishers.)

AVOID LONG COPY BLOCKS Colored type is a bit harder on the eyes than black on white, and just as continuous blocks of reversed type are hard to read, so too are long copy blocks of type in color. Your reader may begin to tire and lose interest in a long, uninterrupted page of color text. If you have a lot of copy, break it up. Pullouts and boxes can keep the reader from becoming bored and giving up.

OUTLINING

While it obviously works well only in larger type sizes, outlining is an interesting way to achieve very crisp headlines, especially when you have to deal with a busy, confused, "dirty" background, like a tree full of leaves or a street-level city scene. The outline is there to set up another visual barrier, or point of contrast, between the letterform and its environment. Its cousin, the drop shadow, can be a lot of fun to work with, but it usually only complicates the letter and does not often look as clean as a well-turned outline. When you design using an outline type, avoid the extreme thick/thin faces; play a little with using over-sized lowercase, and make the body of your letters either a straight reverse or a color that contrasts heavily with the background in value (light/dark). The outline itself should, if anything, be on the opposite side of the background in value, and should be a color in harmony with the general look of the background. (Refer to Figure 5).

These few tips can serve as reminders and guideposts, but once the basics are mastered, the rest is mostly common sense and the determination to make the best looking printed page you can. ∎

Robert Fleury is coauthor with Alton Cook of the new book "Type & Color, A Handbook of Creative Combinations" (Rockport Publishers).

Take a Typographer to Lunch.

Take a Typographer to Lunch.

Take a Typographer to Lunch.

Take a Typographer to Lunch.

Now is the winter of our discontent made glorious summer by this sun of York, and all the clouds that lowered upon our house in the deep bosom of the ocean buried. Now are our brows bound with victorious wreaths, our bruised arms hung up for monuments, our stern alarums changed to merry meetings,

Now is the winter of our discontent made glorious summer by this sun of York, and all the clouds that lowered upon our house in the deep bosom of the ocean buried. Now are our brows bound with victorious wreaths, our bruised arms hung up for monuments, our stern alarums changed to merry meetings,

Figure 2 Compare these two headlines set black on white (30 pt. Bodoni at top; 30 pt. Garamond Book below), then in harmonious colors (100C/20M/80Y on a background of 5C/20M/80Y). The Bodoni head loses much of its impact in color. Now compare the same two typefaces in a column of colored text. The Bodoni, the better headline in the beginning, is now a slower-reading, cumbersome block, while the more modest, runner-up headline has become the Cinderelia. Bodoni is a beautiful, brilliant design, but it was first drawn in black and white, as most faces are. Add color, and you are entering uncharted waters.

Typography, Color & Design

Typography, Color & Design

Figure 3 The closer the values on the color wheel, the bolder the typeface you will need to specify for legibility. The further the values, the finer the serifs can be, for example.

Figure 4 The piece at left was designed by Michael Doret for the Toronto Blue Jays. It features a blue title on a yellow background that is drop-shadowed in red. Although blues right next to reds tend to violate basic legibility rules, here the strong yellow background keeps the red and blue from vibrating. Normally the eye is jarred by the combination shown on the cover of *Model Magazine* (A.D.: Martin Jacobs) at right, but the bright yellow hand-lettered title varies so much in value and hue from the hot red-orange background that it attracts our attention. The white subheads help cool the hot background.

Figure 5 Reversing type out of a four-color background can be done safely in instances like the one shown at left where the background is not busy and provides enough contrast. But the smaller your type—or if your type is also in four-color—the harder it is for the printer to hold the letterform against the dots. Four-color type on four-color backgrounds, especially small four-color type, often results in disturbing shadows and vibrations if the registration isn't perfect. Outlining helps set type apart from its background, such as this white outline on the *Time* logo (at right); it is immediately readable on the newsstand. (Designer/Illustrator: Michael Doret; A.D.: Rudy Hoagland.)

Typography: More Than Words

Learn how typeface use is influenced by the project, audience, means of production, medium and your own palette of preferences.

By Martin Solomon

Typography and painting are very much related disciplines for me. While I was trained as a fine arts painter, I have been aware of the power of typographical forms since I was a child. Because of these influences, I approach design and specifically typography the same way I analyze a painting—by putting myself into the composition.

I study the media used and their application, search for the illusion of plane and dimension and notice the subtle changes which take place when my physical position to the art shifts: how the figures connect the parts into a unified whole and how the bend of a tree or the crest of a wave suggests direction and motion. This approach makes it possible to experience art as a participant rather than as an observer.

Design should invite the same kind of participation. A well-designed composition is the sum of its parts—the natural as well as the controlled—and it is this duality that brings it life.

The major elements that comprise any composition, whether it is a painting or a typographical expression, are space, line, mass, tonal value, texture and plane. All of these elements are united through a common set of design principles. These include:

● Relationship—A connecting force which orders the elements. In typography, the use of one family of type is the most common means of achieving relationship.

● Transition—Used to create an orderly progression so that the passage from one element to another remains related to the subject. In typography, this is often done by varying the point size, by setting text and subheads in the same typestyle as the main headline or by selecting different styles for subheads that complement the headline.

● Repetition—The recurring use of the same element or theme to establish a harmonious relationship. By repeating the same typestyles, sizes, weights and even decorative borders, unity is created.

● Opposition—Used to take advantage of the attraction of extremes. The shape, size, weight of letters and the relationship of type to the picture plane can all be used to set up oppositions within a composition.

● Priority—Determines the order of dominance in a composition. In typographic design, priorities are established through position, size, weight, spacing and tonal intensities.

● Position—The placement of elements in a specific area. The guide for planning the space within a design combines dynamic lines of motion with a balanced, symmetrical or bisymmetrical division of the picture plane.

Attributes of design—balance, emphasis, contrast and rhythm—project the personality of a design and are the foundation upon which it is built. Control of these attributes is necessary to project the image a designer wants.

Since design is complex and quite personal, these underlying factors should be looked upon as guidelines instead of steadfast rules. But however an idea is interpreted, the technique should not overpower and obscure the message since communication is the objective of design.

TYPOGRAPHIC DESIGN

I consider myself an experimentalist, and although I favor minimalism and a classic approach to design, I constantly search for new devices through which I can communicate. Given my affinity for typography, I admit I prefer solutions which utilize type over those which are purely pictorial. I also prefer conceptual designs over obvious and trendy imagery. Trends are junk food graphics. They are convenient, but offer little substance since few designers understand the background from which they have originated.

ROUGHS When approaching any typographic design problem, my first step is to develop the concept. I think best with a drawing instrument in my hand. My thumbnail sketches are spontaneous, non-detailed roughs done solely to generate

Figure 1 In the latest of a Shakespeare series, "The Two Gentlemen of Verona," I set type within a square format, creating a typographical stage on the introductory and first pages of each of the five acts and on the dramatis personae page. The prominent Franklin Gothic in the four corners embrace the Bookman type (both from Mergenthaler/Linotype Co.) and set the perimeters of the stage. These faces were chosen because they are classic in their own right and have complementary personalities. The bolder scene settings and act numbers create balance and contrast. When introducing contrast through weight, a variation of greater than 20 percent is necessary in order for the difference to be effective. In addition to the typographer's refinement program, I personally reviewed the copy, refining spacing to ¼-point adjustments. Line breaks were also evaluated, keeping within the guide of the Shakespearean style.

D R A M A T I S

DUKE OF MILAN — *FATHER TO SILVIA*

VALENTINE | PROTEUS — *THE TWO GENTLEMEN*

ANTONIO — *FATHER TO PROTEUS*

THURIO — *A FOOLISH RIVAL TO VALENTINE*

EGLAMOUR — *AGENT FOR SILVIA IN HER ESCAPE*

HOST — *WHERE JULIA LODGES*

OUTLAWS — *WITH VALENTINE*

SPEED — *A CLOWNISH SERVANT TO VALENTINE*

LAUNCE — *THE LIKE TO PROTEUS*

PANTHINO — *SERVANT TO ANTONIO*

JULIA (SEBASTIAN) — *BELOVED OF PROTEUS*

SILVIA — *BELOVED OF VALENTINE*

LUCETTA — *WAITING WOMAN TO JULIA*

SERVANTS | MUSICIANS | ATTENDANTS

P E R S O N A E

A C T ONE

**[Verona.
An open place.]**
[Enter]
Valentine
[and]
Proteus.

VALENTINE. *Cease to persuade, my loving Proteus:*
Home-keeping youth have ever homely wits.
Were't not affection chains thy tender days
To the sweet glances of thy honored love,
I rather would entreat thy company
To see the wonders of the world abroad,
Than, living dully sluggardized at home,
Wear out thy youth with shapeless idleness.
But since thou lov'st, love still, and thrive therein,
Even as I would, when I to love begin.
PROTEUS. *Wilt thou be gone? Sweet Valentine, adieu!*
Think on thy Proteus when thou haply seest
Some rare noteworthy object in thy travel:
Wish me partaker in thy happiness
When thou dost meet good hap; and in thy danger,
If ever danger do environ thee,
Commend thy grievance to my holy prayers,
For I will be thy beadsman, Valentine.
VALENTINE. *And on a love-book pray for my success?*

T **ONE**
SCENE I

Figure 2 Different typographical solutions were developed for each of the seven private printings of Shakespearean plays I have designed. In "Troilus and Cressida," Bodoni Book (Mergenthaler/Linotype Co.) in combination with Kabel Ultra (ITC) was the solution. I felt the Bodoni, a contemporary interpretation of a modern roman face, contrasts well against the gothic Kabel—a powerful face that relates to the intensity of the illustrations (created by Isador Seltzer). To add movement—make the page less static—and to give the Kabel a slight informality, I specified an 11-degree oblique. The text was set in 16 point Bodoni with 8 point Kabel Ultra (oblique). The Bodoni Book headlines underneath the act pages are set in 12 point. The diphthong (combination of vowels) in the "a" and "e" of personae is an appropriate typographical treatment for a Greek play.

ideas. A free-thinking, uninhibited flow is very conducive to creative problem solving, and I find this approach both productive and exciting.

These thumbnail sketches are then developed into full-size roughs, making sure that all elements essential to the message are included and all extraneous material is eliminated. (Refer to Figure 1.) When I have established the basic composition, I turn my attention to specifics such as choosing a typeface.

SELECTING A TYPEFACE Selecting typefaces is similar to picking actors for a play. Before the cast can be selected, a complete understanding of the script and audience is essential. Actors, despite their different personalities, must be compatible and support each other's performance.

I audition typefaces by loosely comping a typestyle on my layout. I usually do not think in terms of a particular face, but search for a general typeface category. I concentrate on factors such as readability, proportion, tonal value and relationship. I get a feeling for point size and spacing, then determine if any letter combinations or units need extra attention.

Frequently, this "pen to paper" approach —an important developmental step—is being substituted for the convenience of the computer screen. I would like to offer a word of caution here. Working directly with desktop computers can often inhibit creativity. One reason is that designers are limited to the library of faces available on the system. This is restrictive not only in terms of typeface selection, but also in denying designers the opportunity to fully explore the characteristic variations which exist among the various foundry cuts. Typography is a subtle art which involves careful analysis and preparation. In my opinion, placing such limitations on the typographical palette for the sake of convenience, especially at this early stage in the design process, can compromise a design.

Once I have a feeling for style, I begin actual typeface selection. I always refer to type specimen sheets since they are a valuable legend of information which shows letterform characteristics, point size, tonal value, tracking and special features.

Each typeface has a distinct personality which is determined by structural design, period and culture. A typeface is further defined by the "attitude" that is created through size, weight, proportion, pica width, spacing and placement on a page.

Typeface selection is influenced by the project, audience, medium and means of production, in addition to designer's personal preferences.

Typography is an art form which communicates literally and pictorially. To be effective, the design of the face should enhance the literal message. The same message set in different typefaces will convey different visual and psychological impressions. For example, the letter "T" in Franklin Gothic and Bodoni Book wears two different uniforms, each with its own personality. I perceive the first as intense and masculine, the second as formal and elegant. But even within the same family of type, uniforms vary. Bodoni Bold and Bodoni Book are quite different, as are their italic and condensed relatives. When computer modifications of condensing, expanding, slanting and weight alterations are added, a single type family can contain numerous personalities. Some members are so distorted that while they maintain the family name, they have lost most of the characteristics of the original design. The differences within a family of type provide designers with enough contrast to create an effective composition.

SPECIFICATIONS AND ADJUSTMENTS Again,

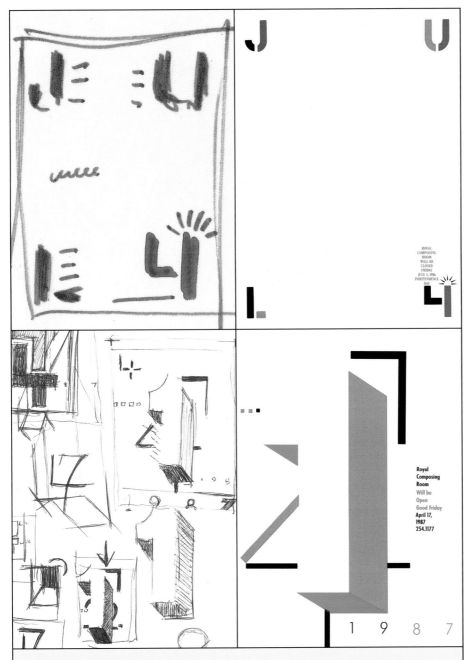

Figure 3 Sections of Futura Demi Bold letters were removed to create the stencil effect in this July 4th announcement (top left and right). This allowed portions of the letters to be printed in different colors, giving the art a festive look. The abstract imagery in this Good Friday announcement (below left and right) uses the play of positive and negative shapes to create the numbers 4 and 7. Typographical bars were arranged to create the design. The message is set in 10/12 Futura Bold Condensed, track 2 spacing.

the type specimen sheet provided by the typographer who is setting the job is important since typeface cuts, tracking and refinements vary from shop to shop. Try to anticipate and include refinements such as ligatures and hanging punctuation in your initial specification. I prefer the typographer contact me if there are questions about my specification rather than make judgment calls on his or her own. On many projects, I communicate directly with the compositor setting my job to ensure my specifications are understood. When reviewing the first composition, I mark any changes on the submission proof. I particularly notice line breaks, spacing and optical alignments. A job may go through several revises before I am satisfied with the composition. More often than not, final adjustments, usually spacing, are done during mechanical preparation.

COMBINING TYPEFACES

Design projects often need typographic solutions which extend beyond the family. Combining faces from different families can result in visually unexpected and exciting statements, but these relationships can be complex. Since unrelated faces were not originally intended to be composed together, a good deal of effort is required to form a compatible union.

TYPE FOR SHAKESPEARE The challenges of combining unusual typeface combinations can be especially rewarding. The private press printings of Shakespearean plays I design each year are excellent opportunities for such experimentation. Galliard and Gill Sans, Bodoni and Kabel, Bernhard Modern and Futura, have all formed exciting combinations.

For "The Two Gentlemen of Verona," the latest book in this series, I coupled Bookman and Franklin Gothic. (See Figures 1 and 2.) These faces are contrastingly different in personality and support the spirit of the play (especially the assumed identities of the main characters). Although I selected typefaces that reflect the mood of the play, faces which represent the personalities of the individual characters could have also been used.

Faces of independent design must be

Figure 4 In this poster, the title word "order," was photographically reduced to a 13.6 pica measure (from the left turn of the "o" to the right side of the "r's" stem). Hanging the turn of the "r" maintains optical alignment with the corresponding block of copy on the bottom of the page. The quotes, which express various ideologies, are all 8/12, track 2 spacing with hanging punctuation. The entire poster is set in variations of Futura because the family is comprised of a full complement of tonal values with excellent contrast. The drafting dots are added to endorse the architectural theme.

fine-tuned into a harmonious union through size, weight, spacing and layout refinements. This is necessary in determining the typographical image of the words. Letter- and word spacing determines the cadence, and the unconventional layout, coupled with the contrasting asymmetrical and bisymmetrical format, reflects the theme's whimsical elegance.

Combining different typestyles with similar weights is a more difficult problem since the contrast is lost. In these cases, I analyze cap-height, x-height, ascender and descender relationships, and make refinements such as reducing (or enlarging) the point size of one face to match the x-height of the other. This helps to maintain tonal consistency. With faces of different weights, tonal consistency can also be maintained by adjusting point sizes. For example, a bold face type may appear larger than a lighter version in the same point size. Reducing it by one half of a point size will help maintain a smooth optical flow.

FAVORED FACES While I am receptive to the entire typographical palette, there are several typefaces for which I have a particular affinity. Their classic designs and versatility make them easily applicable in a variety of situations.

The Futura family of type, originally designed by Paul Renner in 1927-28, is one of those favorite faces. Designed in the spirit of the Bauhaus, Futura does not hide behind a fancy facade. Because of its directness and geometric structure, it works well alone or in combination with other faces.

The holiday announcements designed for Royal Composing Room, a New York City typographer, are examples of Futura combined with other typographical elements. These mini-posters utilize type for both message and image. (See Figure 3.)

TYPE IN POSTERS

Like architecture, typography is an art form that must respect the space it occupies as well as the space that is adjacent to it. These art forms transform their space into functional entities. The whole is assembled from and supported by its parts. Design is the selection and arrangement of these parts into a cohesive unit. Order is the logic of design, and space controls order.

These ideas were the impetus behind an architectural poster I designed titled "Order," which features quotes by prominent architects. Since it is generally the exterior of a structure which is noticed, I used the abstracted imagery of a collapsible cup, manipulating this "shell" into different elevations to represent buildings. (See Figure 4.)

Since the art is composed of variations on the same symbol—the cup—I chose to support this concept by using variations of one typeface—Futura. The lines and curves of this typeface taper slightly at the joining points to optically maintain a mono-weight structure. In addition, the Futura family is comprised of a full complement of tonal values with excellent contrast.

In this poster, the title word "order" was photographically reduced to a 13.6 pica measure (from the left turn of the "o" to the right side of the "r's" stem). Hanging the turn of the "r" maintains optical alignment with the corresponding block of copy on the bottom of the page.

The quotes, which express various ideologies, are all 8/10, track 2 spacing (interletter spacing) with hanging punctuation to maintain bisymmetry. Weights and obliques relate to the illustrations. The remainder of the quotes are set to enhance the illustrations.

TYPE AS ILLUSTRATION Typeface selection and composition, of course, are dependent upon the requirements of each individual project. Another architectural poster, this one based on quotes by Louis Kahn, is an exercise in positive and negative shape as it relates to regimented order. Here the typography itself is used to create the art. Though directed to the discipline of architecture, these comments also articulate the power of typographical space. (See Figure 5.)

This poster contains four sans serif type-

Figure 5 This poster contains four typefaces set in all capital letters. The word "Columns" is set in 11 point Franklin Gothic. The columns of type are 10 picas wide with 10 picas of space in between and set respectively in 12.5/13.5 Univers 49 Light Ultra Condensed, 14/13.5 Gill Sans Condensed and 14/13.5 Trade Gothic Extra Condensed No. 17. Text type is set in track 2 letterspacing with word spacing justified to fill the column width. (Architect Louis I. Kahn's quotations are taken from the book "What Will Be Has Always Been.")

faces set in all capital letters. They were chosen for their distinctive overall tonal values rather then the compatibility of their individual letter structures, as in the Shakespeare plays. I chose serif/sans serif combinations because I wanted a contrast of visual sounds. When combining faces of similar structure, however, caution is necessary. The condensed faces used here were also more conducive to the narrow pica width. Point size was based upon cap-height compatibility.

Copy serves as both message and illustration, with visual effect given priority over readability. Had the message been the priority, specifications would have been different. For example, instead of all capital letters, which are more conducive to creating a regimented visual effect, I would have specified upper and lower case. Point size would be reduced, increasing characters per line and thereby equalizing overall tonal value. I would not have deliberately justified pica width through word spacing to create the marbleizing impression of an actual column. My preference would be instead to hyphenate words rather than pump out lines to fill a given pica width.

Justifying a pica measure can also be achieved through the modifications of expanding and condensing letterforms. This practice distorts the typeface, giving the appearance of wrong fonts by changing its tonal value which in turn disrupts the consistency of the entire copy.

BEST OF BOTH WORLDS

Although the production of typography has undergone changes since I began my career, my approach to this art remains the same. In fact, I feel I have an advantage over designers who are only familiar with current computer technology. Working with metal type has made me sensitive to true letterform characteristics and spacing refinements. It also provided me with a more extensive typographical palette since I am aware of wonderful characters, such as quaint ligatures, biform letters, pi and sort options, which are not available on today's typesetting systems.

Applying this background to current technology gives me the best of both worlds. The computer is a wonderful tool and as long as designers do not limit their creativity to the confines of this technology, understanding that they are responsible for its direction, typography will continue to advance as both a productive medium and art form. ■

Martin Solomon is creative director of Martin Solomon Co., design director of the New York-based Royal Composing Room and an instructor of typography and design at Parsons School of Design and at Marywood College. A board member of both the Art Directors Club and Type Directors Club of New York, his work is internationally recognized. He is author of the book, "The Art of Typography" (Watson-Guptill, 1986).

990
ANNUAL
DESIGNERS
GUIDE
TO
TYPO
GRAPHY

P

blended all
the fixative—
powder, or
what makes
We have man
tives including
ver, oakmoss
vardian potpou
f these fixative
pothecaries or be

ential Oil. La
lly in a recipe
st important e
pure, unadu
ou'ice, or herb
Spilhaus the potpo
who lavishes n ht use c
fur coat or any oth nder, c
"They are toys," say whe
is an expert on the s te
thing that helps you escap
humdrum of life is a toy."
Spilhaus, 78, is an inver

t

st as
ne mo
ney sa
ver, fig
ne last
ve figur

We wo
lways hav

Y

P

Plastic
bines art an
plastic surgee
concepts in m
plastic surgery.

A

of Baltin
Business
building fo
locations a
strip joint us
Mt. Royal Av

Slated for c
mated cost to
facility is now
cording to Dea
sible site is the
southwest corne
Royal. The secoi
corner of Maryland
now occupied by a

"Both sites are
says Stern. "But we c
schedule hostage to th
second site. We have th
and we prefer to build s
With $500,000 of state fu
the university will soon re
from architects for pre
studies for the 150,000-
which is expected

I have develope
based on a nev
applied to bone
ics flesh. Tissue
artistic, and this
each surgeon to

Tissue Clay is
with Avitene, a fil
sed in operati
It was almos
While performi
itene to abs
tene and blo
ance. It h
ay. Whe
under th
y. And
al bo

$1 billion.
bills, laid en
times. By 19
State of Maryla
more in the I-2

higher educatior
$1 billion. Doze
projects comple
Opening I-270

archs
ians o
W

sures you e
at savings c
treat yourself
style, sass, wit
and keep tabs
guaranteed a gr

A new camp
ty complet
of Maryla
ciences
commit

Among the reasons
ilding to the campus i
tiered classroom
dents and professors
ting case study discu
in the old-fashioned
t Charles Hall. The
received full accr
an Assembly of Co
lness, also is lookin
er labs and research f
Stern cites the projec
ulty from its current c
ve to 108 over the nex
a construction incenti
e fall at least three new
board. Milton Jenkins
versity, has been name
& Electric Professor o
mation Systems. Mike
gional economic ana
modeling from the U

O
Once
wher
medita
tantric
they go t
the Opera."
Los Angeles
Well, that's wha

A generation o
models, movie peo
tects and reformed
them with the right
settled in the lush c
swarming the beac
an '80s version of

Y

r

G

H

Yo
b
S
n
ju
you'd have m
At 28, she'd
money. It was
She'd just nev
environment,
being support
ever, she felt
So how did
ready-for-anyt
ings that show
A shake-up,
success that s
image to matc

To go back
influenced trac
in Salt Lake C
And she w
"sudden enth
the University
sent her to Vir
her
ish
on
can
smo
dise
com
And
risks. Combining smo
Pill multiplies the ri
attack by *40 times* (tl
women who
menopause earlier th
Hormones: Womer
tectors," *page 13*

The good news: Q
nary-disease ris
st as fast as to
women have b
—while men sti
l, in the past 20
ed only 6.2 pe
ercent in men
itsmoke teen b
igarettes

WHERE
REGAR

CORPORATE GRAPHICS AND SIGNAGE

This section addresses the critical role typography plays in conveying a corporation's identity to the outside world. Here you will learn how some of the best designers working in the corporate arena today use type to visually express not only the company itself, but its products, publications and signage.

Mary Millar, a Baltimore, Md., freelance graphic designer, tore initial cap letters out of magazines and spray mounted them to assemble this design. "I liked the texture of the ripped papers," says Millar. "I did not want to include any illustration—it was important to use all type. And I hadn't seen the ripped letter technique used in this context before."

Typography in Corporate Identity

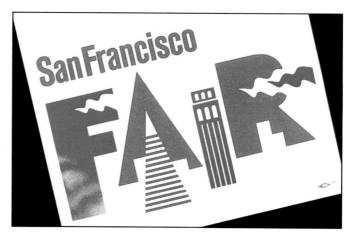

Corporate typography needn't be dry, but it should be consistent, unique and uniformly applied.

By Jerry Kuyper

The principles and aesthetics governing sound typography in corporate identity work do not differ significantly from other areas of graphic design. However, the need for an enduring quality that can survive for decades, combined with the often conservative nature of large corporations, tends to define an approach not associated with wild experimentation.

Typography is a primary component in both the development and application of a corporate identity. Most graphic designers involved in corporate identity create a wide range of logotypes, wordmarks and marks (often referred to as symbols or logos).

LOGOTYPES/WORDMARKS

Logotypes may be composed of typeset, altered or newly drawn letterforms. They can range from a single proprietary letterform to those in which each letter is a unique expression. Logotypes may also be incorporated into a shape as a means of establishing a proprietary identity.

Wordmarks incorporate a mark into a logotype. The mark is often extracted to be used alone or in conjunction with additional names, providing flexibility to the identity program. Marks range from purely abstract to quite literal and often incorporate letterforms into the design. (See illustrations above.)

The challenge in designing a logotype or wordmark is to maintain a balance between visual interest (uniqueness) and legibility. The more a logotype is made unique, the more difficult it may be to read and comprehend. On the other hand, mere clarity and legibility at the expense of uniqueness appear uninspired and not very memorable. Highly legible logotypes with no compelling visual interest and visually intriguing forms that cannot be readily deciphered are the equally unsuccessful ends of a continuum.

In the past, entire alphabets have been developed to provide propriety and identity to a company's communications. But today, as the number of well-drawn typefaces has proliferated and the skill required to create a unique yet formally correct and legible alphabet has become rarer, existing typefaces are more commonly used. When corporations add names or divisions, an existing face can be easily specified. Although the evolution of software simplifying the creation of typefaces has produced a trend toward unique typefaces, the skill and knowledge necessary to create them appears to be lagging behind the technology.

STEPS IN DEVELOPMENT

Although each identity program is shaped to the needs of the client, the basic creative process is similar for most projects. Generally, each project is stepped through four phases—Analysis, Design Development, Design Refinement/Extension and Documentation. A recent corporate identity project for Walt Disney Productions demonstrates how typography is used throughout these phases.

In addition to developing the name and design for Touchstone Films, a subsidiary of Disney, Landor Associates (the firm with which I am associated) was asked to develop a new identity for the parent corporation. Although the final recommendations were not implemented, the work demonstrates the role typography plays in developing a corporate identity.

ANALYSIS Uniqueness, memorability, flexibility, strength and longevity are widely accepted general criteria for most corporate identities, and they exert an influence on the use of typography. In addition, management interviews yield a list of specific attributes to convey, forming the basis of the design platform against which we evaluate our design exploration. As a part of this information gathering phase, we also conduct a visual audit to ascertain the general level of quality, variety of applications and equity of any identity elements currently in use. (See Figure 1.) From the Disney analysis, a decision was reached to explore the use of "Disney" as the communicative name of the company and to retain Walt Disney's complete signature for use on all films and projects in which he was directly involved.

DESIGN DEVELOPMENT As part of the design brief, a team of designers receives the general and specific criteria, and the desired positioning statement. In addition, the project director has the communicative name typeset in a number of alternatives. (See Figure 2.) Typically, these include settings in serif and sans serif, roman and italic, upper case and upper/lower case, as well as variations in weight and width. The designers may set additional type as the project evolves.

During design development, the inherent structure of the name, as well as specific communicative qualities of the different typefaces is examined. Although a wide range of typefaces may be explored, designers generally prefer classic serif families such as Bodoni, Garamond, Melior, Serifa and Times Roman and sans serif families such as Frutiger, Futura, Gill, Helvetica and Univers. These type families have withstood the test of time whereas more trendy typefaces tend to become dated.

The approach in the initial stages of design is "to leave no stone unturned." The team works in a variety of ways from quick brainstorming group sessions to individual exploration yielding both rough sketches and carefully rendered expressions. (See Figures 3 and 4.) With the increased use of computers, we find that more ideas can be generated, each at a higher level of finish than was previously possible. Designers present their work every two or three days in a series of internal critiques involving the entire team. Together, the project director and design team select areas with the greatest potential, and these three or four directions are refined and extended to a number of highly visible prototypes. These applications form a key component of our presentation to the client.

At this point, secondary or support typography is selected. The objective is either to establish a unity between the identity and surrounding typography by using a typeface in the same family as that used in the identity or to create a distinct contrast, which will cause the identity to appear more unique in applications.

The work session that concludes this phase includes a review of the analysis and design development phases leading to a presentation of approximately three different design directions.

Typographic Identities The Quantum logotype (far left, opposite) incorporates a distinctive "Q" with the Walbaum typeface. The red accent puts an obvious emphasis on the "Q." (Designer: Jenny Leibundgut.) The San Francisco Fair logotype (near left, opposite) captures the festivity of the fair and the unique architecture of San Francisco. (Designer: Paul Woods.) The identity for the Principal Financial Group (above left) incorporates Univers 75 into the triangle with Times Roman Bold Italic as the secondary typeface. (Designer: Margaret Youngblood.) Created twenty years ago, the use of the horizontal stabilizer design as the "A" in Alitalia (above right) provides an immediate association with airplanes and flight. (Designer: Kevin Elston.)

DESIGN REFINEMENT After a design is selected by the client, the designer explores suggestions from the client work session and incorporates any successful changes into a final recommended solution. At this point, reductions are made and, if required, alterations or additional drawings are made to ensure legibility at small sizes. The careful attention to detail at this stage is justified by the enormous number of times the identity will ultimately be reproduced.

Additional prototypes of key items may be created to establish the basic appearance and structure of the identity program. Secondary or support typography is resolved at this time. It is important to choose widely available typefaces with a series of well-drawn weight variations in roman and italic. This helps to ensure consistency and flexibility in the applications. Typefaces stretched or condensed by computer may have a contemporary appearance, but they are often difficult to read and can date the identity.

Upon client approval, master art is created for the new identity. (See Figure 5.) The typography is carefully letterspaced to maintain a visual uniformity. (See Figure 6.) These steps may be completed by hand or by using the computer. Slightly open or relaxed letterspacing is often more useful than tight spacing because the identity must appear at many different sizes and be viewed under a variety of conditions. Identities are often used at small sizes in applications such as stationery, brochures and ads, or at large sizes which would be viewed from great distances or from a moving vehicle. These larger applications would include building signage and billboards. Our experience confirms that open spacing preserves legibility at each extreme.

The logotype, using the "D" from Walt Disney's own signature, combined a freely drawn gesture from the past with a more corporate typeface. (See Figure 7.) This solution was determined to be appropriate for use throughout the corporation.

DOCUMENTATION Generally, corporations place a high value on communicating an image of reliability and stability. However, our visual audits often reveal great inconsistencies in the use and applications of existing identities that contradict the desired image. These inconsistencies are often the result of poor or non-existent program documentation.

A standards manual is the primary means of ensuring a coherent application of a corporate identity program, and it is a critical tool to a company producing communications from several decentralized sources. Standards manuals may range up to several hundred pages, although most are in the 75- to 150-page range.

Manuals are usually comprised of three main sections:

● *Basic Standards* clarify the underlying principles of identification, including naming and graphic standards;

Figure 1 While the existing Disney corporate stationery appeared dated and lacked some consistency, the divisional stationery had a variety of paper stocks and many treatments of Mickey Mouse, colors and sixteen different typefaces. Research also uncovered numerous identity expressions.

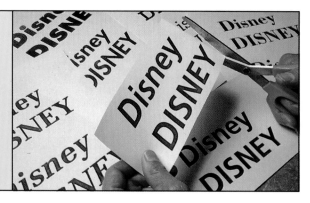

Figure 2 The design team uses the typographic variations as a resource. Settings in serif and sans serif, roman and italic, and upper and lower case were generated on the Macintosh.

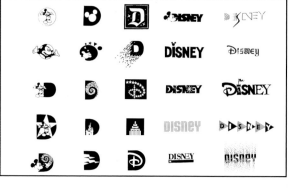

Figure 3 A selection from hundreds of initial sketches includes studies incorporating the letter "D" and logotypes. This initial stage leaves "no stone unturned."

• *Applications* show the identity applied to specific media such as stationery, forms, brochures, vehicles, signage, and so on, and provides standards to guide on-going creative work;

• *Reproduction Materials* provides reproduction art of identity elements and color swatches.

A successful manual is not so rigid as to exclude creativity in the implementation process but, on the other hand, is not so ill-defined that a coherent identity cannot emerge. Invariably, certain uses of the identity are prohibited in the realization that if they were done by the right designer in the right way at the right time, the results would be acceptable. Unfortunately, the potential for disastrous results is too great. Ideally, this will change as corporations continue to hire talented staff or consultants to implement and maintain an identity program.

A standards manual usually specifies recommended and acceptable typefaces. Selecting compatible serif and sans serif type families provides a richer, more flexible environment for the identity elements. Additional manual pages cover placement and "clear space" guidelines which help to control alignment of the identity elements with other graphic, photographic and typographic components.

In addition to defining how the identity may be used in advertisements, advertising guidelines often designate the typeface to be used in all headlines and text. Corporations are increasingly interested in achieving a common look in all identity applications, and the use of a consistent typeface in many different applications helps to optimize the synergy between and impact of all applications. ∎

Jerry Kuyper, an associate of Landor Associates, has directed projects for clients in the telecommunications, publishing, retailing, banking, transportation and hotel industries in the U.S. as well as in Southeast Asia and Europe. He has also taught design in the U.S. and abroad.

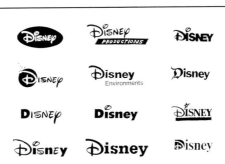

Figure 4 These studies, combining the "D" from Walt Disney's signature with other typefaces, were the basis of one of the directions presented to the client.

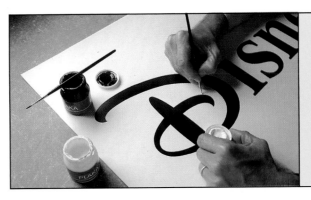

Figure 5 Final artwork was created by carefully rendering the letterforms with black-and-white paint. The thick and thin quality of the distinctive "D" was extended throughout the name.

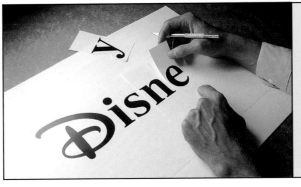

Figure 6 The letterforms are carefully spaced and judged at different sizes before a final version is determined. Here the separate letters are pasted down as different spacing variations are tested.

Figure 7 The finished logotype balances the expressive "D" from Walt Disney's signature with a more corporate typeface. The logo's link to the past, the gestural "D," is preserved. (Designer: Jerry Kuyper.)

GLOBAL AND REGIONAL IDENTITIES

Over the past decade, Landor Associates has been involved in an increasing number of corporate identity programs both in the U.S. and abroad, requiring unique typographic solutions. The following material outlines the tactics the design firm has taken with four of those corporations.

VALMET Valmet is a Nordic-based international engineering company, producing a wide selection of tractors and forest equipment. While a number of identities were in use throughout the company, the primary logotype had little uniqueness or communication value. (See Figure 1, top.) The recommended identity consists of a mark combining a "V" and "M" to suggest precision, growth and movement (Figure 1, below). Univers 85 was selected as the typeface for the communicative name. Its bold, precise quality and sharp counterspaces relate to similar qualities in the mark better than Helvetica Extra Bold which appears very soft by comparison. The all capital letter setting of the name, with its strong consistent height, accentuates the vertical movement within the mark.

US SPRINT US Sprint is a partnership of GTE and United Telecommunications and replaced GTE Sprint and US Telecom. The new company prides itself on the flawless transmission of its fiber optic network, and this quality is suggested in the mark. The identity looks as though the name "US Sprint" has moved across the mark to emerge clear and strong, visually integrating the two elements. Our visual audit revealed that Sprint's major competitors, AT&T and MCI, were using bold sans serif and slab serif letterforms. (See Figure 2, left.) After exploring many alternatives, Times Roman Bold Italic was selected; it differed from the competition, and it had a connotation of

Figure 1 (Designer: Creighton Dinsmore.)

movement, clarity and refinement lacking in the sans serif alternative. The Times Roman Italic was extended to stationery and signing applications (Figure 2, center and right).

SINGAPORE TECHNOLOGIES This technology-based engineering firm is comprised of 50 different companies, most of which previously had unrelated names and different identities. (See Figure 3, left.) To compete effectively in the global market, the name "Singapore Technologies"

was recommended with four sector descriptors. The mark depicts the strength, energy and brilliance of the sun as well as a sense of order, precision and technology inherent in engineering. Univers 67 was chosen for a number of reasons (Figure 3, center). Visually, the condensed letterforms provide a rich contrast to the roundness of the mark. Also, the vertical quality of the letterforms and the inherent rhythm convey a sense of technology. And on a pragmatic level, the condensed letterforms allow for a more compact presentation of the communicative name. The new stationery system provides a strong sense of clarity and order through the use of the sector identities (Figure 3, right).

UNION BANK In creating a new identity for Union Bank, it was necessary to question the requirement that a single identity be used in all applications. The configuration used for print applications included a palette of three components: the hand-drawn signature, the sun/eagle seal and the name "Union Bank." (See Figure 4, left.) These elements were chosen to achieve a number of communication objectives. The signature, a fundamental requirement in most bank transactions, is a sign of personal involvement and commitment. At the bank's suggestion, we consulted two handwriting experts as a final "fail-safe" check regarding the signature. Fortunately, no negative character traits were discovered. The image of a sun conveys strength and warmth, and the eagle, a familiar element on our money, suggests responsiveness. The eagle also carries forward an element of Union Bank's visual heritage (Figure 4, center); and the typographic expression of the name provides clarity. The alternative configuration comprised of the mark and name is used on all signing applications to provide stature (Figure 4, right).

Figure 2 (Designer: Jerry Kuyper.)

Figure 3 (Designer: Jerry Kuyper.)

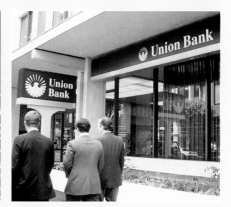

Figure 4 (Designers: Jane Martens, Karen Smidth.)

Humanizing Corporate Images

How Alan Peckolick creates identities that people can relate to.

New York-based designer Alan Peckolick believes that abstract symbols have been overused in corporate identity and says it is time to revert back to recognizable type and images. "I could never really understand why a designer could create an identity that could only be recognized and understood by a very small audience," explains the creative director of Addison Design Consultant's New York City office. "Many of them are so indistinguishable from one another that if you took the type from one and exchanged it for another, a good portion of the public wouldn't know you made the switch. So the question remains, how valid are they?"

For Peckolick, a protégé and former partner of Herb Lubalin, the all-type Coca-Cola logo remains the most successful identity ever created because it can be recognized and understood. In fact, one of his primary goals in designing corporate identity is that a mark be easily grasped. "The graphics and the type that I put into a logo should help solidify the message both on an intellectual and an emotional level," notes the designer. "If someone doesn't understand what we are trying to do graphically, they will understand it intellectually. I try to bring identities closer to a human level so people can relate to them."

THE PROCESS

Peckolick's preferred methods for giving identities a more personal, human appearance are either creating original letterforms and then having them hand lettered, or hand-altering existing faces. "These are often based on existing forms, but more than that, they are based upon an attitude and flavor that I want the identity to have," explains the designer. "You can always open up a type book and find something that works, but the point is to create something unique. I rarely set a face or a line of type and leave it alone. Wherever possible, something should be done to it to give it a personalized iden-

Figure 1

Figure 2

tity. This can be done in many ways. The first is to create letterforms that do not exist elsewhere. The second is to create something within the framework of the letterforms that helps emphasize it as a personalized identity." At times, Peckolick may select a face that may not be the easiest to read—"it may demand attention," he says—but he believes the viewer will spend the extra fraction of a second to read it. At other times, he will alter a face to make it easier to read, but keep the same flavor. "Even a simple chance of spacing or ligature carries it somewhere else," says the designer.

Questions that Peckolick must ask himself as he begins to formulate these identities include: Should it be a typographic solution? Should it be contemporary, futuristic, classic, elegant? By answering these, he can translate ideas communicated by the client into a visual form. "A designer doesn't really do anything but

make a translation—from one kind of language to the language of graphics," he explains.

CHOICE OF TYPEFACE The choice of type—whether it is within a graphic symbol, standing alone or supporting a symbol, and whether it is based on an existing face or is original—is dependent upon the needs of the identity. Unlike many designers who feel there is only a handful of faces that can work in corporate logos, Peckolick is open to the entire range of typefaces available and to what he can produce with a little imagination. "Many designers in corporate identity would say there are only two typefaces in the world. One of them is Helvetica, which they think is the solution to all ills. I never use Helvetica. I find it a very neutral, bland face without much of a personality." In cases where a practical face like Helvetica is needed, Peckolick prefers to use Avant Garde or Futura. "Futura is a classic face and has more things happening to it within the framework of the font—more beautiful letters," he says.

SIMPLE COMPS When an idea is formulated, Peckolick presents to his clients simple comps—normally a stat of a very tight pencil sketch that to the untrained eye looks like a piece of finished art. He usually shows several sizes so clients will have an idea of what the logo will look like in different applications. While he may present a range of closely related ideas to clients, he always makes a recommendation. "I will always come in with a stand. I think it is a mistake to just throw four, five or six designs on the table and ask which one they like. You are the creator and problem-solver so you should make your recommendation." When the client accepts a design, Peckolick begins the refining process, and after approval takes the art to the mechanical stage.

SOLVING SIZE PROBLEMS Because corporate identity so often involves producing logos and other materials at both small (business cards) and large sizes (signage), Peckolick and his colleagues often create separate art so logos will visually look the same no matter what size they are reproduced. The letterforms for art that is created for reproduction sizes of between ¼ inch up to six inches are specced with slightly heavier weights.

campus

Figure 3

Figure 4

New York University

Figure 5

Figure 6

Letterforms for art that will be reproduced larger than six inches will employ lighter weights. Also, the medium in which the art will be reproduced is taken into consideration. "If I do a logo that will be reproduced in newspaper advertising, which uses a very coarse screen, I will create a second piece of art which is bolder with slightly heavier weights. It is not really noticeable by the public, but it is something that will hold up against the screen."

WHAT RULES? Unlike many of his peers, Peckolick does not believe in a strict set of rules when it comes to corporate identity. "As far as I am concerned, there are no rules, except that a design should work," he emphasizes. "A solution for one problem will not work for another, so it is important not to set up these arbitrary rules." It is in this spirit that he creates identities with a more personal, human touch.

RECOGNIZABLE IDENTITIES

To illustrate how Peckolick gives a more human appearance to the corporate identities he creates, here is some of the thinking behind the designs shown on this spread.

FIGURE 1 For this logo, created for a company which manufactures a line of soft drinks, Peckolick drew inspiration from the neon signs of American diners in the 1950s. The labels are die-cut aluminum to reflect that signage. The letterforms are hand-drawn, and the color changes on

the background circle identify the flavor.
FIGURE 2 In this logo for a fur coat manufacturer which does not have a readily recognizable name, Peckolick wanted to create an image that was elegant and contemporary, and to phonetically break the name in a subtle manner so it could be easily pronounced. While based on a headline typeface called Condensed (available from Photolettering), the letterforms were totally redesigned. "Although Condensed is not a great face, what I liked about it was that it has the thick and thin elegance of Didot, yet it is very condensed."

FIGURE 3 When this established sportswear company needed an updated logo, Peckolick created hand-drawn letterforms which are all similar in shape—the "a" is the "s" backward, and the "u" and "m" have the same rounded look. The designer felt this gave the logo a uniform style. "I wanted [the type] to look like a distinct unit rather than a typeface. It is an example where type becomes a symbol."

FIGURE 4 For this Aircraft Leasing Co. logo, Peckolick wanted to create a "light and airy feeling that suggests flight," eschewing a "corporate look." The hand-drawn logo, created with similarly shaped, ribbon-like bands, can also be read upside down, although this was not part of the designer's original intent.

FIGURE 5 This logo, which is used in advertising and all promotions for New York University, is based on Times Ro-

man, which Peckolick calls a "classic, elegant and timeless face." His goal was to create an authoritative image that would combine the official name of the university with its more familiar name, NYU. The overlap of the "N" and "U" also has an added benefit of "eating up the negative space in the U," he says. Tight kerning produces a symbol rather than type. Peckolick chose to use upper and lower caps because the shapes of the caps in Times Roman are beautiful, and together they create a more effective shape. In addition, the use of lower case letters would have created more holes. The final artwork was hand lettered.

FIGURE 6 "This is a good example of what I try to do when a symbol is the solution to an identity," explains Peckolick. When three small New York savings banks merged, they created the name American Savings Banks. Because the primary clientele is comprised of blue-collar workers, the designer wanted an image that would have particular appeal to this audience. The half star, half "A" solution visually repeats the name American. In most applications, the "A" is red and the star is gray on a white background. ∎

Alan Peckolick is creative director of Addison Design Consultant's New York office. A graphic designer for more than 25 years, he has created award-winning logo designs, corporate identity, collateral materials, annual reports, packaging and publication design.

Specifying Type in Annual Reports

Here are five important design considerations to remember when specifying type for annual reports.

By Leslie Segal

The key to successful typography in annual report design is the recognition of two fundamental facts: 1) There are going to be a lot of words; and 2) They are going to change.

There are many exciting aspects to designing annual reports: the opportunity to use the best photographers or illustrators, expensive paper, the finest printers, the best of everything. It is a graphic artist's dream. Because of these very visible factors, many neophyte annual report designers tend to overlook the considerable typographic opportunities in

the report and sometimes even consider the words a "problem to deal with."

At the other extreme, the emerging view of the annual report as a creative playing field has led to excesses that are just as destructive to the final product as lackluster type. There are too many books where the type is "designy" as opposed to "designed." The trick is finding the proper balance. While there are certain customary formats for annual reports, there are really no rules for annual report typography anymore than there are rules for advertising typography. If I had to sum up the goals for annual report typography in a few words, they are readability, suitability and flexibility.

It might be appropriate at this point to give a brief definition of what an annual report really is. It is a chief executive officer's battle flag and calling card—a once-a-year opportunity to report on the past, present and future of the company. The list of those the CEO is talking to includes investors (bosses, if you will), customers, employees, legislators, the press

and peers. The CEO considers the report an important document and so do those who work at the company. It has to represent the company for a full year. It is an emotion-laden project. The cost of failure is high. Adrenaline flows, and if energy is properly channeled, the results can be very satisfying to the designer.

FIVE CRITICAL CRITERIA

I will share five questions that designers at my firm ask themselves at different points in a project. The questions tend to remind us of our professional obligations, help us to avoid fatal design flaws and, on a lighter note, just keep us from having a nervous breakdown.

IS THE TYPE READABLE? First we work on the assumption that all those beautifully printed photos and illustrations are in the book to make someone read something. So the primary question is: "Is the type readable?" If that seems like a silly question, look at the award-winning entries in some of the contests judged solely by designers. (See Figure 1.)

Norton focuses much of its product development in areas where it perceives real growth opportunities for the future.

A mplex color-coded lapping compounds provide highly concentrated precision-graded, or micronized, diamond powder, dispersed in permanent suspension. Among other uses are the flat lapping and polishing of hard, dense materials used in today's electronics industry.

S ilicon nitride (ceramic) antifriction *Noralide* bearings are hard and strong, microstructurally uniform and wear-resistant. They are ideal replacements for other materials in environments where lubrication is impossible, heat a problem.

Norwel fluoropolymer components provide precise uncontaminated results in groundwater sampling and testing. These components (white) are ideal when extremely accurate measurements and purity are required. They are chemically inert, and are corrosion- and temperature-resistant.

L arge diamond blades, used for deep sawing of steel-reinforced concrete highways and bridge decks, utilize a laser weld technique to assure maximum integrity of the blades and superior cutting qualities.

Figure 1 Corporate Annual Reports, Inc. President Leslie Segal keeps five criteria in mind when designing annual reports, the first of which is, "Is the type readable?" On this Norton annual report spread, the simple and straightforward handling of type carries the reader through the spread using a reclining "S" pattern. The consistent use of sans serif type, in dark gray and black, is also easy on the eye. (Designer: Sylvia DeMartino.)

Figure 2 Segal's second design question is, "Does the typeface used reflect the character of the company?" The no-nonsense approach to this layout from an Olin Corporation annual report matches the company's demeanor. As a defense department supplier and chemical manufacturer, the Olin Corp. requires a serious approach, but the designer did intersperse full-page, color photo pages with all-type ones to keep the delivery congenial. (Designer: John Laughlin.)

Figure 3 "Does the typeface enhance the message?" is Segal's third annual report design consideration. In other words, does the type convey the message the company is trying to get across to its investors, customers, employees and peers? In another spread from a Norton annual report, the serious nature of the copy is reflected in the straight-forward ragged-right type layout. Even the "ragged-right" art stays within this strict columnar set-up while adding a colorful focal point. (Designer: Beverly Shrager.)

Chemicals

Defense

Engineering Materials

DOES FACE REFLECT COMPANY CHARACTER? The second assumption has to do with the prime function of annual reports—to deliver the chief executive's message. So you must ask yourself, "Does the choice of typeface reflect the character of the company and the person leading it?" I often think of type as the fabric in a suit of clothes. I know one successful designer who dresses in well-tailored buckskin, another who patronizes Brooks Brothers exclusively and a third who has never owned a tie. They all manage to deal with clients in a successful way. I suspect none of them would function very well dressed in the other's clothes. (See Figure 2.)

DOES THE FACE ENHANCE THE MESSAGE? A properly planned annual report should leave the reader with one overpowering message about the company. Ask yourself, "Have we done all we can to make the typography enhance the message?" This is your chance to think about the key words the client is trying to convey: "Power?," "Momentum?," "Stability?" We should go back and see how the size of the titles, the weight of the type, the position of the captions and even the width of the margins contribute to the tone of the message. (See Figure 3.)

Wholesale Banking
continued
Florida-based developers.
The elimination of certain tax advantages associated with commercial building investment may dramatically affect the commercial real estate business, especially in light of the excess supply of commercial real estate in certain markets. We believe, however, that commercial real estate markets will offer future opportunities for well-positioned financial institutions.
Another area in which tax reform is likely to have a significant impact is our leasing business. Repeal of the investment tax credit and changes in both depreciation and tax rates may neg-

atively affect demand in certain traditional market sectors. At the same time, we believe that, for virtually all businesses, leasing will take on greater importance than ever from a corporate tax management perspective, and will be especially useful for those organizations wishing to avoid the newly-created alternative minimum tax. Leasing—which offers returns that are among the most attractive available among all of our businesses—is one of the few tax-sensitive businesses on which the Tax Reform Act of 1986 places no restrictions.
Mellon has many competitive advantages in wholesale banking, and we are dedicated to maintaining our position as a leader in serving wholesale markets.

The Corporation continues to increase its expertise in investment banking, including asset liability management, capital markets products and dealer businesses. In one dealer business, regional securities, we often structure financings for colleges and universities. This involves advisory services to the schools and the eventual structuring, underwriting and distribution of securities.

Investment Banking

The development of investment banking skills is an effort to which Mellon has dedicated substantial resources over the past several years. Investment banking capabilities are essential in order to offer comprehensive services to the Corporation's customer base; to capitalize on the continuing trend toward securitization of assets; and to participate in

14 15

Figure 4 The placement and choice of type on this layout from a Mellon Bank annual report is an integral part of this layout. Its proper fit and feel therefore does not distract from the report's message, Segal's fourth criterion. (Designer: Beverly Shrager.)

International accounted for 39 percent of total sales and 27 percent of profits.
Europa Group
Included in the Europa group's operations are five of Sterling's designated key country markets: the United Kingdom, Germany, France, Italy and Spain.
In 1986 the Europa group turned in a strong performance. It successfully overcame negative external forces, specifically industry-wide regulatory changes that had prevailed in the United Kingdom and Germany in 1985. The solid unit growth registered by the group was bolstered by improved exchange rates against the dollar for most European currencies.
In the United Kingdom, pharmaceutical specialties sales in 1986 showed improvement over the previous year when this business was severely affected by government measures which excluded many branded medicines that previously could be prescribed under the National Health Service (NHS). During the year Sterling argued successfully for reinstatement of certain products under NHS. Additionally, the group effectively promoted existing ethical pharmaceuticals, including two anti-arthritis medicines: Benoral (benorylate) and Plaquenil. Promotion and clinical education programs were also effective in increasing physician acceptance of Danol (danazol).
The group last year instituted aggressive advertising and promotion campaigns in the United Kingdom for many delisted products which could not be advertised to consumers when they were under NHS. As a result, the company's over-the-counter analgesics, led by Panadol, Solpadeine and Hedex, secured the top position in this market category.

Among consumer product activities in the U.K., the Sterling Roncraft division, which markets "do-it-yourself" products for home repair, registered good year-to-year increases. The gain was due in part to the successful introduction last year of Ronseal Fencelite preservative, an environmentally compatible wood preservative for fences, and to initial sales of a recently acquired product, Isoflex moisture curing polyurethane for waterproofing roofs.
In Germany, to reverse a downtrend in the hospital disinfectant market brought about by governmental spending cuts, the group's Schülke & Mayr GmbH disinfectant business last year took steps to diversify its product line by launching a number of products in new categories, including dermatologicals. It also expanded the Sagroplus household product franchise with two line extensions: a carpet cleaning powder and a disinfectant spray.
The group's pharmaceuticals business in Germany, which was adversely affected in 1985 by that government's reclassification of Fortral (pentazocine) under more stringent prescribing restrictions, registered good sales gains for other ethical drugs, including Wincoram (amrinone) and Winobanin (danazol). The addition of the prescription pharmaceutical line of anti-rheumatics and anti-acne products acquired from Schwarzhaupt GmbH at the end of 1986 should expand Sterling's presence in this third largest pharmaceutical market in the world.
Last year Maggioni Farmaceutici S.p.A., acquired in late 1985, was combined with Sterling's existing business in Italy. The Italian company now has established positions in both ethical and over-the-counter medicines. Equally important, it now has the infrastructure necessary for future growth in this key country market.

Italy, sales of Danatrol (danazol) increased significantly over the prior year. Verecolene laxative, a leading over-the-counter product of Maggioni, increased its market share in 1986.
In France, Sterling has a small but rapidly growing pharmaceutical specialties business. Backed by inventive marketing, sales of Lipanor (ciprofibrate), a lipid-lowering agent taken once a day, rose dramatically and achieved a 30 percent market share in its first full year of marketing. A full-scale launch for Omnipaque has just begun.
To build an over the counter medicines business in France, Sterling at year's end acquired two French companies with combined sales approaching $30 million. Laboratoires Valda, based in Paris with manufacturing facilities in France and Italy, is best known for its Valda pastilles which, in addition to being market leaders in both countries, have strong export sales. Laboratoire du Docteur Furt of Bordeaux produces and markets Tamarine and Colarine fruit-extract based laxatives.
In Spain, the smallest of Sterling's European key country markets, the group took advantage of that government's recent removal of its advertising ban on analgesics and aggressively promoted Panadol pain reliever. As a result of increased sales for the brand as well as good growth for Sterling pharmaceutical specialties, the company's business in Spain reported excellent results in 1986.
The group's operations in the Benelux countries and Scandinavia, organized into one region early in 1986, reported record results, due in large part to the continued success of Panadol and Hedex pain relievers.

Consumer products for the German market

Acquisitions increasing market presence in Europe

Leading OTC analgesic in Australian pharmacies

Number one in its category in Canada

Popular room air freshener in Australia

New Sterling entry in Canadian household products market

20 21

Figure 5 In this Sterling Drug annual report, preventing type from conflicting with the message was handled differently. Even though type predominates the spread, a friendly, informative tone is conveyed through the use of a lighter italic face. Additionally, key words such as brand names are underlined and placed in a roman face. (Designer: Yoav Palotnick.)

DOES TYPE DISTRACT FROM THE MESSAGE?
Barney's, a New York haberdashery, has a wonderful ad that reads, "Clothes shouldn't attract attention, they should hold it." My fourth question, then, is, "Does the type call more attention to itself than to the message?" (See Figures 4 and 5.)

DOES THE DESIGN ALLOW FOR CHANGES?
Finally, going back to my introductory observation about the nature of this business, you should consider, "Have we designed the report to allow for changes in the length of the copy?" There is nothing like one overcrowded page to destroy the integrity of a beautiful book. Lawyers' changes aside, a writer's assurance of firm word counts are about as dependable as a printer's delivery promises. We traditionally allow for variance of up to 25 percent right on up to press day. Our goal is not designing a handsome book, it is producing one. (See Figures 6 and 7.) ∎

Leslie Segal is president and co-founder of Corporate Annual Reports, Inc., a major producer of annual reports for Fortune 500 companies. The three things he looks for in hiring designers are typography, typography and typography.

Figure 6 Segal's fifth and final annual report design consideration, "Does the design allow for changes?" can be the most important one in some situations. Even the best conceived, well-intentioned designs can fall apart when the almost inevitable type changes start rolling in. This layout (from a Pechiney Corporation annual report) maintains a ragged bottom for its text columns so that additions and deletions are easily absorbed. The indeterminate depth of the italic cutlines also accommodates changes easily. (Designer: Victor Rivera.)

Figure 7 This "newsy" format (from a Travelers annual report) also allows for additions and deletions using a different approach, a ragged top. While the report does maintain a maximum page height, the columns have enough "give" to accommodate dissimilar copy block lengths. Additionally, the use of italic quotes from customers adds more flexibility. (Designer: Victor Rivera.)

Turning Type into Signs

Before you plunge into an environmental design, here are a few considerations for type, including formulas for figuring size and legibility.

By Wayne Kosterman

You are a practicing designer with a few years under your belt. You have a reputation for being sensitive to good typography. One of your clients likes the logo you just finished for him and wants you to use it on a new site identification sign and possibly in his entrance lobby. Of course you can do it, you say, since signs are really environmental graphic designs, and you know a lot about graphic design. But if you are not in the steady business of sign design, here are a few factors which have been known to cause problems for even experienced sign designers.

MESSAGE SIZE

More than one designer has sweated over all the details of an exquisite sign creation only to find upon installation that the message is barely large enough to be read. To help you determine type size in signage, several formulas are used.

For example, using Helvetica Medium set in caps and lower case, normal sighted viewers need at least one inch of x-height (height of the lower case letter) for every 50 feet. So a sign message that is 100 feet away needs an x-height of two inches, or cap height of two-and-three-quarters inches or more. To complicate

Figure 1 There is no set formula for a typographically successful sign. This Alberto Culver logotype has been "fattened" slightly for its application in reverse can illuminated letters. The front and sides of these letters are metal, while the backs are open. At night, the letters float off the surface with a halo of light. (Alberto Culver Headquarters: daytime and nighttime.)

matters, the formula assumes two things: The viewer is standing still and looking straight at the sign and there is a high contrast between message and ground. But, of course, this is not always the case. A pastel green message on a pastel blue ground needs to be significantly larger than the same message in black on a white ground. (See Figure 1.)

For determining type size at greater distances, sign companies use charts. (See Figure 2.) These kinds of type charts usually assume that the letters are a bold block style and that they contrast strongly with the background. Instead of trusting formulas, however, the surest method to determine what works, especially in critical situations, is to make up a full-size prototype with foam board, set it up and view it on-site from the distances viewers will see it. In one instance, a hospital agreed to have our firm make up a five-foot-wide-by-three-stories-high, full-size prototype for its officers to see—hoisted in position by a crane—before agreeing to

the final sign design.

Add in the variables of viewing a sign from a moving vehicle and the distance the sign is placed from the roadway, and you begin to get a feeling for the complexity of determining appropriate message size. (John Follis and Dave Hammer treat these issues in their book, "Architectural Signing and Graphics," Whitney Library of Design, 1979. It is a good source for those new to environmental graphics.)

LEGIBILITY AND TYPE SELECTION

If legibility is a primary concern, flamboyant and decorative typestyles that make intriguing logotypes should be avoided in signage. Helvetica Medium or Bold, the typographic equivalent of the safe, functional, corporate blue pin-striped suit, has outdistanced virtually all other typefaces in signs. Because it lacks a strong personality, it does not call attention to itself. Because it is so popular, it is also readily available from sign fabricators. In recent years, however, because of the use

of vinyl die-cut letters and Gerber-type and computer-driven cutters, designers have many more font options at a reasonable cost.

Be cautioned that fonts with strong thick-thin stroke contrasts tend to be far more difficult to read. (See Figures 3 and 4.) In general, a font with a consistent width and a medium stroke is easier to read than a thin-stroked font. If the stroke gets too thick, it tends to fill in the counters (the open spaces in the letters). **SPACING** To improve legibility, avoid the trend so popular in ad headlines of jamming the letters together with tight or "touching" letterspacing. Since normal sign reading distances tend to do that for you, you should compensate by using normal or wider than normal letterspacing. Leading (the space between lines) cannot be ignored either. (See Figure 5.) For two or more lines of copy that are intended to be read as one message, a leading distance of one-half the cap height of the font you are using is usually a good place to start. Minor modifications can be made for fonts with smaller or larger x-heights.

After you have heard all the rules, you soon find out that this business is filled with examples of how people have successfully broken those rules. One way to do that is simply to make the message larger than minimum requirements to compensate for tight spacing or difficult-to-read typestyles.

IS ALL CAPS BETTER? Old readability studies have determined that as messages get longer, initial caps with lower case is read and comprehended more quickly than all caps. (See Figures 6 and 7.) On the other hand, if you are creating a distinctive corporate headquarters sign which will be placed where the speed limit is 15 mph, all caps may work just fine.

HANDICAPPED REQUIREMENTS While most of our population is not blind, a large percentage has significantly less than 20/20 vision. Signing interiors of buildings with sensitivity for visually handicapped viewers means using messages that are a minimum of ⅝-inch high, which means that if you do not use all caps, the lower case x-height has to be ⅝-inch or more. Federal requirements also recommend the use of dark backgrounds with light copy, rather than the reverse, to eliminate the glare often associated with light backgrounds.

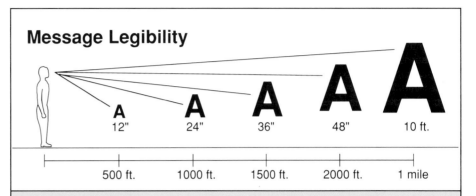

Figure 2 When determining type size for environmental graphics, designers and sign companies use charts like this. The basic rule of thumb is 12 inches in letter height for each 500 feet of viewing distance.

PRODUCTS OR SERVICES ARE YOUR SPECIALTY. COST-EFFICIENT ADVERTISING/SALES PROMOTION IS OURS

Figure 3 Designers should be cautious of specifying fonts with thick-thin contrasts and packing them tight in advertising style, as in this example, because they tend to be far more difficult to read than a font with a consistent width and medium stroke.

Figure 4 This sign uses extreme thick-thin strokes. However, despite its extreme contrast, it is easy to read because it contains only four characters made large enough to compensate for the letter style. (1212, Chicago.)

Figure 5 The open spacing (or leading) used on this signage aids the readability of these floating letters. (Seven Continents Restaurant, O'Hare Airport.)

Figure 6 Even caps and lower case lettering with additional letterspacing allows the message to be read from an extreme angle. (Metro Square One, Libertyville, Ill.)

Figure 7 Large and small caps were used with added letterspacing in this sign. The slightly larger caps make it easier to read than same size caps. (School District 211, Palatine Ill.)

Figure 8 This sign, which has since been replaced, fails in terms of legibility because of negligible contrast. (Roselle State Bank, Roselle, Ill.)

Figure 9 In the business of design, most rules can be broken. However, even though the use of outline Helvetica was elegant, it could only be read from short distances. (Sears Bank and Trust, Sears Tower.)

Most buildings using federal funds also require raised (1/32-inch) rather than engraved or incised letters and prohibit the use of overly extended or condensed letterforms. To complicate matters, individual states issue their own regulations which are sometimes different from federal rules.

FABRICATION AND TYPE

The choice of signage material can enhance or deter the readability and legibility of a sign. Selecting the wrong typestyle for the fabrication method you are specifying can be downright embarrassing. (See Figures 8 and 9.) For example, it is impossible to achieve nice crisp corners or use serifs in single stroke engraving since the letter is generated by the single stroke of a round engraving bit which is the full width of the stroke. If you want the crisp engraved look, consider multi-stroke engraving in which three or more strokes of a smaller diameter bit are used. Or try photoengraving or photoetching. (See Figure 10.)

INDIVIDUAL LETTERS If you are using individual letters mounted to a wall—cast, molded or flat cut—remember to use a typestyle that has enough stroke width to accommodate the adhesive or stud mounting behind each letter. Flat-cut letters formed with a laser or band saw give you an almost unlimited choice of typestyles. In cast or molded letters, you are limited to the manufacturers' available molds. In projects that warrant it, you can have custom molds made for a name or logotype, but be prepared to both wait for the service and pay for it.

When you order any kind of individual letters, remember to check the spacing template which the manufacturer sends with the letters. It represents your final chance to make spacing adjustments, even if that means completely respacing the letters on the template before they are installed. As a final precaution, we even ask our clients to sign the spacing template (in position on the wall, if possible) before installation begins.

COMBINATION LETTERS Called "combination" letters these letters' backs are made of metal (usually aluminum, brass or stainless steel) and the sides are manufactured of an acrylic or polycarbonate material.

Chart by Wayne Kosterman from "Library Technology Reports," Vol. 14, No. 3, May/June 1978.

1 Excellent
2 Good
3 Average
4 Below average
5 Not recommended

Image/Method	Material/Surface	Durability	Vandalism resistance	Image detail/quality	Small messages (3/8"—2")	Large messages (2 1/2"—)	Suitability for low unit run per message (under 5)	Suitability for high unit run per message	Suitability for in-house fabrication	Suitability for in-house assembly	Bright colors	Muted colors	Metallic colors	Suitability for visually handicapped	Relative cost range
1 Adhesive film die cut letter	1st (front) surface acrylic, glass	2	4	2	2	2	1	3	2	1	1	1	1	4	Low
2 Adhesive film die cut letter	Subsurface	1	1	3	2	2	1	3	3	2	1	1	1	5	Low
3 Transfer (rub down) lettering	Any smooth surface	4	5	2	1	4	1	5	1	1	2	5	5	5	Low
4 Transfer (rub down) lettering	Subsurface	2	1	3	1	4	1	5	2	2	2	5	5	5	Low
5 Photographic film image	Subsurface	1	1	1	1	2	3	1	5	5	3	2	5	5	High
6 Photographic silk screened letter	1st surface	2	2	1	1	1	4	1	4	3	1	1	2	5	Low-high
7 Photographic silk screened letter	Subsurface	1	1	2	2	1	4	1	4	3	1	1	2	5	Med.-high
8 Cut plastic dimensional letter	1st surface acrylic or wall	2	4	3	3	2	2	4	4	2	1	2	4	2	Med.
9 Cast plastic letter	1st surface acrylic or wall	2	4	3	2	4	2	3	5	2	1	2	3	1	Low
10 Foil hot stamped letter	Acrylic	2	3	3	2	5	2	3	5	5	3	3	1	4	Low-med.
11 Formed plastic letter	Wall surface	2	3	2	4	1	1	2	5	2	1	1	4	2	Med.
12 Photo-mask sand blasted letter	Phenolic plastic sandwich	1	1	1	2	1	3	2	5	5	2	3	3	3	High
13 Cut metal letter	1st surface metal or wall	1	3	2	2	1	2	4	4	2	3	3	1	2	High
14 Cast metal letter	1st surface metal or wall	2	2	2	4	1	2	3	5	4	3	3	1	1	High
15 Machine engraved message	Phenolic plastic sandwich	1	2	4	2	5	1	3	2	2	1	2	5	4	Low-med.
16 Machine engraved message	Bronze, brass	1	1	3	2	5	2	3	4	4	4	3	1	5	High
17 Photo engraved message	Aluminum	1	2	1	1	3	4	2	5	5	4	3	1	4	High
18 Die raised letter	Aluminum	1	2	3	4	2	2	3	5	5	1	1	1	3	Med.
19 Photo screened letter	Porcelain enameled steel	1	3	2	2	2	3	2	5	5	1	1	2	5	High

Figure 10 This chart can help you determine what materials to use in a sign and when each is most appropriate. First check over the vertical column marked "Considerations" for those materials most appropriate for a given project, then refer to the horizontal "Image/Method" column for the best fabrication method for that application.

These letters need stroke widths of at least 1¼ inches to allow the neon tubing to mount inside without "arching" electrically with the metal sides. Combination letters often benefit from wider than normal letter- and word spacing to eliminate the visual bleeding together of tightly spaced letters, a problem that happens at night because of the glow of the neon. If you have a logotype you would like to produce using combination or reverse can letters (see next paragraph), and the sign size limitations do not allow you to make the logotype large enough for the minimum stroke width of 1¼ inches, consider generating an adjusted "fatty" version.

'REVERSE CAN' LETTERS The front and sides of these letters are metal, while the backs are left open. The letters are then mounted several inches off the background so that the letters "float" off the surface with a halo of light reflecting from behind each stroke. (Refer to Figure 1.) In addition to the same 1¼-inch stroke width requirement, reverse can letters need added letterspacing to prevent the overlapping of letters when seen from an angle other than 90 degrees. ■

Wayne Kosterman is president of Identity Center, a graphic design office, and of Generic Sign Systems, an environmental design firm. He is a founder of the Society of Environmental Graphic Designers.

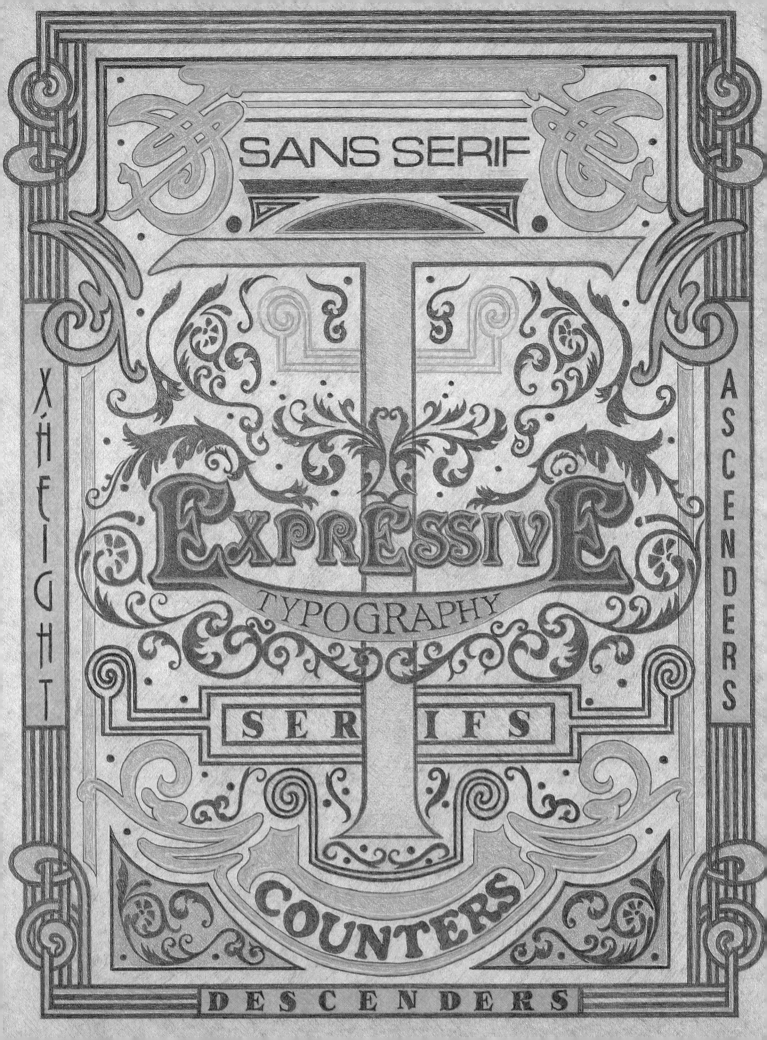

SANS SERIF

EXPRESSIVE

TYPOGRAPHY

SER IFS

COUNTERS

X HEIGHT

ASCENDERS

DESCENDERS

ADVERTISING AND PUBLICATIONS

From surprising your readers with unexpected type solutions in print ads to creating type as imagery, this section focuses on how designers can effectively use typography in some of the most common forms of media. (For more on newspaper typography, turn to "Custom Designing a New Typestyle" in the "Desktop Type" section.)

Using colored pencil on 300 max bristol board, graphic designer Donna S. Slade of Graphtiques, Inc. in Research Triangle Park, N.C., produced this typographic design. "I have been doing children's books with illuminated letters in them, and this was a spin-off from that," she says. "I do a lot of very tight comp work, so the type I do is almost done like illustration."

Crafting Advertising Typography

Ad veteran Gene Federico discusses how type conveys an ad's message (with tips from Mike Winslow and Nancy Rice, too.)

For Madison Avenue veteran Gene Federico, type in advertising must offer the unexpected. "There are so many typefaces, sizes and positions available on a page," says the art director, "that you have to boil it down to something which is not expected—I'm not saying revolutionary, I'm not saying something that opens up new ground—I just don't like to do the expected thing."

But it is also important that type in ads not be overemphasized or isolated from its primary function, which is carrying the ad's message, emphasizes Federico. "Obviously, the first thing one must think about is a solution to the problem, and there are many ways to do that. Type is really part of the whole package of communications. It is not that you specialize in it; it is part of the whole."

It is this kind of thoughtful consideration to all aspects of advertising that has given Federico the reputation as one of the best art directors in the business. While known for his elegant use of typography, he is modest about his type talents, preferring instead to say that he pays attention to every aspect of an ad and doesn't "let type go by the boards."

What is especially interesting about Federico's advertising solutions is that through the ads he crafts, he attempts to create a visual identity for his clients: Instead of merely selling a product, he sells an idea, and at times, the entire company. Typography, its placement on the page and how it is integrated with visuals, becomes one means of achieving this goal. Federico is also an advocate of using the product as an ad or as an integral element of the typography.

"Dirty" Design In this brochure announcing a show of Federico's work in advertising and graphic design, he sought a "messy and dirty look" to visually show his "passion" for design and how ideas are explored. "I often do this kind of doodling on margins, so I put some ink on a board to see if the idea would work," he explains. Many of the "doodles"—rendered with china brush, spray paint, pencil and pen—play off the art director's name. There is even a doodle by the late John F. Kennedy. The black square on the cover—purposefully created with nearly illegible type—is repeated on the inside of the brochure. The Futura type on the inside lists dates and times, and is perfectly legible.

RHYTHM AND SOUND TONES

When designing the type that will be used in an ad, two important considerations for Federico are the rhythm of the line breaks and the "sound tones" a potential typeface produces.

Many designers largely ignore the problem of line breaks and simply break copy according to a visual format or look of the ad. This is a dangerous practice because the rhythm produced by the line breaks helps convey the idea in an ad, says Federico. "You must read the copy over and over again to catch the sound of the words so the idea won't be ruined. If the line is broken at the wrong place, reading and comprehension is slowed down."

To help establish the proper rhythm, Federico places the emphasis on different words or phrases to determine which breaks will best emphasize the meaning. Clarity is the ultimate goal. "I read the copy until I learn where to break the line properly. If I find it doesn't work well visually, maybe I will go to another type that is more condensed."

By "sound tones" Federico does not mean the gray tones on a page, but the personality a face conveys. "You must choose a typeface with a sound that isn't against the idea and image you are trying to convey, unless, of course, you are introducing an irritating sound, an irritating typeface for a specific reason. Most of all, you are trying to establish a voice."

Because of his experience, the art director does not spend a lot of time poring over type books, but instead relies upon his visual memory to choose a face with the right sound. At times, what may be more important than the choice of typeface is the size at which the face is used. For example, Bodoni, one of Federico's favorites, "can serve all kinds of sounds—elegant or strong, depending on the size. The type has hardly changed in the 200 years since it was designed and it is still contemporary," he says.

In addition to Bodoni, Federico also favors Franklin Gothic and Light Line Gothic. Also on his list are Garamond, Times Roman and Futura, which he calls

"one of the great ones." He is also fond of such lesser known faces as Cantonian and Scotch Roman. He very seldom resorts to hand lettering because he says he can find all the typefaces he needs.

CENTERED HEADS: A CRUTCH Just as line breaks are important to reader compre- hension, so is placement of type in a printed advertisement. Federico finds that the current trend of stacking and centering headline copy is often detri- mental to comprehension. Specifying a headline in this format results in badly broken lines which force readers to re- read the copy in order to decipher the intended meaning. "Young designers are hung up on this centered typography," notes the art director. "It is a crutch to them. It is done to achieve a certain look, but typography is more than letterforms on a page. The words must be read and

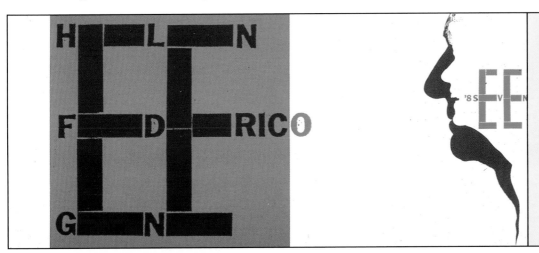

Holiday Cheer In one of a series of holiday greetings, this one for 1987, Federico combines Franklin Gothic with old type rules (to form the "E's"). The double "E" used in the names and date becomes a playful and effective design device. The use of color is bold and unusual.

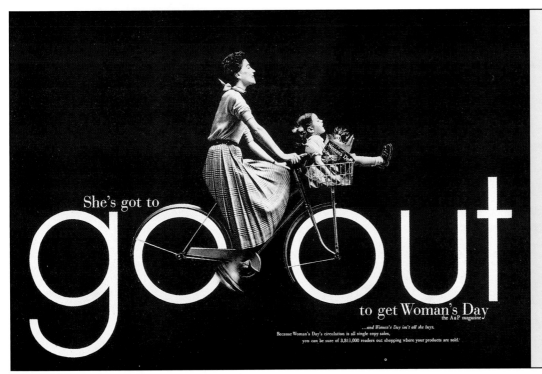

Type Plus Image In one of Federico's most notable ads, type and image become one. Futura Light was the perfect choice for the wheels that produce the illustrative headline because of its perfectly round "O's." He combines the sans serif face with an elegant serif, Bodoni Book, to emphasize the contrast.

the message understood." According to Federico, the practice of centering typography is a leftover from hot metal days when title designs for books were centered. The format, in which every line was a different thought, was never intended to be used for long quotes or sentences, as is done in today's print ads.

"Now we are using the same system— three, four, five or six lines—to express one thought. It really doesn't work that well, and there are so many other options to make the copy clearer. My point is that it is done without much thought. It is easy to create an ad with type down the center, but people don't read down the center. Just look at newspapers. If you had to read centered typography, your eyes would get tired a few inches down the column. Why does flush left and right exist? Because it is easier to read. The argument for centered typography is that it looks better. But it doesn't look better; it looks awful because it is not doing its job."

DIGITAL TYPE

While "the more the better" may suit many art directors when it comes to typefaces, in Federico's opinion there are probably just too many faces available. With the advent of digital type, the problem is compounded and a paradox is created: While computers have provided an entirely new way of creating letterforms, in the art director's opinion there has not been a typeface designed yet that is representative of our time. "There

Art As Copy In this ad for Movado watches, "The product works with the copy, not as an adjunct to it," says Federico. The art director explains that it was "absolutely natural" to combine the face of the watch as a drop cap for the text set in Times Roman. The deep page indent and the ragged right format creates an open, inviting look.

NCE in a great while a creation achieves a lasting place among both the contemporary and the classic. The Movado Museum Watch is a rare blend of form and function. You can see it at The Museum of Modern Art, among the Picassos, Utrillos, Van der Rohes, Calders, and other inspirations which have brought beauty to the world.

Over 200 new styles are in the honored Movado Collection. They range from the delicately designed Museum Watch to the bold high frequency Chronograph. Movado. For men and women. $100 to $3,000. At selected jewelry and department stores.

FOR FREE COLOR BROCHURE, WRITE TO ZENITH MOVADO TIME CORPORATION, 610 FIFTH AVENUE, NEW YORK, N.Y. 10020

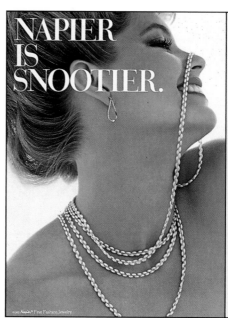

NAPIER IS SNOOTIER.

©1987 Napier® Fine Fashion Jewelry.

Elegant Type In his long-running campaign for Napier Jewelry, Federico uses Bauer Bodoni Title to create an "elegant" sound. "This is not necessarily the most elegant jewelry in the world, but the type and visuals make it look elegant," he explains. This is a case in which the entire ad becomes the corporate logo.

A Friendly Authority In this work for the *New Yorker*, Federico combines two faces, Times Roman Italic to create a conversational sound and News Gothic for authority. Breaking the blocks of copy with the photo further emphasizes the different sounds each typeface makes.

"I like the stimulation of New York. Just to be able to go into the streets and surround myself by people is fun for me. I love to be able to duck into millions of book stores and record stores, which you don't find other places. Plus, I like to go to the movies, and I have an enormous, enormous choice of movie houses in New York…I frankly couldn't think of living anyplace else."

WOODY ALLEN WAS BORN AND RAISED IN NEW YORK CITY

This message about New York is brought to you by the national magazine that knows New York. The magazine that has recently compiled useful, pertinent facts about New York, and all of America's top tier markets for quality goods and services, in a new "Guide to Selective Marketing."
The New Yorker. Yes, The New Yorker.

To get your copy, call your New Yorker representative or send your request, together with $5, to William P. Buxton, V.P. Advertising Director, The New Yorker, 25 West 43rd St., N.Y. 10036.

PROFILES
THE GIRL IN THE BLACK HELMET

Understated Ad In another ad for the *New Yorker* which appeared on full pages of the *New York Times*, the product becomes the ad. Caslon 540, which reflects the magazine's typeface, is used here. Notice the only advertising copy, which is placed in the lower right corner, is purposely understated to allow the product to sell itself.

TYPOGRAPHIC ANATOMY OF AN AD

Madison Avenue certainly isn't the only place to find art directors who are talented at creating ad typography that is very exciting. One such individual, Michael Winslow, works for McKinney & Silver in Raleigh, N.C., a firm well known for growing some of the best. Here is how Winslow designed the typography for an award-winning ad promoting tourism in North Carolina (pictured here).

Q: What typefaces did you specify for the headline and body copy, and why did you choose these faces?

A: I chose Cloister for the headline, condensed that about five or eight percent, cut it and altered some of the heights of the characters, both the ascenders and descenders. Then I specified Berkeley for the body copy. This is the third look for the state of North Carolina campaign series. In people's minds, it's a folksy, down-home place. But I didn't want to make it look too country or rural. I wanted it to be contemporary. I think each one of the typefaces I have used in the history of this campaign maintained that warm, inviting personality of North Carolina.

Q: Could you walk us through your selection process?

A: What I usually do is go through several type books and mark a bunch of faces, then pull them out and photocopy them. Others in the studio help me and I'll have them cut maybe two words for a headline. This way I can tell real quick if it's going to work or not. Then I just throw those away and narrow it down to about three or four. For those finalists I cut the entire line and start narrowing that number down to one or two that I begin to alter, if I think it's necessary. You have to go back through the same process and pick a body copy that complements it.

Q: Why did you alter the heights of the letters in the headline?

In North Carolina, some of our greatest works of art never hang in a museum.

Dove-In-The-Window. Star of Bethlehem. Wild Goose Chase. Wedding Ring. High in the North Carolina mountains, quilts are made to be purely practical. Yet their ageless patterns make them purely beautiful. Quilts, however, are just one expression of our highland artistry. Some people can put their penknife to a block of sugar maple and magically reveal the form of a wild turkey or a good hunting dog. Others make sturdy pots with glazes as guardedly secret as prized family recipes. And still others display their art in jars of jam and jelly, or in jugs of amber apple cider found at roadside stands. Wherever you travel, from our mountains to our shore, you'll be certain to find art that exhibits itself proudly. So, if you're the kind of person who appreciates finer things, you really don't have to visit the museums. Come to North Carolina, and visit us instead. **North Carolina**

For our new travel package, just write NC Travel, Dept. 589. Raleigh, NC 27699. Or, in Michigan, Ohio, Illinois and Indiana, call weekdays 8 a.m.–5 p.m. 1-800-VISIT NC. Operator 589.

(Art Directors: Michael Winslow, Mark Oakley; Writer: Jan Karon; Photographer: Harry DeZitter; Agency Producer: Suzanne Dowdee; Client: State of North Carolina, Div. of Travel & Tourism.)

A: I liked the style of Cloister for the headline, the old character of the typeface—the little nibs on the lower case, for example. But I felt if I condensed it just a little bit, it would become a little more contemporary looking.

Q: How did you alter the headline?

A: We have a photocopier here that is capable of condensing and extending the x-height of the letters, so I just played with it. I did a wide range of different percentages. And I ended up choosing either five or eight percent. After I stacked the headlines, I cut the ascenders and made them shorter—that way I was able to drop the top line down and visually close the space up.

Q: You rarely specify the same body copy face as the headline. Why?

A: A lot of display faces just don't come in a light weight for a body copy and sometimes there is just not enough of a contrast. There's a little nicer feeling if you have a bolder headline and you use a lighter body face.

Q: The body copy characters in this ad, for example, the lowercase "e," seem to be somewhat similar to the display face but yet not too similar.

A: I look for a face that has some similarities in the characters but is lighter and crisper like this one. I had the typesetter use minus leading so it would have just the right color and weight. It just felt good. For example, in instances where the descenders on one line could hit the ascenders on the next, I'll go in and cut the two lines and try to tighten up one line and open up the other so the characters lie apart.

Q: What, in your view, is the key to good advertising typography?

A: Every product or service has a personality. If you choose the right typography, that personality will come out.

—Lisa Lichtig

A Balancing Act The typeface in this very interesting yet rejected comp (the symbol of the knotted pencil was created in 1962 and has been copied in numerous ways since then) is Lightline Gothic. To balance the copy on the right, which was set first, Federico created rules that were the same width. The art director says he knew he would come out with the same number of lines as the right if he placed the question mark on a line by itself. The device not only creates balance, but puts added emphasis on the question and hence the product.

How
do
you
solve
a
problem
that
requires
10
billion
calculations
?

Problems of this enormous complexity are so common in nuclear physics that the Atomic Energy Commission asked IBM for a computer 100 times faster

than
the fastest in existence. The result is the new IBM Stretch computer, the world's most powerful.

Natural Balance In this piece, set in Railroad Gothic, Lightline Gothic and Gothic 545, Federico's goal was to use the gothics then available in metal type (no longer available today) and stack them without having to cut and paste. The red, white, blue and gray of the spread is clean and functional. The order and placement of the all caps type creates a delightful balance.

WE BEGIN WITH APPLES BECAUSE THEY HAVE SUCH LOVELY NAMES

NORTHERN SPY
JONATHAN
GRIMES GOLDEN
WINESAP
BEN DAVIS
RED ASTRACHAN
WEALTHY
HUBBARDSTON
LADY
EARLY JOE
GOLDEN PIPPIN
HOWARD BEST
CRANBERRY PIPPIN
MAIDEN BLUSH
PRIDE OF GENESEE
GLADSTONE (HAPPY ROCK)
PHILADELPHIA SWEET
CHENANGO

might be a good reason for that. We're so used to seeing certain forms that if we saw something that was completely new, we wouldn't be able to comprehend it. But it will eventually happen."

Federico's ad agency has a Mac II, but his involvement with the computer to date has been simply to use it as a comping tool. Assistants type in heads to his specification and he plays with the printouts while designing his ads. "Some of the faces really aren't bad, and it is so fast. Also, you can avoid having to hand letter the comps."

While Federico says the computer will obviously prove to be a helpful tool, it will not solve the art director's primary problem, which is to visually communicate a client's message. And for that endeavor there are no magic solutions except to study the problem and search for the answers. "I know the solution is in the problem," he says. It is just a matter of uncovering it. And that takes a little time." ■

Gene Federico is one of the principals of Lord, Geller, Federico, Einstein, a New York-based advertising agency which he helped found in 1967. He has served on the boards of numerous design organizations and his work has been recognized internationally.

ONE SIZE DOESN'T FIT ALL

By Nancy Rice

In typography, there is only one rule: There are no rules. Therefore, the following is merely advice.
● Type is a means, not an end. Type is one of several elements used to deliver a message. It should be a clear, simple road map, not a detour or barricade.
● Good typography is like a good watercolor: One has to know when to stop. Overwork it and it gets muddy.
● Typography should reflect the personality of the message, not the designer. One size (or style) does not fit all. Everything else is subjective.

Nancy Rice is a principal of Rice & Rice Advertising, Minneapolis.

The girl with dark hair was coming toward him across the field. With what seemed a single movement she tore off her clothes and flung them disdainfully aside. Her body was white and smooth, but it aroused no desire in him; indeed he barely looked at it. What overwhelmed him in that instant was admiration for the gesture with which she had thrown her clothes aside. With its grace and carelessness it seemed to annihilate a whole culture, a whole system of thought, as though Big Brother and the Party and the Thought Police could all be swept into nothingness by a single splendid movement of the arm.

Futuristic Theme In this calendar for 1984 highlighting the names of designers and art directors, Federico used George Orwell's "1984" as the theme. A passage from the book is set in Bodoni Bold, while the numerals and initials are set in Franklin Gothic. The red type functions as a beautiful accent color against the bold cap letters.

Lucantonio Giunta of Florence created this mark for his press in 1563. An artist as well as a master printer, he spared no effort to make it a symbol of originality, distinction, and devoted craftsmanship. A similar dedication produces today's IBM typewriters. That is why the IBM "Executive" Typewriter can add the unique quality of fine printing to your correspondence...create impressions beyond words.

Ad As Logo In this IBM ad, Lightline Gothic is set justified to create a balance on the page. The typeface, which is subtle yet as distinctive as the coat of arms, does its job effectively without calling attention to itself. In Federico's view, the entire ad becomes a logo.

Producing Type for Television

Chiat/Day/Mojo's type director offers some universal design and production considerations for designing type for TV.

By Graham Clifford

Typography and television are not new to each other, but what is new are the ways how type can be manipulated for the video screen. Technological innovations now allow designers to play with type in ways never imagined. In the hands of a skilled designer, type can be as interesting and creative as the sequence of images portrayed. Because type on television moves and is seen within a specific time frame, the discipline of specifying type for a television ad is quite different from designing for print advertising, where readers can study the ads or turn the page at will. In television advertising, time is the key factor. Since type appears on the screen for a matter of seconds, it needs to be very legible so the message is instantly accessible.

From a purely technical point of view, there are a few basic guidelines that need to be followed when designing type for TV.

● Word recognition must be instant so the message is projected and absorbed in the shortest possible time.

● To prevent type clashing, the intercharacter and word spacing must be kept open (slightly more than visual metal spacing). Most suppliers will actually refer to this as "TV spacing."

● Leading will also need to be increased in proportion to the intercharacter spacing.

• The use of hairlines or delicate serif typefaces is not recommended because in the process of being transferred to video tape (most commercials are shot in 16 mm film), detail is lost. Type loses definition and appears to be set tighter than what was actually specced.

• Virtually all the titles supplied to TV production companies are white type on a black background. This allows the video operator greater flexibility in adding color, outlines, drop shadows or any other effects.

Be forewarned, however; you can take great care in getting a title to production, only to have an insensitive camera operator flood it with light without any regard for focus and/or positioning. To avoid problems like these, detail your requirements thoroughly, or better yet, be present when the piece is edited.

STATIC TO VIBRANT Even at the production stage, there are many ways to liven up a shot with type. I recently worked on a spot for a fast food company in which the titles were static. But by jumbling up three different sizes of type and by using exciting color in the titles, we were able to create a lighthearted feeling that was in keeping with the tone of the spot. To create the vibrant colors, and at the same time maintain complete control, we used

A Complete Concept In a 1989 Valentine's Day message for the Royal Mail, England's post office system, type was quite brilliantly used by filmmaker Oliver Harrison (with production by Debby Mendoza). A love song, "Amore Baciami," sung in Italian was beautifully illustrated with a rolling script (in sans serif type) of the song's lyrics. As each new phrase is introduced, the previous one dissolves. The interesting use of color and pacing in this piece—how the type was revealed—created a nostalgic feeling. The idea and execution worked together to create a complete concept.

Integrated Use of Type One of the most remarkable uses of type in recent years was M & Co.'s work on the Talking Heads' video, "Nothing But Flowers." Unlike many videos which are produced with the philosophy, "We better put some type on it; now where will it fit?" it was shot with the type in mind from the beginning. Various phrases and words from the song (of the same name) are illustrated with all type. For example, as lead singer David Byrne mentions the word "cars," the word races across the screen, while "waterfalls," specced in white type on a black background, cascades letter by letter over an all live action shot.

the Video Paintbox system "on line" to the editing suite. We mixed four different colors with the system's palette and used them alternately on the characters against a black background. The colors were as vibrant as we could technically choose. Caution must be used when choosing color because some TV monitors will buzz if the frequency of the color is too high. Television companies will not accept these commercials.

In the same spot, we also employed a technique of casing the figures with a black drop shadow and enlarging the numerals used to tell viewers the price. This gave the offer more emphasis and added to the humor.

AVOIDING GIMMICKS Whether spoken and/ or set, most TV titles are typical pack shot endlines. The trend at the moment is to use quick cut film with title cards. My objection to this procedure is that it is often just another visual trick or gimmick—the same as jump cut editing, using a hand-held camera or computer graphics. It is merely another surface style used without content. "Style is a virus," says British designer Neville Brody. "Merely looking at the surface of things is a distraction from the content." While the creative use of type is welcome in commercials, it must be done in a relevant, original and interesting way.

TV: A NEW CHALLENGE

With typography, we as designers have the ability to present words in a fresh and challenging way, no matter what the medium. As technology advances and experiments with type continue, the future of type on television will no doubt prove interesting. While to some designers, learning the ins and outs of creating type that moves may seem like a foreign language, it does not have to be that way. For the aim of type in any medium is to communicate, and television is a logical progression of that challenge. ■

After learning his trade in England, British type director Graham Clifford is now working in New York, lending his type expertise to Chiat/Day/Mojo.

Animating Type Animated type is an effective means of bringing life and personality to any television commercial. A noteworthy example is the English spot for McEwans Low Alcohol (L.A.) lager by Snapper Films Ltd. in London. Through the use of advanced computer graphics, a bright red character "A" becomes the star because of its ability to perform. The lower half of the descending strokes becomes the legs, while the upper half is carried along in a fanciful strut. Letters in the background become the supporting characters for its performance.

Creating Dangerous Typography

The secret ingredient for success when breaking the rules is contrast.

By Greg Paul

We all know the rules: Never use three type styles on a page, two is dicey. Better to stay with a single family: It is safer.

But wait a minute! Look at the current design annuals; typography is going crazy and the crazy stuff is winning awards! What gives? Are the old rules old hat? Who and what can we believe in this age of post-modern design?

The truth be told, it is possible to mix two, three or more typefaces and live to tell the tale, but at best it is tricky business, and can sometimes be downright dangerous. Like David Letterman says,

"Warning kids, do not try this at home."

Even the risky stuff follows some basic rules, however. The secret for success lies in the single, unassailable truth in typeface-mixing: Always employ contrast.

Using four typefaces together is not unlike conducting a barbershop quartet. If the baritone should sing flat, the resulting discord can be exceedingly irritating. "Someone is *way* off," one might protest. But, in reality, that is not the case at all. When a singer sings flat, the sour note is a mere one-half tone off. If that interval were way off, say a whopping three tones, a perfect harmony would be produced.

These same dynamics apply in typography. Mix similar fonts (like Goudy and Garamond) and you will hear some sour notes. Common sense tells us that a single family of old style roman is adequate: Adding a second, similar family lends nothing but confusion without extending the design's textural or emotional range. However, bringing a contrasting typestyle into play can create har-

mony and logic throughout the design.

Obviously, the easiest route to typographic contrast is mixing serif and sans serif styles. Other surefire typographic contrasts include wide/narrow, heavy/light, roman/italic, caps/lowercase, script/roman, and round/square combinations. Skilled designers can sometimes combine two or more serif designs (mix a bold slab serif with a delicate old style). However combining sans serifs is much more difficult. The stripped-down sans letter shapes tend to look more alike than different, limiting the possibilities for strong contrasts between styles. Not to worry, for few are the situations where a single sans serif family is insufficient. (The rare exceptions emphasize strong heavy/light and wide/narrow contrasts.)

TEXT TYPE When playing typographic mix-and-match, remember that these guidelines apply principally to display type. Body copy is another story altogether. Good text should be read but not seen, an evenly colored sea of gray. When choosing

Italics Mix Well Italics mix extremely well with most any roman letters, and even more successfully when serif/sans serif, caps/lowercase, positive/reverse and color contrasts also come into play. The diamond motif and thematic color provide the glue that holds the whole thing together. (Pages from *Boston Woman*. Designer: Greg Paul.)

ATOMIC ENERGY

Boisterous, anarchic John Cusack is graduating from teen comedies and liable to 'Say Anything'

By Ralph Rugoff

JOHN CUSACK WANTS YOU TO KNOW HE'S FOR REAL. "I'M NO Fonda liberal," he says. "I'm not out there doing TV spots for bike safety." Sprawled on a couch, his legs hiked over the armrest, Cusack looks you dead in the eye, and you can almost see the gears whirring upstairs. His six-foot-two frame clad in dirty sweatpants, high-top sneakers, and a postal worker's jacket, Cusack looks like he just left a pickup basketball game instead of a photo shoot for a trendy lifestyle magazine.

You're starting to think that maybe he really is a regular guy, a homeboy from Chi-town who just happens to have a talent for emoting. Then he begins telling you about his cross-country trip with his actor buddy Tim Robbins, on which they were guided from beyond the grave by the spirit of Elvis Presley. "We went from New York to Memphis before we found out that Elvis was actually dead, that he'd mated with a female bear, and their son—a half-man bear-child was alive and the heir to the throne," Cusack casually relates. "But it wasn't until we ended up in Vegas twisted drunk that the trip really got dark."

After a few false starts in a spate of forgettable teen comedies, Cusack is finally demonstrating this anarchic range of character onscreen. In John Sayles's *Eight Men Out*, he played gritty good guy Buck Weaver, the dedicated third baseman who refused to cooperate with his Black Sox teammates in fixing the 1919 World Series. Then, as slimeball Ivan Alexeev in *Tapeheads*, Cusack delivered a comic tour de force as a sleazy, ingenuously unscrupulous hustler with a taste for shaskkin suits and cheap cigars. In his weightiest role to date, he will appear later this year as a hero-worshipping physicist in *Fat Man and Little Boy*, a Roland Joffe film based on the history of the atom bomb and the Manhattan Project, starring Paul Newman. And as if to keep the pigeonholers from taking him too seriously, Cusack just starred in one more teenage comedy, *Say Anything*—admittedly a "serious comedy" about a nineteen-year-old nonconformist, directed by Cameron Crowe (author of *Fast Times at Ridgemont High*). "I almost didn't do the film," says Cusack. "I turned it down a couple of times. I didn't want to graduate high school again. But then I thought, I'm 22 now, I'm only going to be this young once, and I might as well close that part of my career on a good note."

PREMIERE JUNE 1989
117

LOVE ON WHEELS

Joan **CRAWFORD** *Clark* **GABLE**

MARRIAGE TO OLDER WOMEN WAS A HABIT CLARK GABLE WAS ABOUT TO GIVE UP IN 1934—HIS SECOND WIFE, RIA LANGHAM, A WEALTHY SOCIALITE SEVENTEEN YEARS HIS SENIOR, COULDN'T COMPETE WITH HOLLYWOOD'S BEST. CAROLE LOMBARD WOULD EVENTUALLY NAB THE MOST LUSTED-AFTER MAN IN DEPRESSION AMERICA. BUT GABLE HAD ALSO THOUGHT ABOUT MARRYING JOAN CRAWFORD, AT THE TIME HIS COSTAR IN *CHAINED*. THE TWO ARE POSED HERE IN FRONT OF CRAWFORD'S MOBILE DRESSING ROOM.

PREMIERE JANUARY 1989
100

Resident Style Thick and thin, wide and narrow, serif and sans, and large and small are the built-in relationships of *Premiere* magazine's two predominant display fonts. When other typography is added, it is usually a script or custom-lettering (for example, "the way they were" label). (Design Director: Robert Best.)

PILLOW TALK

In the wake of the AIDS epidemic, lovers and other strangers are conducting an anxious bedroom dialogue. The result is a new sexual ethic with an old-fashioned spin.

BY BECKY CHESTON

A peck on the cheek at the end of the night. One steady guy, rather than two or three. Marriage to your high school sweetheart. It all has a sort of 1950s ring to it.

But to many women these days, some of the sexual habits of the '50s are beginning to sound like good common sense for the '80s. As AIDS becomes an increasing reality for the heterosexual community, it is becoming apparent that fear of the disease has done more than boost the sale of condoms. It has sown seeds of discontent within the sexual revolution.

The association between sex and disease is nothing new. But sex and death are unacceptable bedfellows. Faced with consequences more cataclysmic than herpes, chlamydia, or gonorrhea, women are rethinking casual encounters, reexamining relationships, and rediscovering old methods of birth control as well.

Spawned by the advent of the Pill and the political upheavals of the '60s, the sexual revolution brought with it experimentation, new freedoms, and profound change. Looking back on their sexual coming-of-age, most women reflect on both the good and bad with an appreciation for the fact that they were free to experiment, and make mistakes. Now, as the AIDS epidemic hints at a return to "old-fashioned" sex—fewer partners, rediscovery of condoms, postponing that first sexual experience with a new partner—many wonder about what to expect from the pendulum's backward swing, and about what lies ahead for future generations.

WHAT DO WOMEN involved in heterosexual relationships have to fear? As of last December, among 28,523 reported AIDS cases, the heterosexual total was 1,079, or just four percent. But what worries most women who are beginning to rethink their sexual habits is the prognosis for the future: the national Centers for Disease Control in Atlanta predicts that within five years, the pro-

Combining Sans Serifs The most difficult typographic combination is two sans serif families. Here we see Eagle Bold and Univers 49 sharing the same page. The secret is in the wide/narrow, bold/light contrasts combined with the unifying visual themes of semicircles and arrows seen in the headboards, clock, pill dispenser, and headline typography. (Pages from *Boston Woman*. Designer: Greg Paul.)

Recipe For Success This type-salad succeeds through sheer contrast and a celebration of diversity. Consider the ingredients: serif, sans serif, script, roman, italic, bold, light, large, small, color, texture, plus upper and lower case along the way. All lend contrast to the composition. The repeated circle and dot shapes unify the design and subtly suggest the web-offset printing process. (Designer: Greg Paul.)

THE PROBLEM OF AAS • ELECTRONICS IN PRODUCTION • SPECIALTY PRINTERS

NOVEMBER 1988/$4.00

Magazine
DESIGN & PRODUCTION
FROM CONCEPT THROUGH DISTRIBUTION

Ozi&s
z
.8 8

THE SECOND ANNUAL PUBLICATION DESIGN AWARD

type for text setting, I recommend a legible letterform of relatively even stroke weight, that has some structural relationship to one or more of the accompanying display fonts. A good example is the text you are now reading, ITC Century. It is a solid, dependable body setting with a strong kinship to the more contrasty ITC Modern seen in the *Step-By-Step* logo and feature headlines. While Modern's distinctive thick/thin characters add personality to the magazine, it is a poor choice for text, hence the structurally related ITC Century.

With caution, sensitivity and subtle manipulations of typographic contrasts, it is possible to mix fonts in the bold, non-traditional, anachronistic style of post-modernism. If we look closely, however, we will see that the best of this new, "risky" design is, underneath it all, still responsive to the rules of good typography. ∎

Greg Paul is a partner in the design and editorial consulting firm Brady & Paul Communications, Inc. of Boston, Mass. and Fort Lauderdale, Fla. He is the design consultant for Step-By-Step Graphics.

Try Reversing Reverse type adds even more contrast to the thick/thin, wide/narrow, short/tall contrasts necessary to get these two sans serifs working together. (Pages from *New Age Journal.* Designer: Chris Frame. A.D.: Greg Paul.)

THE CHELATION CONTROVERSY

Patients say this new treatment for heart disease and circulatory problems is the kiss of life. The medical profession is divided: some call it quackery—a placebo, at best—while the more than one thousand physicians who practice chelation consider it a medical breakthrough.

by Judith Glassman

AFTER my angina came back, I thought, This is the end for me. I sold my big house, sold the plastics business I had been in for thirty years, did a lot of cleaning up to make life easier for my wife after I was gone," fifty-nine-year-old John Fiore of New Jersey says. "When I first started EDTA chelation therapy, I was planning on dying."

Fiore had had a triple bypass three-and-a-half years earlier, but when the chest pain returned and an angiogram revealed that his grafted arteries had closed up, he refused to even consider more heart surgery. "That operation was the most awful thing in my life," he recalls. "I'd die before I'd do that again."

Instead, Fiore began an unconventional treatment—and thrived. At the urging of a neighbor, he began seeing New York City holistic physician

Judith Glassman writes frequently on health and alternative medicine.
(ILLUSTRATION: KISSING 1983, ALEX GREY)

Warren Levin, who gave him a detailed medical workup, then recommended a drastic change in diet, nutritional supplements, and treatment with the controversial drug ethylene-diamine-tetra-acetic acid, a manmade amino acid commonly known as EDTA.

The treatment consists of a series of intravenous infusions given two to three times a week for a total of 20-40 infusions or more, depending on the particular case. The infusions usually last three and-a-half to four hours, and each generally contains three grams of EDTA.

When Fiore began the therapy, he had trouble walking the short distance from the train station to Levin's office. "I couldn't walk a block. My legs felt as though they were going to collapse." But after about fifteen treatments, his chest and leg pain had totally disappeared. "I feel terrific," he says now. "I even look younger—I don't have any more little wrinkles around my face. Chelation has given me a new lease on life."

Since the '50s, 400,000 people like John Fiore have undergone chelation therapy for a staggering variety of ailments, including angina pains, peripheral vascular disease, gangrene, memory loss, senility, chronic skin ulcers, and retina damage from diabetes. Many of them have pronounced it a miracle cure.

The 1,000 M.D.'s who practice chelation claim it has valid long-term effects. These physicians maintain that EDTA has an extraordinary success rate—long-lasting subjective improvement in 75-90 percent of all patients. Says Elmer Cranton, former president of his county medical society and author of a recently published book called *Bypassing Bypass*. "My patients don't all get completely well. But 85 percent improve enough so

that they're happy with the treatment." Furthermore, Cranton and his colleagues claim that when administered according to established protocol, EDTA is one of today's safest medications, less toxic than aspirin.

If reports such as Fiore's, Cranton's, and others are accurate, chelation ranks as one of the greatest medical discoveries of all time. Most of the ailments chelationists claim to treat successfully stem from impaired circulation, often caused by arteriosclerosis—the progressive accumulation of arterial plaque that clogs and stiffens arteries, leading inevitably to heart attacks and strokes. Arteriosclerosis affects up to 100 million people in the United States, and modern medicine offers no cure. Drugs and surgery temporarily relieve symptoms but do nothing to stop the progress of the disease.

Still, not everyone shares chelationists' enthusiasm. The treatment is at the center of a whirlwind of medical controversy, with the big guns of mainstream medicine—the American Medical Association, American Heart Association, American College of Physicians, American Academy of Family Physicians, and the American Osteopathic Association—maintaining that EDTA is useless to treat cardiovascular diseases. Even the most open-minded physicians—like William Castelli, medical director of Framingham Heart Study, the longest-running analysis of the relationship between diet and heart disease—are skeptical. Castelli concludes, "I know of no objective evidence whatsoever that EDTA is of any value."

Many physicians believe that chelation therapy is not only useless, but hazardous as well. Alfred Soffer, editor in chief of the medical journal *Chest* and executive director of the

TALKING AIDS TO DEATH

Esquire
MARCH 1989

Have you heard the one about the waiter and the salad dressing?

I'M TALKING TO MY FRIEND Kit Herman when I notice a barely perceptible spot on the left side of his face. Slowly, it grows up his cheekbone, down to his chin, and forward to his mouth. He talks on cheerfully, as if nothing is wrong, and I'm amazed that I'm able to smile and chat on, too, as if nothing were there. His eyes become sunken; his hair turns gray; his ear is turning purple now, swelling into a carcinomatous cauliflower, and still we talk on. He's dying in front of me. He'll be dead soon, if nothing is done.

DEAD SOON, if nothing is done.
"Excuse me, Mr. Shilts, I asked if you are absolutely sure, if you can categorically state that you definitely cannot get AIDS from a mosquito."
I forget the early-morning nightmare and shift into my canned response. All my responses are canned now. I'm an AIDS talk-show jukebox. Press the button, any button on the AIDS question list, and I have my canned answer ready. Is this Chicago or Detroit?
"Of course you can get AIDS from a

mosquito," I begin.
Here, I pause for dramatic effect. In that brief moment, I can almost hear the caller murmur, "I knew it."
"If you have unprotected anal intercourse with an infected mosquito, you'll get AIDS," I continue. "Anything short of that and you won't."
The talk-show host likes the answer. All the talk-show hosts like my answers because they're short, punchy, and to the point. Not like those boring doctors with long recitations of scientific studies so over-

BY RANDY SHILTS

123

PROFILE

Sly's Progress

By Elizabeth Kaye

"I USED TO WAKE UP SINGING," HE SAYS. He doesn't anymore. But he never regrets that the night is over. His sleep is fitful, restless, unsatisfying. In the last fifteen years, he has slept undisturbed no more than three nights. He hates to sleep. It's a waste of time.

He collects art, he plays polo, he feels pain.

For Sylvester Stallone, time was always a troubling preoccupation. Now, forty-two years into a life that sometimes strikes him as more interesting than his films, time is becoming an obsession. "If you live to be seventy-two," he often says, "you don't get a million hours." He owns more than thirty watches. His hobby is painting, and lately, clocks appear in all of his canvases. He resents being subject to the clock, yet he checks the time constantly. "When you start to see the encroachment of age," he says, "you can hear every second. Clicking. It becomes like a metronome."

Usually he is up by six, sometimes by five, always by seven. "You're rich, you're famous," his agent tells him, "take a month off, go on a vacation." He doesn't do it. He can't. "I feel as though I haven't accomplished anything. I don't feel satisfied at all. My mind is constantly questioning: What next? Where to? Why now?"

Do Experiment Four display-size typestyles mix in the "AIDS" page, achieving a difficult combination of three serif letterforms. The bold slab serif (the words "talking" and "death") with the delicate Craw Modern deck is a relatively easy twosome, but the addition of the geometric-square serif Bodoni-style "AIDS" is much more risky. The strong size and width contrasts are what make this combination work. "Sly's Progress" relies on the sure-fire contrast of italic and roman, and builds in extra distinction with engraved caps. (Pages from Esquire; A.D.: Rip Georges.)

VOLUME II ● NUMBER 1 SPRING 1988 ● $3.95

Golden days as the batboy at Ebbets Field

Patterson vs. Johansson in 1959 & '60

D.C. Senators throw it away in 1961

Cunningham's new record at Dartmouth

Sports Heritage
THE JOURNAL OF OUR SPORTING PAST

CAUGHT SHORT

Down But Not Out, **WISCONSIN EXPLODES**

New York

THE ANNALS OF MANHATTAN CRIME

from 1741 until today

BY PATRICK M. WALL

The ghosts of criminals and victims are all around us. Rioters, poisoners, gang bosses killed by other gang bosses, lovers who killed in passion, robbers who murdered for greed, assassins, bystanders, snipers—all have left their mark on Manhattan. The Strong Arm Squad was born here. A baby-faced cop killer inspired a famous Cagney role. *Looking for Mr. Goodbar* became a parable of the lonely singles life.

I often pass by 149 West 43rd Street, a rather dreary building near Broadway. Years ago, I learned what had happened there one night in July 1912, when it was the Hotel Metropole. Now I cannot walk by the spot without imagining the gambler Herman Rosenthal as he left the hotel early one morning and wandered into a fatal ambush (see number 33, page 46). And when I pass Sparks Steak House, on 46th Street near Third Avenue, I

see not only the body of crime boss Paul Castellano (number 85, page 55) but also the mob of thousands that sacked the nearby Provost Marshal's office in 1863, setting off the biggest riot in the nation's history (number 16, page 43).

I practice criminal law, and my fascination with crime is professional rather than morbid. At least, I can make a good argument to that effect. I am also a native New Yorker; I love this city and try to learn all I can about its past. The combination of my vocation and avocation has produced this article. I've selected these particular crimes (which are pinpointed on a map on page 45) because of their notoriety and historical importance—but also to illustrate that human nature (and the crimes it produces) remains remarkably consistent through the ages. Someone else would come up with a different list, certainly, but most of these crimes belong in any accounting of the dark side of the island's heritage.

Match Your Topic Arbitrarily changing fonts for each line of type easily achieves an antique newspaper or playbill effect that aptly reinforces the right subject matter. (Cover from *Sports Heritage*. Designer: Greg Paul. Page from *New York Magazine*. Design Director: Robert Best.)

Typography in Book Jacket Design

Louise Fili discusses her working methods and the critical role type plays in designing book jackets.

Since singling out jacket design as her signature specialty in the late 1970s, Louise Fili has been quietly transforming the look of American books. As art director of Pantheon Books for 11 years, Fili imbued the hundreds of titles she either designed or art directed with her own elegant style. Since leaving the company in late 1989 to open her own design studio, she has continued to play a major role as visual interpreter of American letters.

Perhaps what makes Fili's work so interesting is that she believes there is only one face that is right for every jacket—

and she goes to great lengths to find it. Fili has resurrected forgotten typefaces from the early part of this century and has used them in fresh, often striking ways, and she is an avid collector of old faces, many of which she has found in European flea markets and used book shops.

While known for her rich use of illustration, especially on fiction titles, she also believes type-only covers can be equally effective in expressing the content of a book. In fact, she says, some titles or subtitles are so powerful they require nothing else.

Fili has taught a senior portfolio course at the School of Visual Arts, has been recognized through awards by almost every design organization, and was a recipient of a grant from the National Endowment for the Arts in 1984. In the following interview, Fili discusses how she approaches a typographic cover design, her sketching method, her extensive reference collection, considerations when integrating type with images and how to

achieve a distinct visual voice among the many look-alike "designer book jackets."

Q: To what would you attribute your general sensitivity to type treatments and applications?

A: Type has always been my primary interest, even before I knew what type was. When I first became an art director, I found that when I was given a project to design, I would first imagine the typography and then I would commission an illustrator for an image to go with it. I don't work quite that way anymore, although sometimes I'll admit that I do.

In my early years, I was always very interested in calligraphy. When I was in high school, before the calligraphy rage, I sent away for an Osmiroid pen that I saw in the back of a magazine and taught myself how to use it. Since there were very few books on the subject at that time, I copied everything I saw. I found out in college that if you were interested in cal-

Quiet Treatments Fili felt the book at left, one of a series which she designed, all by the same author, needed a "spare but quietly beautiful" treatment. She found the figure in a type book from her extensive collection, cropped it and had it redrawn and airbrushed so it would be barely visible on the page. The type was redrawn from a face found in French poster designs in the 1930s and '40s. The adaptation included properly varying the weights, adjusting the crossbars and changing the design of certain letters. In the book at right, the last in the same series, Fili wanted a less dream-like quality than previous covers, so she chose John Martinez as the illustrator. The typeface, which she refers to as "Louise," is one from her private stock. The title of the book is set in Master Script, a face statted out of an antique type book, pieced together and reworked.

ligraphy that meant that you should grow up to become a designer. And then later I found out that designers grew up to be art directors.

Q: Explain how you approach a typographic design by walking us through the steps you take. As we understand it, your process might typically begin with a very thorough read, followed by thumbnails to develop a concept.

A: I read all of the fiction, and for the nonfiction titles, I read a synopsis and usually the introduction and the first chapter or so. It's really not essential to read much more than that for nonfiction.

After reading, I usually have very specific ideas about what I want, and I'll show that in a rough sketch. Usually I just sketch out the type for the title over and over again on a tracing pad. From a very rough scribble, it gets tighter and tighter and the type becomes more defined and focused. It will have the mood and the

approach I'm looking for, but very often it turns into a typeface that doesn't actually exist. But at that point, that's exactly what I want and I can't settle for anything else. If that is the case, then I usually have it hand lettered.

That can be more expensive than speccing and hand-altering a face, but then you end up with something unique. I think that is essential because there is so much imitation in book jackets—and in everything else—that it is important to give an absolute identity to a design whenever possible. I don't want to use a typeface that anybody can use. I feel I have to go a step further to make it unique and, of course, appropriate to the subject matter, which is also something that is very important to me.

Q: When you spec and hand-alter type, do you use a wide variety of typestyles?

A: Getting the type right is extremely important to me. And that's often what I

focus on the most. I try not to repeat myself with book jackets. I always try to use a different typeface because I feel that every design solution has one specific face that's absolutely right for it. Whether it's a type that exists or not is another question. I often end up resurrecting old faces. In the reference material I collect, I often find that the whole alphabet does not exist, so I either redraw the type or have the missing ones relettered. I'll even invent my own face beginning with an existing face or just start from scratch.

I think it is always a challenge to turn this little thumbnail into something that works. From there, I'll have to select the right typeface and define the right treatment that will carry it through. If I ask an illustrator to show a scene from the beginning of a mystery, I will do a little thumbnail or I'll show reference of the kind of lighting I'm thinking about. I usually supply designers, illustrators or letterers with reference materials because

A Historical Theme This is one of a series of books by Franz Kafka released by Schocken Classics, a division of Pantheon Books (at left). In this series, Fili tried to create a simple, striking feeling reminiscent of letterpress. The scratchboard illustrations are by Anthony Russo. The main typeface is Facade Condensed, a wood face which she expanded. The secondary face is a Morgan face available on Typositor. The publisher's name is set in a script face which she felt complemented the rough quality of the other faces. The stock is Speckletone. Red acts as the accent color to the smoke gray and beige jacket. No photos were available of the Marx Brothers during their radio days so Fili commissioned Bill Nelson to draw an illustration of the pair before a radio microphone (at right). The radio waves were added to emphasize the theme of the book. The script face in both the title and tag is Master Script. The bold type of the title was hand lettered by Jon Valk, based on Fili's tissues. The green and red type pick up the colors in the illustration yet do not dominate the page.

I have a rather extensive library of design reference.

Q: What does your reference library include?

A: Books on poster design, alphabets, all kinds of type design. I'm always combing flea markets and old book shops. I also collect various printed pieces and I have a fairly extensive type collection. Whenever I go to Europe, I'm always photographing signs, which I also keep in my files.

I may give an illustrator or a designer an image from the side of a fruit crate or something else from my collection that has just the right kind of type or design. It is really important for us to see eye to eye from the beginning. With art direction, it's a communication game and there is always something lost along the way.

Q: While you are in the process of selecting a typeface for the cover of a book, can you detail what questions you ask yourself?

A: I think it's instinct. I don't think I've ever had to say to myself, what period are we dealing with and what typeface was being used then? I think it's all subliminal, but again, I think appropriateness is very important. Often it's not just the face you use, but how you use it that is important.

Q: Do you prefer some typefaces over others? What are they and why? And which foundries and type manufacturers do you tend to favor, for particular cuts of faces, if any?

A: I prefer anything that is pre-ITC (International Typeface Corp.). It's getting more and more difficult to find the real Bookman and the real Kabel, and the real Cheltenham and all the others.

I do have certain favorites, but I like to use new typefaces whenever I can. The Photo-Lettering book has a million typefaces that you will only use once, if ever, but I'm always looking for that opportunity. In the back of the book they have all the novelty faces, like Log Cabin and Needlepoint. There is one that looks like

a lasso. Someday I'll have the right book for one of them.

Q: Are there certain faces that you use more often that others?

A: The ones I use the most often tend to be the standards, like Futura Book or Eagle Bold. Or else I have certain private stock faces—alphabets that I've found and have had a letterer rework. Whenever I need them, the alphabets are there. That's the great thing about doing book covers: Every day you can use another typeface.

Q: For what kinds of jackets do all-type covers seem most appropriate?

A: If it's a boring, academic title, then I think it would be heartbreaking to use all type. But if it's a wonderful title that really lends itself to a special type treatment, then why not?

Q: Do you impost any particular rules for yourself when mixing typefaces in dis-

Incorporating Photos This definitive biography of Willa Cather for Oxford University Press (at left) combined a powerful photograph of the author—softened around the edges—obtained from the Nebraska State Historical Society, with a typeface from Fili's collection. The title is highlighted through the use of italic and subtle shading (achieved with an airbrush), which is repeated under the author's name. In this rejected comp for Harcourt, Brace, Jovanovich (at right), Fili used an early photo by Andre Kertesz, which she combined with a hand-drawn face based on Kabel and Bernhard she has dubbed, "Louise Bold." Her attempt in having the face redrawn was to create a bold sans serif with extended crossbars and pointed "A's" and "M's." The editor's tag is set in Futura Book, while the numerals (part of the title) are Kabel. Fili created the seal based on a stat of an engraving to give the cover added appeal.

play and text situations?

A: I don't believe in rules. For every rule, there is an example of how that rule is beautifully broken. A good designer knows when something works and when something doesn't. I also think a good designer is constantly trying to break preconceived conventions.

I'm always testing myself because I am caught in the middle between aesthetics and reality. I know that a book jacket has to be read. I don't believe that it has to be read from across the street. If it takes you more than one glance to read a title, then I think there's a problem. But on the other hand, I have editors who think if a three-year-old can't read it, then it's out.

With text type, I have virtually no involvement, which is too bad. But you'll find in publishing that it's very hard for the two to connect. Because of timing, the inside of the book is done well before I do the jacket. Whenever I am able to do the jacket ahead of time, the inside designer will sometimes try to work off of elements that I've used on the jacket, and that's

wonderful because it has a cohesive look. But very often the two have very little to do with each other.

Q: What qualities do you look for when you choose a hand-letterer?

A: I work with five hand letterers, and they're all very good. But I use them all for different specialties. Craig De Camps is very good with airbrush and with period lettering. If I have a typeface that I want developed or just cleaned up, I'll give that to another person. If I have something that's more script oriented, I give it to Tony DiSpigna. They are terrific craftsmen, but I don't rely on them for design judgements. I really want the design to be totally in my control.

Q: When illustration is a primary element in the cover, do you wait until you get the final art before you start researching the exact typeface you will use?

A: It depends. If we're pressed for time, once I see the sketch, I'll start working on

the type while the illustrator is finishing the artwork. I would rather wait until I have the finish in hand because there are little subtleties that may affect my type treatment and I wouldn't know about them until I saw the finish.

When I look at a sketch for an illustration, I may not have the type worked out exactly. So I always make a photocopy of the sketch for myself. When I've had a chance to study it, I'll call the illustrator back, usually that afternoon, and I might ask for a little more depth in one area. It's important to me that the type fits exactly right.

Q: Do you ask the illustrators for recommendations for type treatments on work they submit?

A: I try to encourage illustrators to do their own typography. I feel that most illustrators do have a very good sense of typography, yet they're afraid to unleash it. Sometimes I have them draw the type from my design as part of their illustration. At other times, I will give them more

Using the Airbrush Fili paired a photo by Marcia Lippman with what has become a trademark for her: shaded type. This type was rendered with an airbrush (at left). Her goal was to make the typeface compatible with the mood of the photo. The typeface is Empire, available on Typositor, but the initial caps were redrawn. (The type is violet gray with airbrushed dark gray shadows.) The type on the recent Knopf release at right (both the title and author's name) was hand lettered by Jon Valk, based on Fili's tissues. The inspiration for the type was old movie posters and lobby cards from the 1940s. A subtitle, originally lettered in the same script and placed on the same angle under "Brooks," was eliminated. The photo is a duotone, created with black and metallic bronze. The author's last name is printed in a violet metallic ink. (A.D.: Carol Carson.)

of a free hand. In most cases it's been very successful. I think it can be a much stronger piece when the type is an integral part of the illustration.

Q: Do you find that they can also choose machine-set type well?

A: That's where we usually run into trouble. There's never anything wrong with it, but it's usually just a little too bland for my taste. That is not what I am relying on them for. I or my assistant can do that. What I want them for is to actually create the type as part of their illustration and to execute it with whatever medium they're working with.

Q: In some of your work, you use a shaded type that has become somewhat of a signature for you.

A: Whenever I give my slide show, I always open with a cover of an advertising annual from the 1930s designed by Gustav Jensen, who was the inspiration for this shaded type. It took me a long time to find out who had actually de-signed that piece because they were very casual about credits in those days. The great thing about being an art director is that when I see something like this that I wish that I had done, I can turn it into a book cover. But I don't think in any of the cases where I have used this shading, it really had much to do with that Gustav Jensen sample. It just launched me in this direction. For this kind of lettering I always work with Craig De Camps, and I direct him very tightly.

Q: What media are being used to create this effect?

A: We tried different styles each time. The first time, with "Daybook," Craig used pencil. A couple of weeks later we worked on a Simone DeBeauvoir book "When Things of the Spirit Come First," and we decided that he should use airbrush. When "The Lover" came along, we used still another approach. The type was done in a fine line, with a shadow on a separate overlay.

Q: Your work has been characterized as part of a movement that finds its primary inspiration in early 20th century graphics, especially in its use of long forgotten and eccentric typefaces. Who and what are these influences?

A: I am influenced by historical styles and typefaces of the past and incorporate them into my work. But I transform them into my own style, give them my own iden-tity. In general, I'm very influenced by European poster design from the 1930s and early '40s—specifically French and Italian. I've always been very enamored with Jean Carlu, whose poster design has a distinct style of typography. But there are certainly many other designers of that period who interest me.

Q: At Pantheon were you involved in every title?

A: I was at Pantheon for 11 years. In the beginning I used to design everything myself. When I first started they had a very comfortable list, about 20 books. It was ideal for me because that was my first experience as an art director. As

Hard-To-Find Type For this book of woodcut illustrations by Belgian artist Frans Masereel, Fili wanted to use a bold, condensed face with a woodcut quality (at left). After sketching the letterforms to get the feeling she wanted, she found a similar face in an old typeface book. But it required major reworking: fixing the crossbars of the "e" and creating an "s." The title of the book was set in a Morgan wood typeface available on Typositor. She also decided upon the size of the book, 5x7 inches, so it would be easy to hold. The paper stock is Speckletone. Red becomes an accent color to the dark gray type. In art directing the cover at right, Fili had to have an image that would work both on this hardcover jacket and a to-be-released paperback. The face is Ultra Modern, which is no longer available, with airbrushed shadows to give it the same quality as the photography, shot by Marcia Lippman. Fili feels that script faces like the secondary face used here, Soler Amrita, only work well when used sparingly.

more titles were added—it averaged 100 to 120 titles a year—I really wasn't able to do everything myself, nor did I want to. So I just started delegating and eventually learned that could be as satisfying as any other aspect of art direction.

Q: What advice do you give your SVA students and young designers on type?

A: What most students lack is a sense of history. When I was teaching, my students' idea of design history went back about as far as Herb Lubalin, if at all. Fortunately, books concerning design history are more available now, making it easier for students to understand the past.

Students just don't realize that there aren't a lot of new things out there. When they're using ITC Bookman, they don't have a clue that there was an original Bookman. But once you introduce it to them, students are receptive to this idea of history. And I think in some ways they're more receptive to that than to what you can do with type on a computer.

I also wish that students could be a little bit more literate than what I found

them to be. When I taught a senior portfolio course in design, none of them ever felt that it was necessary to know the least thing about the book they were designing a jacket for.

Q: In looking at examples of ineffective type treatment, what are some of your most common observations?

A: I think it's all part of faddism. Some people think that all they have to do is letterspace the title and they have a design. It takes a little bit more than that. It takes a concept and a type treatment, which may or may not have anything to do with letterspacing. That's always a problem. It's the same in illustration. People think that as long as you can buy an airbrush you're an artist, but it does take more than that.

There's also a sameness in terms of selecting typography. But even more than that, there is just a lack of depth—a lack of understanding of what the book is. I not only like to look at a good jacket, I like to read a book every now and then. I don't think that a lot of jacket designers

actually think about who is reading these books. Some people just want to make it look wonderful without realizing what tone to give it. That can be very important—the design must be appropriate to the title. There are a lot of decorator jackets out there now that don't have a lot of thinking behind them.

Q: Can design actually affect how a book is received in the marketplace?

A: Absolutely. I think design always has an effect on a book. Consumers are certainly becoming more sophisticated about good design. Of course, if you have a great book by an existing author, it probably doesn't matter what kind of jacket you put on the book. But if it's a first author or an unknown, why not make it beautiful —if that is appropriate to the book. It's always interesting to see when a dark horse inadvertently becomes a best seller, which happens all the time. In those cases, design plays a major role in the success of a book. ■

—*John Fennell*

Other Work For this Simon & Schuster novel about an Australian woman living in Shanghai, Fili used a 1920s photograph from the Bettmann Archive with an engraving of a snake from the same source (left). The deckled edge was a stat from a photo album. Three Toyo metallic inks were used for the background color. The typeface is Dainty, a Victorian face resurrected from an old type book. The gradation was achieved with airbrush. The photo is a duotone. The background is printed in metallic green and silver. (A.D: Frank Metz.) In recent freelance work, Fili has gone beyond jacket design and produced works like this wine label (right). To create a classical, elegant feeling, she combined an illustration by Philippe Weisbecker with a variation of the typeface Egmont (for Knapp) and Riveria Script (for the name of the wine). The letterspacing helps create the open space. The script "K" was developed from a sample found in a French lettering book.

Newspaper Typography: Some Do's and Don'ts

So common as to be almost invisible, newspaper typography actually requires attentive treatment.

By Rolf F. Rehe

With the explosion of technology in the field of publishing and design, there are more options available to newspaper designers today than ever before. Yet in a world with so many possibilities, some of the most basic questions still plague the newspaper designer: What sort of typefaces should I choose? Which kinds of type will work best with a new nameplate? Should my standard typography be different from my text typeface?

These choices are basic to our work. But the sheer number of available options may make the choices seem more difficult than they really are. And technology is continually adding to those options, allowing us to do things in design that were either impossible or at least financially impractical a few years ago.

Still, design is involved in the art of making choices. To make it easier to evaluate those choices, we need to break down the newspaper design into its components and study our options. This article will divide the typographic components according to their uses in the newspaper: text, headlines, standard type, info graphics and nameplates.

TEXT TYPEFACES

Even though it is the most heavily used type in the newspaper, text type often gets the least attention. With so many options available, why do so many newspapers cling to the same basic list of four or five "standards" for text type? The majority of American newspapers, for example, use Crown or Corona as their principle text typeface. And even the most innovative designs still rely on the classic look of serif text type. Whether it is the *New York Times* or the trendsetting *Orange County* (California) *Register*, the best-looking designs in the country all use serif faces for their body type.

This preference for serif type is not just an artistic whim on the part of designers. Research has shown that it takes readers slightly longer to read text set in sans serif type. And, when a group of readers was asked to rank seven typefaces by preference, the sans serif face rated next-to-last. In addition, newspaper readers react negatively to the monotonous look and impersonal feel of the type.

To be consistently effective in a daily newspaper, a good text typeface ought to follow certain rules.

CHOOSE HEAVIER STYLES The face should be heavier than "quality printing" type. Most newspapers are printed on newsprint that is actually a light gray color. The text type needs to provide contrast between the grayness of the paper and the blackness of the ink. Therefore, a slightly heavier type should be selected. (See Figure 1.)

AVOID FINE SERIFS Fine hairline elements should be avoided. Since most newspapers are produced on fast presses, quality is, to some extent, sacrificed for speed. To hold up well under less than ideal conditions, a newspaper's text type should not use tiny hairline elements or feature pointed serifs since these may not stand out strongly on the page—or they may even disappear entirely.

PROJECT AUTHORITY The text type should project an image of authority. It cannot afford to look "weak" on the printed page. That is why faces like Garamond and Palatino, which are perfectly good for book or magazine printing, do not usually work well for daily newspaper work. The fine serif elements of these excellent book-style typefaces are too easily lost on newspaper presses.

CHOOSE ADEQUATE X-HEIGHT Your text type should have a good x-height. The term x-height refers to the relationship of a letter without ascenders or descenders (such as the lowercase letter "x") to a capital letter. The x-height determines the actual visual size of the typeface. An adequate x-height helps you avoid the problem of trapping white space between lines with overly long ascenders or descenders. (See Figure 2.)

NARROW, NOT CONDENSED The text type should be a bit narrower than a standard design (though not condensed). This assures a good word count on the page, without sacrificing legibility. A typeface that is normally just slightly wide for text type can be modified electronically to create a narrower version of the typeface. (See Figure 3.)

LEADING Several other factors will affect the impact of your text type selection on the printed page. For instance, the amount of leading—the space between lines of type—contributes to the "color" of the page. Too little leading creates a gray-looking page as the lines of type appear to run together. Too much leading can also create problems as type appears to drift apart. Serif type calls for less leading than sans serif type because the serifs reinforce the horizontal eye flow. Bolder typefaces require more leading than lighter faces.

COLUMN FORMAT Should the type be set in fully justified columns, or should the text be set ragged right for a more informal look? Most daily newspapers run the bulk of the news and editorial copy in justified columns. Feature pages and lighter elements, such as the page one "brights"—short, snappy entertaining items on the front pages of sections—are often found in ragged right columns which seems to match their more informal style.

Column width also plays an important role in the impact your type selection will have. Short lines force the reader's eyes to spend too much time traveling back and forth on the page. Excessively long lines become monotonous and tiring to the

9/10 Goudy O.S. x 12 picas—

Dulce et decolorum est fipro et patria mori. Nunc efijlinfijlint et semper fet in saecularon saeclorum sed finoitus bonifactus fijlin fecitop fijlin stella regiunus septus.

Consortius fijlipro bonis gloria est tempustius fugit. Magnificat fijdeus animam meambea decolorus est.

9/10 Excelsior x 12 picas—

Dulce et decolorum est fipro et patria mori. Nunc efijlinfijlint et semper fet in saecularon saeclorum sed finoitus bonifactus fijlin fecitop fijlin stella regiunus septus.

Consortius fijlipro bonis gloria est tempustius fugit. Magnificat fijdeus animam meambea decolorus est.

Figure 1 Newspaper printing requirements demand the use of a heavier than "quality printing" type. The text type needs to provide contrast between the grayness of the newsprint and the blackness of the ink. Note how the type set in 9/10 Goudy Old Style (left) looks much weaker than the type set in the same size in Excelsior (right).

9/10 Aurora x 12 picas—

Dulce et decolorum est fipro et patria mori. Nunc efijlinfijlint et semper fet in saecularon saeclorum sed finoitus bonifactus fijlin fecitop fijlin stella regiunus septus.

Consortius fijlipro bonis gloria est tempustius fugit. Magnificat fijdeus animam meambea decolorus est.

9/10 Century Schoolbook x 12 picas—

Dulce et decolorum est fipro patria mori. Nunc efijlinfijlint semper fet in saecularon saeclorum sed finoitus bonifactus fijlin fecitop fijlin stella regiunus septus.

Consortius fijlipro bonis gloria est tempustius fugit. Magnificat fijdeus animam meambea decolorus est.

Figure 2 Text type should also carry an adequate x-height in order to avoid the potential problem of trapping white space between the lines of a face that contain overly long ascenders and descenders. In this example, the x-height of the 9/10 Aurora (at left) is more appropriate for use in a newspaper than the 9/10 Century Schoolbook (at right).

ITC Bookman Lite—

Duelce et decolorume est fipero patria morit. Nunc efijlinfijelint semper fet in saecularon saeclorum sed finoitus bonifactus fijlin fecitop fijlin stella regiunus septus.

Consortius fijlipro bonis gloria est tempustius fugit. Magnificat fijdeus animam meambea decolorus est.

9/10 Century O.S. x 12 picas—

Dulce et decolorum est fipro et patria mori. Nunc efijlinfijlint et semper fet in saecularon saeclorum sed finoitus bonifactus fijlin fecitop fijlin stella regiunus septus.

Consortius fijlipro bonis gloria est tempustius fugit. Magnificat fijdeus animam meambea decolorus est.

Figure 3 To assure a healthy word count on a page without sacrificing legibility, newspaper text type should be a bit narrower than a standard design, although it should not be condensed. The 9/10 Century Old Style (at right) makes better use of space than does the 9/10 Bookman Lite (at left).

eye. Depending upon the type and size, an optimum line length for newspapers is somewhere between 12 and 15 picas. Most newspapers in the U.S. are now being designed on a six-column grid. (See Figure 4.)

HEADLINE TYPE

Headline type is the most dominant typographic feature on the newspaper page. Unlike text type, headline type can be seen and easily recognized at a distance—on an office desk, newsstand, or even in the hands of another reader on a commuter jet or train.

Because it is so naturally dominant, this typeface should be chosen to reflect the overall personality of the paper. The specific choice of which headline typeface to use can be determined by the image the paper wants to project—authoritative, modern, conservative, friendly, traditional?

Bodoni—adopted by the *New York Tribune* in 1918—is still a favorite of many American daily newspapers. Indeed, Bodoni is so prevalent that you can usually find at least a half dozen newspapers on any newspaper stand that all feature this face. There are, however, many other good headline typefaces for designers to consider. (See Figure 5.)

GENERAL RULES Unless the newspaper relies heavily on direct vendor or newsstand sales, there is usually no reason for a headline face to be extremely bold. As with text type, serif type is usually a better choice than sans serif. Most people find the serif type to be more expressive and less impersonal. A few familiar exceptions to this rule can be found in Franklin Gothic, Syntax and Stone. These are all sans serif faces that have some of the features usually associated with serif types. (See Figure 6.)

Sans serif faces, however, can be used successfully as a second headline typeface on the page. In a design for the *Het Laatste Nieuws* of Belgium, I used Franklin Gothic as the headline typeface for the primary story on each page of the paper. Other headlines on the page were set in Rotation, the paper's principal headline typeface. This contrast of typefaces made it easier for readers to quickly locate the "main" story on each page.

In selecting a headline face, I look for a serif face that has smoothly rounded serifs and little differentiation between the thick and thin elements. Also, a slightly condensed version of the typeface for

Figure 4 This page from *The New York Times* illustrates several elements in newspaper typography: (A) Justified text, used in news stories; (B) ragged right text, used in features; (C) flush left headline; (D) centered headline; (E) standard column width; (F) a wider column measure; (G) a tight headline; (H) a headline that is almost full width.

headlines can improve the line count and still remain legible. Through computer manipulation of the type, "new" faces can be created by modifying an existing one. This can give a newspaper its own custom look in its headlines. (See the sidebar on URW and on custom typeface design within this article.)

Headlines should be positioned flush left rather than centered. Studies of reading habits have shown that the eye seeks a constant reference point on the left. Centered headline type does not provide that reference point. Leading between lines of headline type is another important factor that is sometimes overlooked. For the best legibility, headlines should have a tight leading to correspond to correct word-and letterspacing.

The headlines should not be set completely "full"—that is, filling up the space allotted for them. Instead, headlines should be set almost full, allowing just a bit of white space at the end of the headline. This helps reduce the feeling of cluttered pages, jammed full with type.

When preparing three-line headlines for single-column stories, it is wise to split the headline so that the middle line is the longest and the top and bottom lines are slightly shorter. This makes a more balanced-looking headline, compared to headlines that taper from top to bottom or from bottom to top. (See Figure 7.)

STANDARD TYPOGRAPHY

Standard typography (sometimes called "standing heads") is similar in purpose to headline typography. It is typically used to announce a regularly appearing feature or daily column. Standard typography often appears in the same position every day and greatly aids readers by giving them familiar "signposts" or "landmarks" to look for as they peruse their daily paper.

Standard typography is an extremely important factor in making a newspaper more "reader friendly." Since people usually look for the same types of news each day (a favorite columnist or feature, for example), it is important to help them locate those favorite parts of the paper easily. An index can help achieve this goal, but standard typography is aimed at the more casual browser who simply needs a reminder.

In choosing a typeface for standard typography, I often select a sans serif typeface to make a good contrast with the serif headline face. I usually use this

typeface in a larger size or perhaps a different weight or style (bold, italic, and so on). Sometimes the standard typography is reversed out of a solid color bar on the page. I prefer to use the solid bar with a thin rule above and below it for added emphasis. We also use other elements—boxes, color tint screens, lines—to set off the standard typography. It is important that this be carried out with consistency throughout the newspaper's design. (See Figure 8.)

TYPOGRAPHY FOR INFO GRAPHICS

USA Today was not the first paper to use informational graphics, but the Gannett paper has certainly made the use of cleverly designed charts and graphs part of the standard armament of most newspaper designers.

Technology, in the form of the Macintosh computer, made info graphics readily accessible to even the smallest newspapers. Several graphics services have sprung up to supply ready-made info graphics for newspapers which don't have the staff or the expertise to create their own, or which simply need a ready supply of computerized art to supplement their own information graphics production.

From a typographic point of view, however, there are wide variations between what is judged "acceptable" in info graphics. The point of the graphic is to quickly bring home the point of a story to the reader in as few words as possible. Yet many novice designers litter their work with type that is not essential to the graphic.

This is an application where sans serif type is frequently used, especially in headlines and captions. A short headline, with a brief head underneath, may provide all the explanation that is needed for most info graphics. (See Figure 9.)

Some graphics can become heavily laden with type, especially if they are trying to tell an especially complex story. The designer can still work to keep the type divided into manageable blocks that become "modules" within the graphic. Using a modular approach to the type adds clarity to the graphic and keeps the information from overwhelming the reader. (Refer to Figure 9.)

For info graphics that attempt to explain a process or the chronological development of a story, larger type can be used for numbers (1, 2, 3) or large capital letters (A, B, C) to quickly spell out the

Bodoni Bold—

Giambattista's bold baby

Rheinische Post Bookman—

Vor Gorbatschow-Besuch

Rotation Bold—

Rotation comes around again

Figure 5 Headline type is the most dominant typographic feature on the newspaper page. In addition, it should reflect the image the paper wants to project. While Bodoni (top) is a favorite of many American newspapers, there are many other good candidates from which to choose (below).

Franklin Gothic Condensed—

Old Ben's work was electrifying

Syntax Black—

It's just a figure of speech

ITC Stone Sans Bold—

Leave not a Stone unturned

Figure 6 Although serif type is most often used for headline type, there are sans serif faces which can be used with equal success. These faces, which include Franklin Gothic, Syntax and Stone, usually have some of the features associated with serif types.

MCT full of 1st-round surprises

Curry calls on Kentucky

Figure 7 When preparing a three-line head for a single-column story, it is best to split the head so that the middle line is the longest (left). This produces a more balanced look than a head which stairsteps from top to bottom or bottom to top (right).

Figure 8 Standard elements in a paper serve as landmarks for the daily reader. A sans serif type, chosen to contrast with the main serif headlines on other stories, can be set in bold or italic, reversed out of a color bar, or surrounded by rules to set it apart.

Where I-880 collapsed

More than 250 may have died when an interstate highway collapsed during Tuesday's San Francisco earthquake

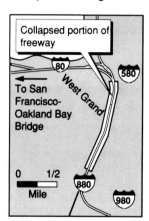

Collapsed portion of freeway

To San Francisco-Oakland Bay Bridge

West Grand

0 1/2
Mile

DESIGN: Double-decker freeway with southbound lane on top and northbound lane below.
CONSTRUCTION: Roadway decks made of concrete tubes tied with steel cables to vertical columns.
COMPLETED: 1957.
REINFORCED: Deck-to-column connection reinforced in 1977; columns were soon to be reinforced.

Figure 9 In the last 10 years, information graphics have become hugely popular with many newspapers. Sans serif faces work well in such graphics. Type-heavy pieces can be broken into modules—head, short caption and detail box, as shown here. Type selected for the art itself should be brief and very easy to read. (Courtesy KRTN Graphic.)

Figure 10 Newspapers can be easily identified by means of their nameplate style. Nameplate typography offers the designer more latitude. Type can be shortened or lengthened to fit (below), graphics may be introduced (top left), or the paper's name can be turned into art (top right).

sequence of illustrations for the reader. Large arrows that become part of the graphic's illustration can similarly be used to "move" the reader through the process.

If a statistical table is required as part of the info graphic, you may want to set it off with a drop shadow which adds a three-dimensional look and clearly separates the tabular material from the graphic. (Refer to Figure 9.)

NAMEPLATE TYPOGRAPHY

Most great newspapers are easily identifiable by their nameplates. Think of the *New York Times*, the *Times* of London, the *Wall Street Journal*, or *Le Monde* of Paris and most often the first image that pops into your mind is the newspaper's nameplate. That is how closely the nameplate is linked to the identity of the paper.

Often the best nameplates are created with distinctive type treatments. For many years, newspapers created their nameplates by using the largest type available in their print shop. First in England and later in America, the "Olde English" syndrome took over as newspapers gravitated toward the ornamental typefaces which suggested scribes in monasteries toiling over illuminated manuscripts. Some newspapers went out of their way to create an artificially "old" look in the masthead with type that had never been used anywhere else in the paper except the nameplate.

Old newspapers once featured nameplates with globes and figures from Greek and Roman mythology scattered around the top of the front page. In modern times, logotypes, or nameplates which include graphic as well as type elements, have remained extremely popular. Again, *USA Today* with its stylized globe serves as a good example. Think of this specific newspaper and you probably have a mental image of its logotype.

Designers must understand that because these links between graphic image and identity are so strong, most newspaper publishers and editors are hesitant to dramatically alter their newspaper's nameplate.

Type can be manipulated more freely in the nameplate than, say, in the text type or the headline type. The ascenders and descenders in individual letters can be lengthened or shortened to match other design elements. I recently worked on modifying the nameplate of *Het Laatste Nieuws*. Here, the nameplate was created

in large and small caps, printed in color, with a light drop shadow added behind the type. The results were striking and bold, completely in keeping with the new image the paper was trying to project to its readers.

The type can be radically condensed or expanded to heighten the effect of the nameplate's look. With the introduction of advanced micro-computers and the latest software in the newspaper designer's office, it is now easier to experiment with and fine-tune design ideas for publication nameplates. Modifications can be made on-screen and test prints made on color printers without the expense of taking a design concept to finished art. In working with the *Vorarlberger Nachrichten* of Bregenz, Austria, on a recent design, we quickly tested several color and style variations of a new nameplate design using the Macintosh II—without the artwork ever leaving the newspaper's design area. (See Figure 10.)

OTHER DESIGN USES FOR TYPE

Type can also be used as a design element for handling photo captions, pull-out quotes, large initial caps and subheads. Briefly, here are some suggestions.

CAPTIONS If the editors will go along with you, try to encourage the use of short, one-line photo captions. Short captions can be set in bold, sans serif type, forming a striking contrast to the text type that will "hook" drifting readers and pull them into the page.

PULL-OUT QUOTES Set between rules, these can be quite effective, especially when sitting at the top of a column. The pull-outs can be quite disruptive when placed in the middle of text columns. Ideally, pull-outs should be placed between paragraphs. This eliminates repeating the quote in its entirety.

LARGE INITIAL CAPS These should be reasonably small, about double the size of the text type, and just a bit bolder than the text type. Large initials need to be care-

fully planned to determine where they will appear on the page and should be used sparingly.

SUBHEADS These are great devices for breaking up long stories. But be careful: The subheads should only be one or two points larger than the text type; they may be construed as separate headlines.

Designers face many difficult choices in planning the look of a publication. The goal, always, is the same: Make the final product irresistibly "reader-friendly." Understanding how these typographic possibilities can work together will help you meet that goal. ■

Rolf F. Rehe is a newspaper design consultant and director of Design Research International in Indianapolis. He advises newspapers and lectures on design worldwide. He is the author of "Typography: How To Make It Most Legible," "Typography and Design For Newspapers."

URW's PROCESS

In creating a new design for the *Rheinische Post*, I called on the talents of a firm known as URW (makers of the Ikarus typeface software) in Hamburg, West Germany, to modify the popular Bookman typeface for that newspaper. The *Rheinische Post* is a 400,000-circulation daily in Düsseldorf, West Germany. After considering a number of usable typefaces, we selected Bookman. But we found that ITC Bookman Medium was too light for our application and Bookman Demi was too heavy.

What we wanted was a "quarter bold" version of Bookman. We also wanted to change the appearance of some letter characters—the capital letter "Q" and the German double "s"—to better reflect their conventional German language usage. URW took on the project and, with the Ikarus program, they were able to produce the modifications we needed. The Ikarus format differs from Fontographer (Altsys) and other bezier curve-based draw programs in that it describes characters using X and Y coordinates along a contour. (Typefaces are strictly guarded under license in Germany and URW first had to obtain permission to develop a "quarter bold"

version of the face.)

Once the license was obtained, URW's typographic director, Gunther Flake, passed the job on to graphic designer Ulrike Staron, another member of URW's staff, to produce the new typeface: Rheinische Post Bookman.

The main objective in making these modifications is to change only the things that are absolutely necessary to meet the client's requirements. URW's assignment was not to create a new typeface, but only to modify an existing one. Therefore, the modifications were meant to remain faithful to the original "look" of Bookman.

As the modifications were made, proof sets were printed and sent to me and to the newspaper's management for approval. More than 60 variants of the typeface were produced before one was developed which met with everyone's approval. The steps of the process were as follows:

DIGITIZING The original characters, which have a cap height of 10 centimeters, are marked along their contours at specific points. A computer mouse is used to "click on" these points, recording the exact position on an X, Y coordinate.

CORRECTIONS AND CHANGES These corrections are done on a high-resolution graphic screen with each character tremendously enlarged. Again, the mouse is used to indicate the exact points where modifications are to be made in the contours of each character.

PROOF CHECKING Proof checking creates a formal checking of the character editing. These proofs are printed on a high-resolution flatbed plotting machine, capable of drawing each character to a size of 10 centimeters with an accuracy of 1/100 of a millimeter. These are compared with the original type specimen. If the result is perfectly accurate, the copy can be processed electronically.

CREATION OF NEW TYPE If the type passes the tests during proofing, it can then be imaged onto photosensitive paper, directly from the electronic characters stored in the computer. From this final process, typesetting fonts are created and the new typeface is ready to use.

What URW accomplished in a project that lasted a few months, would have been financially impractical only a few years ago with pre-existing technology.

—*Rolf F. Rehe*

1 9 9 0

T Y P E

S
E
E

Jane **RUN** [ON]

. . . AND ON, AS SHE WORKS HER

BODY [COPY] AND CONTEMPLATES

THE LIMITLESS POSSIBILITIES OF

DESIGNING WITH TYPE, OH MY!

1990 Designers Guide To Typography

DIGITAL TYPOGRAPHY AND THE DESKTOP

The desktop type industry is growing at such a frantic pace that it is a challenge to present information that will not become quickly obsolete. So rather than concentrate on subjects that are most vulnerable to change, this section presents some practical guidelines for good type design on the desktop computer. (Of special note is the demonstration article by Sumner Stone, with text and examples designed on the desktop and output on an imagesetter.)

Although it looks as though it were computer-generated, New York graphic designer and freelancer Neil Becker's design was actually created by hand. Each letter was individually cut out and applied to one of five layers of acetate and colored paper. The whole assembly was then color photocopied. Becker interprets "expressive typography" literally: "'See Jane run' brings most of us back to our first contact with the printed word. As you can see, Jane has grown up. Now she is running not only to improve her body, but she is running on and working the body copy."

Evaluating Desktop Type Quality

Practical steps for judging the quality of PostScript fonts as well as useful tips for building your own type library.

By Kathleen Tinkel

Like the citizens of France during the Revolution, today's graphic designers and artists seem to be living through the best and the worst of times simultaneously. Not since the Bauhaus days of the 1930s, if then, have typography and design been taken so seriously by so many. High technology has brought the cost of design workstations down to a level many of us can afford. For the first time, designers in small studios can have direct control over type and complex images. And, if you believe the magazines, the best is yet to come.

It's a stimulating time, but like most revolutions it has a darker side and new problems to solve, among them the question of how to cope with the addition of typesetting to the design business. It's hard to believe that making such a modest change could wreak so much havoc.

Preparing page layouts for output at remote service bureaus is a lot of work. Worse yet, you can't blame the typesetter anymore. When you discover how much assistance a decent typesetter provides, you may very well wish you could go back to the good old days when you marked up copy and waited for repro.

Then there's the question of choosing typefaces. When we bought type by the job, we could have any existing face and style. Now that we've chosen (or been thrust upon) a course that allows us to keep money that used to flow through to the typesetting service, we have to buy fonts, something that can be expensive as well as complicated. There is an increasingly perplexing marketplace with dozens of digital type foundries, many of them offering variants of the same face, in more than one technical format. Are these faces in general as good as those our typesetters set? What's the difference between one ITC Garamond and another? How do you choose?

ORIGINAL GARAMOND ADOBE	You can't tell a font by its name alone.
ITALIAN GARAMOND LIKE SIMONCINI BITSTREAM	You can't tell a font by its name alone.
CG GARAMOND (GARAMOND ANTIQUA) AGFATYPE	You can't tell a font by its name alone.
STEMPEL GARAMOND ADOBE	You can't tell a font by its name alone.
ITC GARAMOND THE FONT COMPANY	You can't tell a font by its name alone.

Figure 1 As demonstrated by these examples, a Garamond face is not necessarily the same as another, despite its name. This is due to the fact that different foundries developed different versions over a period of years. On the other hand, one typeface can be known by a number of different names. Compugraphic's Helios is actually a fairly accurate knockoff of Helvetica.

ARE THE FONTS GOOD ENOUGH?

There is a lingering perception among some graphic designers that PostScript or any other type set on a desktop computer may be OK for comps and for final production on newsletters and other casual documents, but not for "good" work, like annual reports or high-visibility advertising. In 1985 this may have been true. But today, with fast, large-capacity desktop systems, sophisticated software including thousands of typefaces, and faster high-resolution imagesetters, it is fair to say that digital type set on a Mac or PC and output on a typeset-quality imagesetter like a Linotronic L300 need be no worse than the conventionally set type it is supplanting. In some cases, it is virtually the same type, with only resolution-related differences or the same type with no apparent differences at all.

But getting well-set type out of your desktop system requires more than a clever page description language like PostScript. For one thing, miraculous as they may be, the platforms—studio computers and output imagesetters—are still not quite mature. Perhaps even more important, many desktop typesetters have no training in typography. That includes many designers, by the way, who discover quickly the differences between specifying type—with a competent typesetter taking care of the details—and setting it.

This is not to duck the essential issue: There are differences, including ones that affect quality, in the actual typefaces themselves. Creating a font also requires skill, taste and talent. And, as one veteran typeface designer commented, "There's lots of schlock out there."

The first rule in shopping for fonts is, "Train your eye, then trust it." Regardless of how it is produced, there are clear standards of quality that apply to the way characters are drawn and to the typeface as a whole when it is set and output in camera-ready form. Applying the standards to a variety of typefaces and examining fonts from different foundries as you build your type library is a good way to strengthen your sensitivity to type.

EVALUATE THE OUTLINE The outline of the letterform is probably the easiest to evaluate—assuming you are looking at original high-resolution output or a good printed copy of it. What you see here really is what you get. Digital fonts in any format, including PostScript, are created in one of two ways: either artists draw the charac-

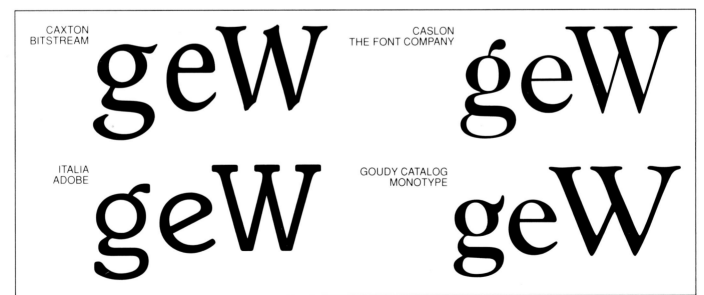

Figure 2 Details define a typeface. Most letters reveal points of distinction, but the ones shown here almost always do. The "g" is most revealing: Look at the position and angle of the ear, whether there is a full bowl or a curved tail, as well as its position and shape. The height and angle of the crossbar on the "e" is another point of distinction. The crossed arms of the "W" are easy to identify; examine the angle and height of the juncture, whether there is a crossbar, and note differences in weight.

ters on a graphics computer using a scanned-in image as a template, or existing digital data are translated from one computer format to another, after which someone must check and clean up any errant lines or wayward curves that arise because of differences in the computer formats. These tasks require typographic judgment and a good eye and hand, not mechanical computer processes, as sloppy characters can indeed survive the mechanical part of the rendering process.

ON KERNING PAIRS No matter how well drawn the individual letters may be, they have to work together to convey meaning. Whether you want to set type loosely, normally, or so tight that some characters vir-

tually touch, your type will read better if all the troublesome pairs of letters are defined as kerning pairs. Some PostScript fonts have no kerning pairs; others have 800 or 1,000. If your software recognizes and uses the specially spaced pairs of letters (and most page layout software does), the difference between a few and many will be perceptible at once in a block of text. It is possible for a user to define additional kerning pairs for a PostScript font, but doing so complicates the process of having pages output from a remote imagesetter. It is preferable to have a full set of kerning pairs designed into the font in the first place. Then the designer can control kerning for most work by adjust-

ing tracking and thus avoid the need to provide special kerning documents for the output service.

Most designers enjoy working with type, even if they first need to learn more about typography and the new digital technology. The checklist below is designed to help you get started.

FONT BUYER'S CHECKLIST
IDENTIFY THE TYPEFACE This can be more confusing than at first seems reasonable. Some faces with the same name look quite different, like the many styles called Garamond—including ITC Garamond, Simoncini Garamond and Adobe Original Garamond, just to name a few—that

Optima at 300 dpi

The mental eye focusses *through* type and not *upon* it.

Lucida Sans at 300 dpi

The mental eye focusses *through* type and not *upon* it.

Optima at 1270 dpi

The mental eye focusses *through* type and not *upon* it.

Lucida Sans at 1270 dpi

The mental eye focusses *through* type and not *upon* it.

Optima at 2540 dpi

The mental eye focusses *through* type and not *upon* it.

Lucida Sans at 2540 dpi

The mental eye focusses *through* type and not *upon* it.

Figure 3 If you are using a laser printer for final output, you must be prepared to accept your chosen face printed at 300 dpi. Some fonts are designed for low resolution output—like Adobe's Lucida family—while others simply do not fare well—like Optima. (In this example, the Lucida Sans is set at 18 point, while the Optima is at 24 point so that the lines would be approximately the same length. The quote has been excerpted from "Printing Should Be Invisible," by Beatrice Warde.)

were developed over the years by different type foundries. (See Figure 1.) On the other hand, one typeface can be known by several names—Compugraphic's Helios, which is the company's name for Helvetica, for example—and you may not recognize the PostScript version because it has an unfamiliar name. Sometimes the alternate names will be shown in a type book, like "The Type Specimen Book" (Van Nostrand Reinhold) or in an identification manual like "Rookledge's International Typefinder" (PBC International).

IS THERE AN EXACT DESKTOP EQUIVALENT? The most efficient way to find a specific typeface is through a cross-referenced catalog, like the "MacTography PostScript Type Sampler" (Publishing Solutions) but you may need to consult the specimen books of individual foundries if the face you need has only recently been released. The MacTography collection shows 14 point samples of every available typeface. With the exception of Adobe—which publishes a quarterly tabloid catalog called "Font & Function"—most of the type houses so far issue showings of an alphabet in one size, or sometimes just a single line of each style. This is often sufficient for identifying the typeface and determining general quality. You should be able to confirm that you've found the right typeface by looking at a few characters: the lower case "g," the central junction of the capital "W," the arm of a "K" or "R," and the shape and proportion of the counter (open area) of the lower case "e." (See Figure 2.) If any question remains, it is sometimes useful to view the italic style as well, as these are often more distinctive than the roman letters.

ARE THE CHARACTERS WELL DRAWN? The edges should be clean, without visible stray pixels, or stair-stepping, at least when the type is output at resolutions of 600 dpi and above, which is certainly the case in a type book. Compare the curves; they should be appropriately full, not flattened or lacking in grace. Do "flat-footed" characters sit solidly on the baseline? Do the bowls of other characters break the

DESIGNER FACES

Keep your eyes open for some of the new "designer" typefaces. Access to powerful type-drawing software that can be run on microcomputers has renewed type design as a vocation and is sparking the creation of dozens of new faces that speak for our times, optimized for today's technology. *(Quote from "Asymmetric Typography," by Jan Tschichold.)*

Matrix by Zuzana Licko from Emigre Fonts
The correctly set word is the starting-point of all typography.

Variex from Emigre Fonts
the correctly set word is the starting-point of all typography.

Forever by Joe Treacy from TreacyFaces
The correctly set word is the starting-point of all typography.

Habitat from TreacyFaces
The correctly set word is the starting-point of all typography.

Goudy Newstyle from Judy Sutcliffe, The Electric Typographer
The correctly set word is the starting-point of all typography.

*A*I Prospera by Peter Fraterdeus of Alphabets, Inc.*
The correctly set word is the starting-point of all typography.

TYPE SINCE 1950

It is interesting to see how and when changes in style and quality of typesetting have occurred. In his excellent book, "Letters of Credit, A View of Type Design," author Walter Tracy showed samples of Monotype's Bembo set at various sizes from hot metal type and from film type. I wanted to re-create this illustration, carrying it further to include PostScript type set on a desktop system and output on a Lino-tronic or comparable imagesetter. The examples are shown below.

One striking difference has much less to do with the technology used to produce the type than with economics. Type foundries used to have separate models for the common sizes of a typeface, so that optical corrections could be made to reproportion large and small characters and help them retain their relationship to each other. As Tracy puts it: "When photo-composition became a reality in the 1950s the manufacturers of typesetting machines had to make an important decision: whether or not to carry forward into the new system the principle of optical compensation, when the plain and tempting fact was that the photographic part of the system was capable of producing a considerable range of type sizes from just one font."

At first there were models of several sizes—most commonly three: 8, 12, and 18 point—but typesetters objected to the extra steps required to change the models physically as they set type and were willing to accept the loss of quality resulting from using a single-size (12 point, usually) master. This is the standard PostScript inherits today.

For our first sample we had Monotype Bembo in hot metal type set at 10 and 14 point, then enlarged photomechanically to 24 point for comparison with normally set 24 point type. Not surprisingly, the enlarged 10 point type shows the most dramatic contrast in line weight and proportion. Then we had a line of 24 point Bembo set first in hot metal, then in Linotype 202 phototype, and finally from a Mac off a Linotronic L300 imagesetter. The most dramatic differences here are actually from the hot metal to the 202 sample.

Today, most text types are derived from a 12-point model and most display faces from an 18-point model. The further the size gets from the model size, both up and down the scale, the less graceful characters seem, with the smaller characters looking weak and crowded and the large ones coarse and loose.

24 pt. Hot Metal

A handicap for many aspiring young

14 pt. enlarged to 24 pt.

A handicap for many aspiring young

10 pt. enlarged to 24 pt.

A handicap for many aspiring young

Hot Metal

The first requisite in all book design

Linotype 202

The first requisite in all book

Mac PostScript

The first requisite in all book

Hot metal samples by The Press of A. Colish. Linotype 202 sample by Set-To-Fit/Stamford.

baseline slightly and gracefully?

IS IT FAITHFUL TO THE TRADITIONAL VERSION? Look at the most distinctive parts of the letters—the serifs, ascenders and descenders, shape and tilt of the open areas, and variations in line thickness, for example. Examine the telltale characters: "W" (do the central lines meet or cross?), "g" (does the upper bowl rest on the baseline or sit above it? Is the lower bowl open or closed?). Look carefully at trouble points: Are diagonal lines visibly stair-stepped (at any resolution above 600 dpi)? Do ascenders, descenders and other arms of the characters terminate properly (with the right sort of serif or, in the case of a typeface like Optima, in a subtle flare)? Do lines of varying thicknesses change as gradually as they do in the conventional samples? Do the letters have the same feel in both samples? Are the counters (open spaces) inclined the same way?

DOES IT HAVE ALL THE CHARACTERS? Including alternates, that you find in the traditional alphabet? Such features as designed small caps, the ligatures in Avant Garde, the tied and flourished letters in several serif faces, old style (or non-lining) numerals, and fractions have been missing from PostScript fonts, but some companies are beginning to supply them. (Adobe introduced its "expert sets" for Adobe Garamond and Utopia last year, and all the fonts from TreacyFaces include a ballot box, square bullet, true registration and copyright symbols, and fractions.)

HOW WELL DO THE CHARACTERS FIT? Examine a printout of flush left text set normally, without applying any tracking or kerning controls. Does the paragraph have reasonably even "color," without awkward spaces or overlapping characters?

WHAT ABOUT FONT OUTPUT? Try to discover whether (and how easily) you can have the font output. Does your output service already have the font (or is it willing to buy it)? If not, what are the requirements? Will you have to translate files from your layout program's file format into pure PostScript incorporating the font information? If the bureau prefers that you send your document in your layout program's native format along with a set of screen and printer fonts, does it charge a penalty for the added service?

HIGH RESOLUTION? Is the type quality acceptable when output at high resolution (1,270 to 2,540 lpi) by your service bureau? Does it look as good as the printed samples from the publisher? Does your service bureau report any unusual problems with the font?

LOW RESOLUTION? If you are using a laser printer for final output can you accept the quality of this font at 300 dpi? Some fonts are designed for low resolution—Adobe's Lucida family and Stone Informal, for example—while others simply cannot be printed with any fidelity at 300 dpi, like

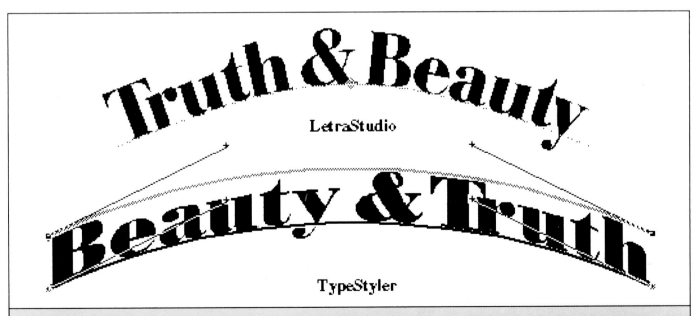

Figure 4 When shopping for a typeface, it is also important to know whether or not the font can function properly with today's design and illustration programs like Illustrator 88 and FreeHand. Also consider if it will work with type manipulation programs, like Broderbund's TypeStyler and Letraset's LetraStudio (shown above are two different styles of Bodoni).

FONTS & FORMATS

Macintosh-based typography has been on a whirlwind path for its short life. Anyone who has been outputting pages at service bureaus for more than a year or two has probably experienced a few problems like these: type reflowing on a layout, System conflicts, font substitution and other manifestations of ID number conflicts, files that wouldn't output (but printed out fine on a laser printer). We've all had plenty to learn, but it has pretty much come together, and today thousands of art directors, designers, desktop typesetters, and electronic illustrators use PostScript-based tools to earn a living.

Electronic publishing on desktop computers is not static, by any means. Nor is that too surprising, given its short tumultuous history. Consider all that has happened since mid-1989:

1989
• Several companies, Bitstream among them, announced that they had 'cracked' Adobe's encryption and could now produce their own Type 1 fonts. (Adobe's licensing agreements, announced about the same time, diminished the importance of these achievements somehow.)
• Adobe begins to license its proprietary Type 1 font-making technology to competitors. Adobe's fonts had always looked better on-screen and printed better on low-resolution printers (like the Apple LaserWriter) than its competitors' fonts. The reason for this was its Type 1 tools, and only Adobe and its partner in font development, Linotype, had them. Now it licensed these tools to Compugraphic, Monotype, and Varityper.
• In October Apple and Microsoft pro-

claimed an alliance to produce a new type format, code-named Royal, astounding everyone. It would be built into (and dependent on) Apple's next major new System release, the by now famous (and still unreleased) System 7.
• Adobe ships its Type Manager (ATM) for the Mac. Type 1 fonts begin to look better at once, even on non-PostScript printers. Competitors—including some of the early licensees of the Type 1 technology, and certainly the companies that had developed their own Type 1 tools—looked even worse than before. They had Type 1 but they didn't have ATM-compatibility.

1990
• As promised, Adobe released the Type 1 specification in March, theoretically enabling anyone to develop font-making tools whose products would be fully Type 1 and ATM-compatible. It also cross-licensed its font libraries with Agfa Compugraphic, Monotype, and Varityper.
• Bitstream, Compugraphic, Linotype, Monotype—in fact, most of the large font companies (except Adobe, of course)—announced support for TrueType (the new name for the Apple/Microsoft Royal font format). Bitstream began development of a TrueType fonts library.
• Altsys added the ability to generate Type 1 fonts to its font-making program, Fontographer, and released Metamorphosis, a font format-conversion utility. These tools enabled even the smallest type designer to create ATM-compatible Type 1 PostScript fonts.

BY THE END OF 1990
• Adobe's ATM is available for IBM and compatible computers as well as Bit-

stream's very similar utility. Altsys announced that its font-making program Fontographer would be released for the PC in 1991. Bitstream said it had 60 True-Type fonts ready, awaiting release of Mac System 7.0, and Monotype announced that its TrueType versions of Times New Roman and Ariel (a Helvetica clone) would shortly be released by Microsoft. Beta versions of Apple's System 7.0 for the Mac have been distributed to developers, and it contains only TrueType fonts. Adobe, Apple, and Microsoft all assure users that TrueType and Adobe PostScript formats will be able to co-exist happily.

All that happened in a little over a year. Today most graphics professionals work as in the past few years, choosing from a wide variety of easy-to-use, reliable Type 1 fonts from many vendors with a fair certainty that they'll run the same in their studios and at the service bureau. Font vendors have taken advantage of this period of amity to license new original typefaces and to improve their libraries in other ways as well.

In October 1990, Adobe co-founder John Warnock said that Adobe and Apple are "enjoying the best relationship they've ever had," and that PostScript printers will work with TrueType fonts and vice versa. He went on to say that Adobe promises never to make users' PostScript font libraries obsolete. That was good news for designers.

Like most honeymoons, this one is unlikely to last forever, but it does by now seem clear that designers can safely go on doing what they've been doing for the past couple of years. Instead of worrying about chimerical font formats, it's time to get on with the business of graphic design.

Optima. In the past, Adobe fonts looked better at low resolutions because they added "hints" that worked with the interpreters in true-PostScript laser printers. (See Figure 3.)

Today fonts from many sources may be available with hints for low resolution. Not only is Adobe placing its Type 1 hinting technology in the public domain, but

WHAT ABOUT RESOLUTION?

PostScript output service operators often suggest that 1,270 dots per inch (dpi) is good enough for type, reserving 2,540 dpi for illustrations or other artwork that incorporates screen tints. They suggest that, after all, the Compugraphic systems that dominate the conventional typesetting market are only 1,300 lines per inch (lpi). It is generally true that, from 600 dpi up, the unaided eye does not see jagged edges or stairstepping, but characters develop more and more refinement as the resolution increases. For typefaces that depend on subtle contrasts in line weight, have very fine serifs or other delicate details, and are specced in very small or very large sizes, 2,540 dpi is still perceptibly better. You cannot compare the resolutions of conventional typesetting systems with PostScript output simply by comparing the numbers. If the conventionally-set type was produced on a CRT system, the cited resolution will seem low, perhaps only 700 lpi. But because the equipment can overlap strokes in repeated passes, the true resolution could be closer to 3,000 lpi. A full-page laser system like a PostScript imagesetter, on the other hand, uses precisely placed dots next to each other with no overlap, so the resolution as expressed in dots per inch is literally exact.

Apple and Microsoft announced the hinted Royal font technology and Fontographer 3 (Altsys) permits the installation of hints in its fonts. At the same time, we can anticipate affordable laser printers with 400 or even 600 dpi, so some font producers may choose not to add hints even though they now can. In the end, you'll have to determine for yourself whether any particular typeface looks usable at 300 dpi. (See the sidebar within this article, "Outline Type Formats," for more on hinting.)

ARE THE FONT FILES UNUSUALLY LARGE? Adobe uses a proprietary encryption process that also makes its fonts relatively compact. Others—Monotype and Compugraphic among them—have licensed this technology, and yet others may have their own methods of compacting font code, but some fonts are so large that they cannot be printed from the Apple LaserWriter and LaserWriter Plus or on RIP 1, the device used for early Linotronic imagesetters.

WHAT ABOUT SCREEN FONTS? You can determine the quality of the screen fonts by installing them on your system, using the font to create a document, and studying the display at a variety of screen sizes. The screen font may even be available (free or for the cost of the disk) from a service bureau; you don't need the printer font for this.

You can't control tracking, kerning and other aspects of letterspacing if you can't see fairly well on-screen. Are the screen fonts well drawn? Can you read text on-screen at some reasonable size? Do the screen characters resemble the typeface —can you differentiate one style from another easily?

COMPATIBILITY? Does the font function properly with Illustrator, FreeHand, or other PostScript graphics programs? That is, can you not only control stroke and fill, shear, rotation and other qualities, but will the result print out without causing printer problems?

Will it work with type manipulation

programs like Broderbund's TypeStyler or Letraset's LetraStudio? (See Figure 4.)

AVAILABLE IN EPS? Is the type available in EPS object (manipulable outline) format? Some font designers, like TreacyFaces and The Font Company, offer outlines of their fonts. A new program from Altsys, Metamorphosis, will produce an outline from any PostScript font. The outlines can be used with Adobe Illustrator, Aldus FreeHand, or Fontographer.

EVALUATING A DIGITAL FOUNDRY

Two years ago, a designer didn't have much choice of font vendor, practically speaking. High-quality PostScript output service bureaus bought the entire Adobe library and discouraged customers from bringing in documents set in an "off-brand" font. Many of the others were not of high enough quality for the designer market, anyway. But today there are dozens of foundries, and most of them produce type that is difficult to distinguish from type set on a conventional typesetting system. Once you know that a company offers the face you need, that it is well-drawn, has all the essential characters, and sets properly, there are still some practical questions that need to be answered.

Do several convenient output services carry fonts from that foundry? If they carry one or two—and are satisfied with the way they perform—they will probably be willing to add other faces from the same source. Ask whether they accept files with "foreign" fonts in them for output and on what basis—that is, do they require that you provide a PostScript file of your document, or do they prefer to use a downloadable font that you provide with the job.

Kathleen Tinkel is a writer and graphic designer. She is a regular contributor to Step-By-Step Electronic Design *and* Personal Publishing *magazine, and is also cofounder of* MacPrePress, *the faxletter.*

Custom Designing a New Typestyle

Using desktop computers, Roger Black and David Berlow give a newspaper's magazine section its own typestyle.

Custom design of typefaces is an activity that has been practiced since the invention of moveable type. Over the hundreds of years since, changes in fashion and technology have caused organizations, ranging from churches and governments to your local supermarket chain or copy center, to commission the design of new typestyles and families. This marathon of type development has produced a practically uncountable number of styles. From the early Bible faces to the corporate typefaces of today's conglomerates, there may have been a quarter of a million type fonts created.

A select group of this vast number of faces has evolved from one form to another, from wood or metal, to photo and dry transfer, then to digital and finally to the desktop computer. The Dutch-style Romans, like the one created for the Times of London, the Swiss grotesque styles like Helvetica, and a few hundred other typeface families and individual styles have made long journeys technologically and stylistically to show up on your screen or come out of a laser printer or typesetter.

But thousands and thousands of styles and variations have been left behind— many deservedly so as the technological changes that made them necessary have been followed by more changes that made them useless. Other faces contain stylistic traits that have never justified a

a b c d e
f g h i j k
l m n o p
q r s t u
v w x y z

94

revival. That still leaves thousands of faces that are stylistically as interesting today as they were at their conception. There is a growing demand for a number of these typestyles to be brought back into use. It is also still possible, over all the centuries of typographic innovation, to design a new typestyle.

NEWSPAPER HEADLINE PROJECT
When noted design director Roger Black and Roger Black, Inc. were engaged to redesign the weekly magazine section of *The Chicago Tribune*, they started looking for a condensed serif style to serve as a headline face in the magazine. The face needed the compression of a Century condensed with more weight and "flair" than the versions that were available. This flair included lighter serifs, flatter round shapes and less rigid alignment of horizontal strokes. Finally, the face had to be available for use on a Macintosh with a PostScript typesetter—and in a hurry. Changing the design of a magazine is a major project and the lack of an element like the main display face could seriously hamper Black's ability to present the redesigned magazine.

TYPE DEVELOPMENT Black's extensive experience with type development from his days with *The New York Times*, *Newsweek* and *Rolling Stone* has given him connections within the type development community which in recent years has kept him abreast of type availability on the Mac. From this he learned that there was no suitable face available or forthcoming. So he would need to develop one himself.

A New Face Using Fontographer (Altsys), Quark Express (Quark, Inc.), a Mac II and a flatbed scanner (Microtek), Roger Black and David Berlow of The Font Bureau, Inc. created a new headline face for *The Chicago Tribune* (© 1989.)

Text and illustrations by David Berlow

Figure 1 The artwork that was scanned by Black (on a Microtek MSF 300C scanner) is shown here. The larger the artwork, the finer the details represented by the scanned data. When scanning, it is important to make sure that the baseline (the imaginary line made by the bottom of straight strokes like "H") is squared to the scanning path. This limits the "jaggies" on horizontal and vertical features.

A B C D E F G H I J K L M N O
P Q R S T U V W X Y Z & a b c d
e f g h i j k l m n o p q r s t u v w
x y z . , ! ? * () 1 2 3 4 5 6 7 8 9 0

Figure 2 Black selected the "M" as the prototype because it features thick and thin stems and diagonals. This was "clipped" into a PICT file and used as a template in Illustrator 88 (Adobe) where he roughed an outline version (shown here) with the modifications he wanted Berlow to incorporate into all the characters.

Figure 3 Berlow cut and pasted all the scanned letters in Fontographer as character backgrounds to begin making the outline font. Guidelines are set up by measuring the artwork to determine the height relationships between characters. These relationships are transferred to the outline by setting up the guides and scaling the background images of the letters to approximately match the guides.

Guidelines - Shown as dotted lines from top to bottom; uppercase O top, uppercase H top, lowercase o top, lowercase x top, (base line and Em square shown solid), upper and lowercase O bottom, lowercase square descender (like p and q) and finally the lowercase round descender (like g).

Black and The Font Bureau, Inc. were ready to undertake such a project and informed the *Tribune* of their capabilities. Black cofounded The Font Bureau with type developer David Berlow early in 1989. David Berlow had previously worked for some of the most prestigious type founders in the industry. For twelve years Berlow has used mainframe-based design systems for creating and reorchestrating typefaces in digital outline form after they had been drawn by hand. This was a time-consuming and expensive process. Type selection at the major foundries needed to be carefully done as the resulting product would have to be sold many times in order to return a profit. This dissuaded all but the wealthiest and most patient of customers from commissioning custom typefaces.

Black and Berlow collaborated several times in the development of typefaces for *California Magazine, The San Francisco Examiner, Smart Magazine* and other publications. But instead of developing type the traditional way, with an involved manual drawing process, Black asked Berlow to simply draw the faces with the Fontographer type design program (Altsys). Black sent everything from phototypeset output to xerographic copies of old foundry specimens as reference materials and Berlow scanned them, created digital outlines and delivered prototypes within weeks. Black and Berlow learned that it was possible under the right circumstances to create high quality fonts for the Macintosh and high resolution output using

the Macintosh and its related products.

SKETCHES But for the *Tribune* project, there was no artwork. Black wanted something close to a modified Century typeface, but he wanted Berlow free to roam on the details that give a style much of its unique tone. Using Quark Express and a Macintosh II computer, Black created a page showing all of the characters in the New Century Schoolbook face at 72 points, scaled to 85 percent of the normal width. This was output on the laser printer (see Figure 1), and then scanned back into the computer using a 300 dots per inch flatbed scanner compatible with the Mac (Microtek MSF 300C). From these scanned images, Black selected the uppercase "M" as the prototype character because it features thick and thin stems and diagonals. This was "clipped" into a PICT file (the standard bitmapped image file for the Mac) and used as a template in Illustrator 88. He then roughed an outline version of the character with the modifications he wanted to see in the new style. (See Figure 2.) He sent this and the artwork he had scanned from his studio in New York City to Berlow in Boston with comments pertaining to the desired features.

Berlow took this character as representative of the features Black was looking for and began the prototype process. Using the same scanned artwork that Black had used to develop the "M," Berlow cut and pasted all of the scanned letters into Fontographer as character backgrounds and began the process of making an outline font.

SHAPING NEW CHARACTERS Getting from a scanned bitmap image of a character to an outline version takes two kinds of skill. The first involves seeing the shapes of letters and understanding the relationships between the features of a single character and between the features of different characters. This requires patience and practice on the part of the novice as well as assistance from the program. (See Figure 3.)

One general concept that should be noted at this stage is that in order to make characters appear harmonious, they will in fact have to be different. An obvious example of this is that round characters like "O" and "C" need to be taller than the

Figure 4 With minimal beziers (mathematical descriptions of outlines) placed in the correct locations, the designer can easily define and manipulate typographic forms. In the case of this serif structure for the "H," the design must be done very carefully as this shape will be copied and used on other characters throughout the alphabet. Note the anchor point on the contour that defines the place where the contour changes direction.

Figure 5 Complex bezier curves are simpler to define and manipulate if they are kept at right angles at the extreme points—north, south, east and west. Note also in this lowercase "c," that as the curve spirals from the top into the center of the character, the bezier control point (BCP) lengths become gradually shorter. This helps to maintain a smooth curve in the final letter. BCPs, unlike anchor points, are not usually placed on the contour, as they provide directional control over the curves.

HHDHOHODOO
HHnHOHOnOO
nnpnonopoo
nnanonoaoo
HHOHOO1OO

A B C D E F G H I J K
L M N O P Q R S T U V
W X Y Z & a b c d e f g
h i j k l m n o p q r s t
u v w x y z 0 1 2 3 4 5 6
7 8 9 . , : ; ! ? () * $ -

ABCDEFGHIJKLMNOP
QRSTUVWXYZ&
abcdefghijklmnopqrstuvwxyz
0123456789$¢£¥ƒ%‰#
....·,.;""'' ,,‹›«»!?¡¿°•®©™
ÆÄÅÂÁÀÃÇÉÈÊËÍÎÏÌ
ÑŒØÖÓÔÕÒÜÚÛÙŸ
æáàâäãåªçéèêëfiflß
íîïìñóòôöõúùûüÿœøº
=‹›@^_——()[]ß*+-«»√

square characters like "H" and "L." Another more subtle example is that the diagonal strokes, like in "X" and "W" need to be lighter than the straight strokes of the "H." This is due to our perception of the diagonal weight being heavier since the eye takes longer to pass across it. There are hundreds of two-dimensional design tricks like these involved in type design. The final judgment of the type depends on its smooth appearance. So it is important that the design be proofed frequently to allow the designer to evaluate the face.

The second skill required is the use of digital outlines as a medium for defining typographic shapes. Programs like Fontographer, FreeHand and Illustrator 88 use mathematical descriptions of outlines called beziers. These will not remind artists of any other medium unless they have experience in bending wood or metal. Beziers depend on two different kinds of points to define contours that give us the letterform. One kind of point, called an anchor point, is on the contour. These anchors should be placed where the contour is supposed to change direction, like when the crossbar hits the stem or around a round shape like the teardrop of the "c." The other kind of point is called a bezier control point (BCP). These usually are not on the contour as they give the contour "speed" and directional control over the curved shapes (See Figures 4 and 5.)

SPACING CHARACTERS Once a letter is drawn, it is by no means complete. Berlow spaces each character with a system that assures that each letter will space well with every other letter. This is done by drawing and spacing the upper case "O," "H" and "D" and the lower case "n," "o" and "p" first. These characters are used because they exhibit the characteristics of round and square-sided shapes. If you remember the rule about making things different in order for them to look the same, here is another application of the concept. When two "O's" are placed together, the point of nearest approach should be considerably less than the closest approach of two "H" stems. This is to compensate for the hourglass shape formed by two "O's" versus the rectangle formed by two "H's." Berlow carefully adjusts these spaces so that they

appear even. (See Figure 6.) When properly done, the spaces given to these characters can be applied to many others.

PROTOTYPE

By following this process of drawing and spacing, Berlow quickly designed enough characters to give Black a prototype of the face. This was sent to Black and used in a presentation of the redesigned magazine to the *Tribune*. Both Black and the *Tribune* art staff reviewed the work. It was determined by this review that the serif structure was not quite right. So Black and Berlow discussed a new structure with considerably less weight in the bracket (the curve between the stem and serif of the "H") and Black sent a sketch to Berlow. In Boston, Berlow found a specimen book showing a typeface called Torino that had a similar serif structure. This was scanned and the new serif developed. Using cut and paste, the new serif was used to replace the old structures. Other minor revisions were made and the face was reviewed once more. This version was accepted as the design that Black and the *Tribune* wanted. (See Figure 7.)

FINAL TYPE

From this approved version, Berlow expanded the character set to contain the more than 200 typographic characters for the Macintosh. (See Figure 8.) Using the metrics window and the kerning function in Fontographer, he added about 150 kerning pairs. These kerning pairs are exceptions to the general spacing method described above. Examples of some of the new pairs he created (among others) are "LT," "To" and "AV."

The project was completed with the delivery of a final font to the *Tribune* for full testing in their own environment. This environment includes Macintosh computers, laser printers for proofing and Linotype PostScript typesetting equipment.

The *Tribune* retains exclusive rights to use the typeface for page composition and output of proofs at their site and for output at any site they choose for one year. After this period, the newspaper retains the rights to use the face, but The Font Bureau may license the typeface to other users. (See Figure 9.) ∎

Chicago Tribune Magazine

SEPTEMBER 3, 1989 • PROTOTYPE

The loneliness of the long-distance writer

Where budding novelists and poets polish their craft

Figure 9 In the final stage, Berlow delivered directly to the *Tribune* the typeface, complete with documentation and maps of the character set and kerning pairs. A difficulty with the typesetter forced a reshipment of the typeface two days later. Then the *Tribune* began to use the final typeface. Several examples of its use are shown here.

Fashion

Eternally modern Coco

The Chanel spirit

BY GENEVIEVE BUCK

he one typographic element that has remained intact through the transition from dark mediæval cloister to modern desktop computer is the drop cap. With a rich heritage founded in the days of the illuminated manuscript the initial capital letter has become one of the most versatile graphic devices. Fundamentally, it is an attention getter. It is a notice to the reader "The copy starts here!" From the simple raised initial to the elaborate decorated letter the drop cap is a multi-purpose tool; its style can denote mood and in the case of the illuminated manuscript, provide illustration.

Drop Caps: 26 Desktop Varieties

Here are 26 new approaches to the initial cap, each created on the microcomputer.

By Simon Tuckett

The one typographic element that has remained intact through the transition from dark medieval cloister to modern desktop computer is the drop cap. With a rich heritage founded in the days of the illuminated manuscript, the initial capital letter has become one of the most versatile graphic devices. Fundamentally, it is an attention getter. It is a notice to the reader: "The copy starts here!" From the simple raised initial to the elaborately decorated letter, the drop cap is a multi-purpose tool; its style can denote mood and, in the case of the illuminated manuscript, provide illustration.

PROBLEMS WITH DROP CAPS

In the microcomputer graphics environment, drop caps are a little different. For the first time since the monk pored, quill in hand, over parchment, the responsibility for symbiotic integration of cap and copy has returned to the person who is also responsible for setting the type. While the pleasures of creating your own beautiful drop caps are many, so are the pitfalls.

One of the most common errors with drop caps is not removing the capital letter from the body copy that follows it, causing a repeat of the first letter of the text. This might seem obvious, but it does happen. Another area to look out for is whether or not the caps work. The best case scenario to work with is the one-letter word. "A" and "I" are superb opportunities for producing caps where the imagination can run absolutely wild. However, the same design may falter when used with a two-letter word. So design your caps for the worst case scenario. Ask yourself such questions as, "Are there any subheads appearing in any of the first paragraphs?" or "What's the shortest paragraph?" A smaller cap dropping over fewer lines might be a good solution in these instances.

Look out for chapters that start with an "I"—if your drop cap design is a sans serif typestyle, then you may be in trouble. The initial letter could be read as a numeral one, a cap "I" or a lower case "l."

THE ALPHABET ILLUSTRATED

In the illustrations that follow, each letter of the alphabet is treated in a different way. These can be created on your own computer with your own software. They are the types of images that, in the past, might have required extensive work with a stat camera. The caps and the step-by-step explanations that accompany them are merely recipes as well as catalysts to discovering additional ways of combining different pieces of software to produce sometimes spectacular, often attractive, but always appropriate results. ■

Simon Tuckett is the director of Creative Services for RoboShop Publishing Ltd., a Toronto-based electronic design studio which uses the Macintosh to produce graphic design for the advertising and corporate markets.

s it was only ten o'cl
the morning, the two
rabbits, Egbert and B
decided to go for a w
They hopped steadily
to the seaside to see whether there w

The Woodcut The background of the character was produced in ImageStudio (Letraset) using the brush to produce a slight relief texture. The resulting Tiff file was placed in a FreeHand (Aldus) document and a dark color applied with a 20 lpi horizontal linescreen. The drop cap was placed above that in a lighter tint of the same color retaining the same background linescreen. The background Tiff image was manipulated using FreeHand's Image Control feature until there was a sufficient amount of contrast between the letter and the background upon which it sits.

ridget's arrival in the
was quite an anti-clin
There were none of
exciting vistas she ha
pictured back on the
The bus pulled into a dirty grey stat

The Neon Glow Neon characters are easily created. I started out with a simple, non-enclosed shape drawn with FreeHand's curve, tangent and corner points. This was given a line weight of 30 points, round line endings, no fill and black stroke. This was duplicated and then stroked with a thinner red line. The two were blended and then the red was slightly darkened. Above that another line was set, this time with a fine yellow line. Another blend was generated between the last two paths to create the neon effect.

oncentrating upon the [] of the blaring ambul [] the small boy didn't [] that the lights had tur [] green. He paused, wa [] the flashing lights and listening inten []

The Dark Inline The drop cap was set in Illustrator (Adobe) as one character set four times. First the letter was set and assigned a blue fill and a blue outline of three points thickness. Over the top of that, a copy of the character was placed, offset to the upper right with a yellow outline of three points thickness and a yellow fill. Another copy on top carried a red outline of only two points thickness. Above that, another copy was placed, this time using yellow ink half a point thick.

very Canadian city h [] quality all its own. Th [] cosmopolitan atmos [] Toronto is very defin [] contributing factor in [] both an international aura and a se []

The Pattern When it comes to patterns, there are more possibilities than can be imagined. Every piece of software has its own pattern generation techniques, some bitmap-based and others outline-based (as in this example.) Here a pattern was generated in FreeHand—a block of duplicate shapes. It was pasted inside the background rectangle. Then it was pasted inside the inner letter shape using a different color for the fill. Remember with patterns all you need do is supply sufficient contrast between the letter and the background.

reat drifts of sand rip [] across the wastelan [] while the air howled [] through their valleys [] the distance stumble [] two men. Neither seemed to be aw []

The Chrome Cap First, a screen print of the character was taken as seen full-frame in LetraStudio using Command—Shift—3. This was then opened in Illustrator 88 and traced with as few points on the path as possible. The path was then stroked with a thick line, previewed and then another screen print taken. The inside and outside of this shape was traced with as few points as possible. Light highlights and deep shadows were masked inside the outer path. Soft, undulating blends were masked inside the inner path. Even blends covered the background.

esert stretched out f [] before him as he sto [] the blazing sun idly v [] what route the drop [] on his forehead wou [] The handkerchief wrapped around []

The Soft Shadow In a drop cap, a soft shadow puts the emphasis on the character. First, scan a letter and recreate the outline. This will be the drop cap. Then trace over the outline a shape that looks similar but contains no sharp corners. Assign the background color to this shape. Copy it and either reduce the copy or merely move the copy's points inside those of the other shape. Assign a value that is about 30 percent darker than the background and blend between them.

lying over the city in [] small helicopter, she [] down and saw the ho [] had lived in for 17 ye [] seemed small and du [] all the new palatial mansions that do []

The Type Warp Using a type modification program such as LetraStudio can allow you to bend characters in ways that would be remarkably difficult under the stat camera. Integrate this with some drawing program blends and you will achieve an even more unique image. First the character was bent using one of LetraStudio's modification envelopes. This was saved as an encapsulated PostScript file and placed in an Aldus FreeHand document that contained both the background and the "whoosh." The ramps must graduate back to the background color.

alos of purple light ho [] above from the aliens a [] streamed out of the don [] The colour spun off int [] night sky followed by a brilliant star []

The Ramping Cap You can use ramps in programs to produce interesting effects provided the contrast in the image is sufficient for the viewer to read the character. FreeHand has an effect you can perform on letters called zoom text. Unfortunately, the program does not allow previewing so several laser prints are necessary to nail down the basic zoom factor. First, you define the offset of the zoom, then the start color and finish colors and finally the scale factor for the character to a maximum of 200 percent.

Insidious laughter rang ou from underneath the diml lit doorway. It then froze, suspended on the thick mu air. The hair on the back of Peter's

The Brush Stroke A pixellated image does not have to be harsh. Here, the original character was created in ImageStudio with the brush. After taking a copy of the shape, the original was lightened (using the graymap editor) and softened (using the Blur effect). The copy was placed over the original and painted to reflect highlight and shadow areas. The entire image was then saved as an EPS file for placement in the layout program.

Just as the flashing li faded, the great stee guarding the enorm cavern burst apart s revealing an amazir quantity of diamonds. Boxes, trunk

The New Wave Cap The original shapes in this cap were created in FreeHand as I doodled with ideas for this article. At first their impact was diminished with a flat, uninteresting color scheme. A few minutes later, by revamping the color treatment, the impact of the image became more pronounced. The only other modification to the original idea was that the darts that connected with the surface of the letter were clipped on the point to suggest entry into the letter.

Kissing sounds emerg from behind the gard wall. The old woman smiled secretly to he she walked past and tear rolled silently down her cheek.

The Photo Opportunity Using the gray scale scanner, you can include photos in your caps. In this instance, for want of a photo, I put my head and hands on the scanner and hit the "scan" button. In ImageStudio, the hands were rotated to the correct angles to hold the letter. After scanning and tracing a character outline, the Tiff format photo was placed in FreeHand with the character above it. The outline was edited to include the finger outlines and then a red inner-line was placed inside the character path. The illusion of the hands holding the letter is emphasized.

Lanterns glowed br each window as th darkness descended upon the little villag one knew what caused the electricity

The Panel Cap Here the angle of the italic typeface was used to define the angle of all the other lines in the setting. In MacDraw, a panel large enough to accommodate the largest capital was placed and given a dark shade fill and no outline. Above this, several two point thick lines were placed on the angle of the italic letter and subsequently grouped. A copy of the panel was made, this time treated with a one point outline and light fill. On top of the pile of objects sat a red character with a light shadow offset in the same direction as the panel shadow.

Chapter 1
The Basics of Billiards

Many an evening have spent standing around lit rooms; men propp by long thin pieces of one eye on the game

The Curved Ball First, the illustration of the ball was created with two blends, one for the highlight and one for the reflection. Above that, a letter curved first in LetraStudio (see letter "F") and later modified in Illustrator was placed above it. Two circles were then placed around the illustration and treated with no line and no fill. Using FreeHand's Join command, the chapter number was joined to the inner circle and the chapter title was joined to the outer circle. This circle had been flipped on the vertical axis to make the type baseline bind to the inside of the path.

Never has a skater put o a wonderful performa The ice was her playg and the audience her l As she moved gracefully around the

The Translucent Cap First, create the perspective panel as an outline and fill it with a mid-range tone. Set a solid character above the shape large enough so that the letter could sit inside the panel. Create another panel only half as large as the first, with its top portion intersecting the horizontal middle and request no fill. Clone the letter and assign a darker tone to it than the large panel. Paste it inside the small panel. Place a solid version of the letter inside another path that occupies the other portion of the panel's top surface. Use blended ovals to suggest a two-tone shadow.

bjects of worth are g
placed inside glass c
out of the reach of p
they walk through m
At the Lomprant Inst
Moureton the designers have gone

The Impressed Button The button was created with a mid-range tone with highlights and shadows placed on the beveled edges. The little star was created as a series of four lines blended with four other lines that matched the background over which they sat. The impressioned character was really set three times. First it was set to the lower left using the highlight color, then to the upper right using the shadow color, and then once again, this time in the middle using the button face tone.

uests were more than
diversion for the knig
14th century. They w
Driven by a lack of b
skirmishes (except a
Welsh borders) their order looked m

The Ribbon Cap This multi-layer capital is best generated in a program like Aldus FreeHand. On the bottom layer, some diagonal ribbons are placed, defined as a dark color. Then the capital letter is set and positioned. The next layer above features lighter bars joining up to the background ribbons. A copy of the capital is created, changed to a slightly darker tone than the front ribbons and then cut to the clipboard. This copy is pasted into each of the front bars to achieve the effect of a translucent ribbon.

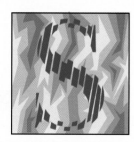

heets of ice hung fron
eaves of the cabin. Ici
thick as a man's thigh
stretched to the groun
supporting the overlo
Inside, the two mountain climbers cr

The Shattered Cap Here is another capital that makes use of clipping paths (Paste Inside command in FreeHand, Mask option in Illustrator 88). First, a character is set and duplicated once. These are then rotated slightly and offset from each other randomly. The letters are then bound to a clipping path that looks rather like an uneven comb, covering only one half of the character's surface area. The same clipping path can be used for the other copy of the letter provided it is offset and slightly rotated. Edit the bound paths by temporarily giving the mask line a stroke.

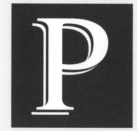

retending not to notic
Amy took off her shi
stood in front of the n
admiring herself. It w
first time they had pla
way. Back in the early years, before

The Double Line Letter The repeating technique seen in the creation of the impressed character can be used again to different effect in the creation of an offset double line. The character is set just three times. First, it is set above the background in white, then offset up and to the right by two points in the background tone. The third time it is set, the character sits removed by the same distance again, but this time in white. This drop cap must always have an even-toned background.

ecent developme
packaging industr
created an even r
unstable environn
entry-level packag
company. Hardware requirements

The Third Dimension If you have time, you may wish to create drop caps in three dimensions. This character shape was drawn as a Pict outline (in MacDraw, Claris) in two-dimensional format. This was imported into MiniCad 3-D where the shape was extruded and a grid surrounding the extruded shape was assembled. The artwork was then rotated into this position and exported again as a Pict file which could then be opened in Aldus FreeHand for colorizing. Each grid face had been grouped so that they could be moved and rotated independently.

here are numerous w
which we, as individ
can help to protect o
enviroment from poi
and contamination. V
there are organizations whose main

The Hand-Drawn Look Take a black marker and some paper and sketch your drop cap in whatever style you wish. A quick sketch will do with chunky, rough lines. Scan this into the computer and produce a MacPaint file. Open this as a template in your drawing program and use the autotrace feature to first take the outline of the scan and fill it with black. Working progressively inward, fill all the holes with color. Not only is this a lot of fun but it can be quite effective. Drop caps done in this way will have a more fluid, friendly feeling to them.

nderneath the toy box was a hidden doorway doorway that lead into magical playground full of teddy be twelve o'clock all the bears held pa

The Kid's Block A child's letterblock can be created by completing a flat version of the artwork; use the drawing program's shear capabilities to line the faces into position. For example, in FreeHand, the left face is achieved using a vertical shear of -30° and the right face with a vertical shear of 30°. Then the top is vertically scaled by 58 percent and sheared by 60° horizontally and 30° vertically. Then the entire block is scaled vertically by 110 percent. Subsequently, each face and the letter which sits upon it are toned to reflect depth.

hether you use a cal automated banking m an electronic telephon computers every day. looks at micro-process from the standpoint of both the use

The Digital Look For a modern approach to initial letters, you may want to create digital characters. You can create them in your drawing program using a series of building blocks. First, define a grid that is a slanted square cut into four small rectangles. Place your building blocks along these line segments (there should be fourteen of them) and then give each of them a red fill. Put a lighter tone line inside the blocks. On this grid almost every letter of the alphabet can be built by setting the unwanted blocks to a darker tone.

achts moved gracefu the harbour. Upon th floated a ribbon of sa ever-changing, never dance. Michael longe there amongst the gulls hearing the s

The Horizontal Line Fill This is perhaps one of the easiest caps to create. First, set your letter in the size you want. Outline it with a three point line. If you have the character outline, create a bank of horizontal hairline rules set one point apart and paste them inside the path of the letter. If not, you can give the character a 10 percent tone and change the halftone screen function for that object to a horizontal line of 72 lines to the inch. Make a copy of the character, giving it no fill, and a white outline of .7 point thickness. Underneath and offset by four points is another duplicate with a black fill and black outline.

iewed by many as a start to the thirties, th the Troops on Janua soon turned into a ro cause was everywhe be seen. People starved in the stre

The Squiggle Here is a technique that is worth it just for the sheer hell of trying. First, a squiggle was drawn with a pencil and scanned. The resulting bitmap was autotraced as one complete shape and then spliced and edited into two shapes. These shapes could then be used as masks with an opening in the middle (of the squiggle) which would show anything underneath—in this case, a diagonal FreeHand ramp from blue to red. Above this I placed a character from one of my own fonts created in Fontographer from Altsys, first in black and offset in white.

enophobia is defined dictionary as "having dislike of foreigners" character in this book xenophobe. From the see him passionately discoursing on

The Multiples Never overlook repetition. In this example, the letter has been repeated in a series of lines running through the background of the capital block. Repeating elements should be kept to a relatively soft contrast so as not to detract from the main letter. First, the letter was set in the large size. A copy was taken and a wave shape was drawn using FreeHand. A line of "X's" were keyed into the program and then bound to the wave shape so that they would follow that as a baseline. Copies were then duplicated down the block by a specified distance.

irc, as he was known in the village, was a st character. The skin or the same translucent the precious stone aft had been named. Most people ign

The Natural Cap No, this is not a trick example, nor is it a cop out. The no-frills approach can be quite attractive when you use a typeface such as this letter set in Demian from the Letraset library of display faces. The characters have been created with such painstaking accuracy that even severely enlarged they appear wholly natural. Only you know that they were electronic outlines. Also look at the possibility of drawing a character with a calligraphic pen and scanning it. Accent it with a soft repeating pattern. In this case, the pattern has a ragged edge to suggest torn paper. ■

Journal of a Sufferer

Patrick Breen, Donner Party
journal, October 31, 1846, to
March 1, 1847, and George
McKinstry, Jr., report of Donner
Party return, April 29, 1847

Truckee Lake [later known as Donner Lake], Nov. 20. – Came to this place on the 31st of last month; went into the Pass, the snow so deep we were unable to find the road, and when within three miles from the summit, turned back to this shanty on Truckee Lake. Stanton came up one day after we arrived here; we again took our teams and wagons and made another unsuccessful attempt to cross in company with Stanton; we returned to the shanty, it continuing to snow all the time. We now have killed most part of our cattle, having to remain here until next spring, and live on lean beef without bread or salt. It snowed during the space of eight days with little intermission, after our arrival here, though now clear and pleasant, freezing at night, the snow nearly gone from the valleys. – 29. Still snowing, now about three feet deep . . . killed my last oxen to-day; gave another yoke to Foster; wood hard to be got. – 30. Snowing fast, looks as likely to continue as when it commenced; no living thing without wings can get about.

Dec. 1. – Still snowing, wind w.; snow about six or six and a half feet deep; very difficult to get wood, and we are completely housed up; our cattle all killed but two or three, and these, with the horses and Stanton's mules, all supposed to be lost in the snow; no hopes of finding them alive. – 5. Beautiful sunshine, thawing a little; looks delightful after the long storm; snow seven or eight feet deep. – 9. Commenced snowing about 11 o'clock. . . . Took in Spitzer yesterday so weak, that he cannot rise without help, caused by starvation. Some have a scant supply of beef; Stanton trying to get some for himself and Indians; not likely to get much. – 17. Pleasant. Wm. Murphy returned from the mountain party last evening; Balis Williams died night before last; Milton and Noah started for Donner's [camp] eight days ago; not returned yet; think they are lost in the snow. – 20. Clear and pleasant . . . Charles Berger set out for Donner's; turned back, unable to proceed; tough times, but not discouraged; our hopes are in God, Amen. – 21. Milton got back last night from Donner's camp; sad news, Jacob Donner, Samuel Shoemaker, Rhinehart, and Smith, are dead the rest of them in a low situation; snowed all night. . . . Began this day to read the "Thirty days' prayers." Almighty God grant the requests of unworthy sinners; – 24. Rained all night and still continues; poor prospect for any kind of comfort, spiritual or temporal. – 25. Offered our prayers to God this Christmas morning; the prospect is appalling but we trust in Him. – 27. Snow nine feet deep; wood growing scarce; a tree when felled sinks into the snow and hard to be got at. – 30. Charles Berger died last evening. . . . – 31. Last of the year; may we, with the help of God, spend the coming year better than we have the past, which we propose to do if it is the will of the Almighty to deliver us from our present

40 William Keith
Donner Pass, c. 1890

An open spread from *O California, Nineteenth and Early Twentieth Century California Landscapes and Observations.* Jack Stauffacher's design for this book was used as the model for the examples presented in the following demonstration article. The original type for the book was Kis-Janson. Stauffacher reset the type for the examples in this article using Adobe Garamond.

Forgotten Characters: *An Adventure in Typographic Navigation*

Text by Sumner Stone
Typography by Jack W. Stauffacher

The typography in this article differs from the rest of the book because it was specially prepared as a demonstration of the principles it talks about. The purpose of the article is to explore the use of small capitals, old style figures and other "forgotten" characters. The typeface is Utopia, designed by Robert Slimbach.

A typographer is the person responsible for taking an author/editor's raw text – a private, rough, amorphous, hard to read manuscript – and transforming it into a public, finished, well-formed, legible document. The typographer represents the interests of the reader.

Since the advent of desktop design and desktop publishing, the designer is increasingly responsible for all typographic decisions. Indeed, anyone who is producing documents with a personal computer and laser printer has, knowingly or not, taken on the responsibilities of the typographer. To paraphrase Pogo, we have met the typographers and they are us.

The knowledge about how to accomplish the transformation from raw to cooked, from private to public, from rough to finished, however, does not consist of a set of rules or algorithms. Typography is a complex and subtle craft which, like cooking, must be learned by doing. A recipe is only as good as the cook who is using it. This article and its examples, therefore, have been designed as guides and references, not formulæ.

Making clear distinctions in the various levels or hierarchies of the text – through the use of typographic conventions which indicate different modes, voices, or levels of emphasis in the text – is one of the primary tasks of the typographer. The most common mistake of beginning typographers is to overdo these typographic indicators. If the signage is too gross, it tends to distract the reader and actually disrupt the smooth flow of reading. Orchestrating the proper balance between unity and diversity is the craft of both the typographer and the type designer. Like good music, the properly balanced presentation of the text should be a harmonious blend of loud and soft, treble and bass, fast and slow.

There are, of course, many aspects of typography which must be considered in order to approach this ideal. The use of small capitals, old style figures (also known as lowercase figures), ligatures and other characters which may have been "forgotten" are just some of the factors to be considered.

In order to demonstrate the use of small capitals and lowercase figures, Jack Stauffacher created the typography for a set of samples based on his design of the book *O California,* published by Bedford Arts, Publishers in San Francisco.

Raw manuscript:

```
Truckee Lake [later known as DONNER LAKE], Nov.20,1846--Came to this
place on the 31st of last month; went into the Pass, the snow so deep
```

Regular capitals, lining figures, em-dash, no ligatures:

Truckee Lake [later known as DONNER LAKE]. Nov. 20, 1846 — Came to this place on the 31st of last month; went into the Pass, the snow so deep we were unable to find the road, and when within three miles from the summit, turned back to this shanty on Truckee Lake. Stanton

Small capitals (letterspaced), lower case figures, en-dash, ligatures:

Truckee Lake [later known as DONNER LAKE]. Nov. 20, 1846 – Came to this place on the 31st of last month; went into the Pass, the snow so deep we were unable to find the road, and when within three miles from the summit, turned back to this shanty on Truckee Lake. Stanton came up

Text from Shakespeare's *The Tempest*:
Adobe Garamond

Our revels now are ended. These our actors,
As I foretold you, were all spirits, and
Are melted into air, into thin air;
And, like the baseless fabric of this vision,
The cloud-capp'd towers, the gorgeous palaces,
The solemn temples, the great globe itself,
Yea, all which it inherit, shall dissolve;
And, like this insubstantial pageant faded,
Leave not a rack behind. We are such stuff
As dreams are made on, and our little life
Is rounded with a sleep.

Act iv Scene 1

Helvetica Inserat

Our revels now are ended. These our actors,
As I foretold you, were all spirits, and
Are melted into air, into thin air;
And, like the baseless fabric of this vision,
The cloud-capp'd towers, the gorgeous palaces,
The solemn temples, the great globe itself,
Yea, all which it inherit, shall dissolve;
And, like this insubstantial pageant faded,
Leave not a rack behind. We are such stuff
As dreams are made on, and our little life
Is rounded with a sleep.

Act iv Scene 1

Adobe Standard Character Set

!"#$%&'()*+,-./0123456789:;<
=>?@ABCDEFGHIJKLMNOPQRSTUVWXYZ
[\]^_'abcdefghijklmnopqrstuvwxyz{|}~¡¢£/¥ƒ§¤'"«
›fifl–†‡·¶•,,,""»…‰¿`´ˆ˜¯˘˙¨˚",�ˇ —ÆªŁØŒº
æıłøœßÁÂÄÀÅÃÇÉÊËÈÐÍÎÏÌÑÓÔÖÒÕŠÞÚÛÜÙÝŸ
Žáâäàåãç©°÷éêëèðíîïì¬–µ×ñóôö
ò½¼¹õ±®šþ¾³™²úûüùýÿž

Adobe Expert Character Set

ABCDEFGHIJKLMNOPQRSTUVWXYZ
ÅÆÁÀÂÄÃÇÐÉÈÊËÍÎÏÌŁÑŒØÓÒÔÖÕŠÞÚÙÛÜÝŸŽ
fffiflffiffl&1234567890$¢₵Rp1!¡?¿$¢(-.,1234567890)
¼½¾⅛⅜⅝⅞⅓⅔$¢(-.,1234567890)ᵃbdeilmnorst
/–-‚‚„"'"‹›ˇˆ˜˝˙˚·–‥ ..,;:‥

To read is to go on a journey, and the function of the typographer is to make that journey as smooth as possible. Choosing vehicles (typefaces), for example, is a critical matter. The words contained in Shakespeare's *The Tempest* set in Helvetica Inserat are the same as those in *The Tempest* set in Adobe Garamond. The experience for the reader is, however, quite different.

The typographer is responsible not only for choosing the typeface, but also for choosing which characters should be used. We commonly suffer from the illusion that the alphabet has a mere 26 letters. Perhaps it is the process of singing the alphabet song as a child, our first step toward literacy, that embeds this notion in our cultural soul.

As we progress through school we soon learn, however, that there are both capital letters and "little" letters. An **A** is not an **a**. We also use numbers and punctuation, monetary signs, fractions, accents, ligatures, mysterious characters like the ampersand and section mark, and others. All together a typical text typeface that is developed for electronic publishing systems contains over 230 characters (the equivalent of almost nine 26-letter alphabets). Today there are a few special typeface families that contain even more characters – small capitals, old style figures, and others.

Capital and lowercase letters are used together in order to perform different functions in the text. The practice of mixing different alphabet styles to perform different functions in the text dates back to the time of Charlemagne. Normally we use capital letters to begin sentences and proper names, and occasionally we set titles or words in all capitals. When a word is set entirely in capitals within a body of upper and lowercase letters, it is so large that it jumps out of the text. From the earliest printing with roman characters a special version of capitals (small capi-

True small capitals & lower case figures:

WILLIAM SHAKESPEARE: THE TEMPEST, ACT 4
Our revels now are ended. These our actors,

Artificial small capitals and artificial lower case figures:

WILLIAM SHAKESPEARE: THE TEMPEST, ACT 4
Our revels now are ended. These our actors,

Design for chapter opening, regular capitals, regular figures, em-dashes, no ligatures.
Adobe Garamond, main text 13.16 (point size.leading), 31 picas ragged, display 19 pt. italic, legend 9.10, 10 picas.

Journal of a Sufferer

Patrick Breen, Donner Party journal, October 31, 1846, to March 1, 1847, and George McKinstry, Jr., report of Donner Party return, April 29, 1847.

Truckee Lake [later known as DONNER LAKE]. Nov. 20, 1846 — Came to this place on the 31st of last month; went into the Pass, the snow so deep we were unable to find the road, and when within three miles from the summit, turned back to this shanty... —29. Still snowing now about three feet deep... killed my last oxen today; gave another yoke to Foster; wood hard to be got. —30. Snowing fast, looks as likely to continue as when it commenced; no living thing without wings can get about.

Final design for chapter opening with small capitals, lower case figures, en-dash, ligatures.
Type specifications are the same as above.

Journal of a Sufferer

Patrick Breen, Donner Party journal, October 31, 1846, to March 1, 1847, and George McKinstry, Jr., report of Donner Party return, April 29, 1847.

Truckee Lake [later known as DONNER LAKE]. Nov. 20, 1846 – Came to this place on the 31st of last month; went into the Pass, the snow so deep we were unable to find the road, and when within three miles from the summit, turned back to this shanty... –29. Still snowing now about three feet deep... killed my last oxen today; gave another yoke to Foster; wood hard to be got. –30. Snowing fast, looks as likely to continue as when it commenced; no living thing without wings can get about.

Marginalia

9.11 point italic, 10½ picas, ragged, lining figures on left, old style figures on right. The lining figures dominate the example on the left. Use of old style figures maintains the appropriate balance. It creates a texture which is harmonious with the main text. The old style figures also generally use less space.

A summary of the Los Angles Directory for 1875 showed the following classifications: 107 carpenters, 72 fruit dealers, 50 attorneys-at-law, 43 blacksmiths, 33 printers, 32 physicians and surgeons, 30 boot and shoe dealers and makers, 30 butchers, 28 teachers, 27 saddle and harness makers, 23 upholsterers, 23 house and sign painters, 22 clergymen

A summary of the Los Angles Directory for 1875 showed the following classifications: 107 carpenters, 72 fruit dealers, 50 attorneys-at-law, 43 blacksmiths, 33 printers, 32 physicians and surgeons, 30 boot and shoe dealers and makers, 30 butchers, 28 teachers, 27 saddle and harness makers, 23 upholsterers, 23 house and sign painters, 22 clergymen

tals), which are optically about the same size as the x-height of the lowercase letters, was used for this purpose. The weight of these small capitals is designed to harmonize with the weight of the lowercase.

Since the advent of phototypesetting, a smaller point size of the normal capitals has sometimes been used for this purpose. These artificial small capitals, however, generally look too light and too narrow compared to the surrounding text, as can be seen in the accompanying illustration.

The letters that we use today can be traced directly back to Roman forms, but the numbers we use cannot. We call them Arabic numerals because they arrived in Europe in the 11th century via the Arabs who then occupied Spain. In fact, it is probable that they originated in India.

The forms of the numerals that we use, therefore, come from a completely different writing tradition. Any type designer will tell you that drawing them so that they look harmonious with the alphabetic characters remains a challenge to this day.

We are used to seeing numerals (typographers like to call them figures) that are all more or less the same height as the capital letters. These are called lining figures and are actually fairly new in the history of typography. Until the nineteenth century, figures were designed to be much more like lowercase characters with ascending and descending parts. We currently call these old style or lowercase figures. When used in upper and lowercase text, they look much more harmonious than lining figures. A series of lining numbers in the middle of a text tends to pop out in the same way as a word set in capitals. As with small capitals, sometimes a smaller point size of lining figures is used in order to imitate old style figures. These figures also look too light.

Typographic conventions which indicate different modes in the text create the need for more characters and more styles for each character. We all learn some of these typographic conventions in school. For example, we all know that proper names are supposed to begin with capital letters (*unless you are e.e. cummings*). Other conventions depend heavily on technology. For example, typewriters generally do not offer the user italic or bold versions. Underlining is generally used for emphasis.

Generally the typographic conventions for a particular work are set by the decisions about the treat-

ment of the main body of text. For example, the most important typographic structure in the book we are using as an example is the main text shown in the design for the chapter opening for *Journal of a Sufferer*. The first thing to note is the line length and leading. The lines are relatively long, so even though the Adobe Garamond has a rather small x-height, they have been liberally leaded. The leading of the legend has been chosen to harmonize with the overall density of the main text. The use of small capitals and oldstyle figures helps the numbers and names to achieve the appropriate level of visual importance in the text. Although these differences may appear slight, their effect is multiplied by their repeated usage throughout the book. The cumulative impact is considerable.

Having set the style for the main body of text, these conventions will also apply to the other sections of the book which surround and support the main text such as the table of contents, captions, marginalia, folios, list of artists, bibliography and index. The treatment of some of these is shown in the accompanying examples.

The purpose of these typographic conventions is to help the reader navigate through the text. They are signposts, indicators which provide more information to the reader in the interests of a smoother journey.

Sumner Stone is Director of Typography at Adobe Systems and designer of the ITC Stone family of typefaces.

Jack W. Stauffacher is proprietor of the Greenwood Press in San Francisco.

Artists
9.11, 16 picas, ragged, lining figures on left, old style figures on right.

Arthur William Best 1859–1935
Born near Petersboro, Canada, Best moved to San Francisco in 1895.

Albert Bierstadt 1830–1902
Born in Solingen, Germany, and brought to America by his parents at 2, Bierstadt first journeyed into the West in 1859 with the government survey expedition led by Colonel Frederick W. Lander. He studied in Rome and Düsseldorf for 4 years. He made two additional western journeys, including California, in 1863 and in 1871-73. His heroic, grandiose paintings of America's natural beauty awakened a sense of national pride. He is referred to as "the founder of the Western school of landscape-painting."

Arthur William Best 1859–1935
Born near Petersboro, Canada, Best moved to San Francisco in 1895.

Albert Bierstadt 1830–1902
Born in Solingen, Germany, and brought to America by his parents at 2, Bierstadt first journeyed into the West in 1859 with the government survey expedition led by Colonel Frederick W. Lander. He studied in Rome and Düsseldorf for 4 years. He made two additional western journeys, including California, in 1863 and in 1871-73. His heroic, grandiose paintings of America's natural beauty awakened a sense of national pride. He is referred to as "the founder of the Western school of landscape painting."

Index
9.11, 16 picas, ragged, lining figures on left, old style figures on right.

Annals of the Bohemian Club, The, 53, 54
Austin, Mary, 14, 43, 128, 140, 143, 156. 162, 168, 171, 188, 246, 249
Bell, Major Horace, 139, 202, 212
Benson, William Ralganal, 50
Best, Arthur William 33
Bierstadt, Albert, 75, 109, 111, 117, 127
Bischoff, Franz Arthur, 209
Black Bart (bandit), 53
Borglum, John Guzton de La Mothe, 87

Annals of the Bohemian Club, The, 53, 54
Austin, Mary, 14, 43, 128, 140, 143, 156, 162, 167, 171, 188, 246, 249
Bell, Major Horace, 139, 202, 212
Benson, William Ralganal, 50
Best, Arthur William, 33
Bierstadt, Albert, 75, 109, 11, 117, 127
Bischoff, Franz Arthur, 209
Black, Bart (bandit), 53
Borglum, John Guzton de La Mothe, 87

Bibliography
9.11, 16 picas, ragged, regular capitals, lining figures on left, small capitals, old style figures on right. The information in the example on the left is overwhelmed by the capitals and lining figures. On the right the small capitals and old style figures make a better reading line. The emphasis of the x-height helps to maintain a constant clarity.

BAIRD, Joseph A., Jr. *The West Remembered: Artists and Images, 1837–1973,* San Francisco: California Historical Society,1973.
DAWDY, Doris Ostarander. *Artists of the American West: A Biographical Dictionary of Artists before 1900,* Vol. 3, Athens, Ohio: Swallow Press, 1985.
HARRISON, Alfred C., Jr. *William Keoth: The Saint Mary's College Collection,* Ann Harlow, ed. Moraga, California: Heart Art Gallery, Saint Mary's College,1988.

BAIRD, Joseph A. Jr., *The West Remembered: Artists and Images,* 1837-1973, San Francisco: California Historical Society, 1973.
DAWDY, Doris Ostarander. *Artists of the American West: A Biographical Dictionary of Artists before* 1900,Vol. 3 Athens, Ohio: Swallow Press, 1985.
HARRISON, Alfred C., Jr. *William Keoth: The Saint Mary's College Collection,* Ann Harlow, ed. Moraga, California: Hearst Art Gallery, Saint Mary's College, 1988.

The Portability of Digital Type

Understanding the effects of technology on type helps us know how to build our digital type library.

By Matthew Carter

In the Beginning The invention of hand-set, hot metal, movable type marked the point at which type became "portable." But when type became mechanized (as on the Linotype machine, shown here), each typesetter manufacturer required that its devices use specially crafted and dedicated type. Portability was strictly curtailed. However, today's digital type has revived type's flexibility.

Designers and other professionals who have traditionally worked with type will agree that their class is not as exclusive as it once was. The evolution of type and the equipment on which it is imaged have now brought the art and mystique of typography to any desktop outfitted with a personal computer and a laser printer. In the journey from carved letterforms on pieces of metal type to digital data stored on floppy disks, many typefaces have been subject to technological issues and the subjective work of myriad dedicated and independent type foundries.

Professional type users and specifiers need to understand the effects of technology on type and the variances among the ever-growing font vendors in order to continue making confident decisions regarding the use of type in their work. Like icebergs, there is more to type than what can be plainly seen. The more designers know, the safer they and their clients will be.

A BRIEF HISTORY OF TYPE

Hand-set, hot metal, movable type was developed some 500 years ago. By the next century, several independent foundries were making type that could be used interchangeably on virtually any printing press. It was entirely possible for types from a variety of different vendors to be set together in a composing stick. Type had become "portable."

About 100 years ago, typesetting became mechanized. Each typesetter man-

ufacturer required that its devices use specially-crafted type, which they generally produced themselves. In this way, type foundries became dedicated, making type for one company's line of devices. A successful manufacturer's type division, therefore, became an important profit center. Since that type only worked on one manufacturer's devices, users had to go back to the maker of their typesetters for additional type, and so type's initial portability became limited.

AGE OF PHOTOTYPE Advances in photographic technology in the early to mid-20th century paved the way for the advent of photocomposition in the 1950s. Type was now imaged by light passing through translucent letterforms onto photographic paper. This method had two

serious effects on type. For one, type became less portable than ever. In fact, type was now just a part specific to a particular device. So even if a user upgraded within a single manufacturer's line, a completely new library of type also had to be purchased. Even though many new type designs were being introduced, users could not avail themselves of the variety offered by rival foundries.

The second effect was that some of the original type designs were altered so that they would perform better on the new equipment. Such compromises in quality were little noticed by untrained eyes, but coupled with the strict particularization of type, it was a most unfortunate result of what was purported to be a technological improvement.

THE DIGITAL AGE In the 1970s, the digital age of typography began and this latest technology has given type unprecedented stature. From a design point of view, digital type offers a greater level of exactness and flexibility than any previous method. From a user standpoint, it is far easier to assemble the necessary equipment and actually use the type than ever before. This ease is what has made type a consumer item and heralded the desktop publishing age.

As will be discussed later, the digitization process varies from one foundry to another. The digital data, however, is generally available in two forms: bitmaps and outlines. Bitmaps describe the actual placement of pixels that image a letterform. A separate bitmap is needed for each character at a specific size. Bitmaps can be fine-tuned to accommodate the peculiarities of certain devices and resolutions without affecting the overall design.

Outlines define letterforms as a series of geometric lines and arcs and are created by plotting key points along the shape of a character. Because they describe the shape rather than the number of pixels that fill it, outlines are inherently scaleable. The software application or computer printer scales the outline to user-specified sizes either in advance or at the time of printing. Because of the mathematics involved, scaling can take quite a long time. (See Figure 1.)

DIRECTIONS IN DIGITAL TYPE

The arrival of digital type has helped fos-

Figure 1 The digital data for a typeface is available in two forms—bitmaps and outlines. Bitmaps, like the version of Charter (Bitstream) shown above (right), describe the actual placement of pixels that form a letter. Outlines, like the Charter character shown below (right), define letterforms as a series of geometric lines and arcs created by plotting key points along the shape of the character.

ter the return of independent type foundries. Because of pressure in the computer industry to publish standards and the market for licensing formats, specifications are generally available to any foundry that wishes to provide type for a particular device. In addition, new computer-driven devices like imagesetters, broadcast video systems and computer-aided design systems needed libraries of type. The manufacturers of these devices lacked the resources necessary to establish their own type divisions, and so have relied on independent foundries for their type.

These foundries have approached the task of digitizing the world's typefaces in different ways, however. As such, there are variances in design, font metrics, quality, selection and compatibility. Designers need to be aware of this and know what to look for in choosing their type vendor.

Digital data can be provided in a variety of formats. So for the first time since the early days of type, there is the potential for portability or device-independence. Many vendors, however, have found their niche in providing type for a specific device or line of devices.

As the potential of digital type is explored, these solutions appear very limiting. A designer needs to do accurate layout from the screen to know what will come out of the printer. The concept of WYSIWYG (What You See Is What You Get) is made possible by providing the same fonts for the printer in another format and/or resolution required for the screen. In today's office environment, a variety of low- and high-end devices are used and the need for a complete type solution is apparent and achievable.

In the PC world, a number of font vendors have developed font generating software that can intelligently adapt fonts to a number of different platforms and environments. The capabilities of these programs vary, but some common features are that they can scale outlines to virtually any size, create matching screen and printer fonts, and share fonts among several applications.

The Macintosh has a more standard operating system and screen and printer formats. But with dot matrix and laser printers, page description languages, clones and the fact that some devices use bitmaps and others use outlines, there is still a challenge to creating a device-independent solution. Some vendors provide bitmaps and outlines, but precious few include a wide selection of both in the same package. The benefit of that is by using the same vendor's type in low- and high-end devices, proofing and production can be more accurate and easier to manage.

The inherent flexibility of digital type is demonstrated in the number of places it can be used: in operating systems, software applications, screens, printers and other output devices such as film recorders and sign-manufacturing systems. Because user-installed type was not a consideration when most operating systems and software were developed, it has been the responsibility of the font vendor to make it fit. Now that type is such a hot commodity and the market is much more type-conscious, it can be expected that the near future will offer more typographically-sensitive operating systems and environments.

It is important to erase compatibility obstacles that hinder the portability of type. As we have seen, vendors whose type is more or less device-independent have had to develop advanced software to manage all the hurdles. Even then, drawbacks, such as heavy storage requirements, uneven output quality due more to proprietary formats than the type itself, and the precarious task of sharing files across devices and platforms, remain. This hurts the user who must purchase a high-quality type solution for one or more devices and still get the variety needed to be fully expressive and competitive.

LOOKING AT TYPE LIBRARIES

In choosing a type vendor, the first step is usually to examine its specimen book. Most vendors will have a selection of typefaces that were designed in-house, but for the most part, the typefaces in any specimen book are taken from the wealth of styles created over the last few centuries.

In this age of digital type, it is more important than ever before to compare type libraries. Because the era is still young and has seen such rapid growth, there have been no digitizing standards set to ensure consistent quality. For one thing, several dedicated foundries that were responsible for altering type designs to work well with phototypesetting equipment did not correct those compromises in the conversion to digital. Their alterations, inflicted for the sake of now-outdated technology, remain in digital form.

Another reason for variances in quality and authenticity between vendors' libraries is the method of digitization used. Most of the workstations that are used to digitize type have been specially customized by the various foundries. The software that is used, the resolution of the digitizing grid's em square and, of course, the skill and knowledge of the designer who digitizes the faces vary from foundry to foundry. Even the number of kerning pairs, the character widths and other metrics differ widely. (See Figure 2.)

Since typeface designs are not copyrightable, it is no difficult matter for a foundry to offer any particular typeface. The names, however, can be trademarked and in the interests of protecting a competitive edge, the owner of the trademark may refuse to license the name. In that case, the foundry can devise a new name for the design and proceed with business. There are two things to note: First, since the designs are not protected, they can be altered slightly to suit the taste of the vendor or the peculiarities of a device; second, the same style takes on a different name from vendor to vendor, causing confusion.

It is important to note, however, that just because a typeface does not use the original name, that has no bearing on the quality or authenticity of the design. Shakespeare made a similar observation with roses, but it stands true with type as

Figure 2 Each digital foundry employs a different hardware/software system and a different method of digitization. Of course, the human element, the level of the designer's talent and skill, also affects the product. As a result, the quality and authenticity of digital typefaces varies.

well. In fact, a vendor who digitizes a typeface based on the designer's original intentions but who must use another name for it could very well have a better version than a vendor with the original name but an altered design.

When a typeface is designed, there are usually at least four styles created: roman, italic, bold and bold italic. Some type families consist of eight, 17 and many more styles. But not all type vendors supply complete families, which has an impact on the designer's freedom of choice. There are also vendors who, rather than create a true italic face, will merely oblique the roman weight. An italic is a completely different design from the roman. While italics naturally have a slant, there are other features that differentiate them from the roman styles. To provide an obliqued face in the guise of an italic style is a serious compromise in quality.

Although businesses, in general, seem to prefer PCs and designers tend to take to Macintoshes, clearly, the time of office equipment integration is here. Information must be shared, and draft copy and designs must be approved. Some type products can take their users into the future better than others. Designers who can foresee an equipment upgrade or the need to cross platforms with their work will want to look into a type solution that will be constant amidst the changes. It is too costly to replace a type library along with a typesetter.

As the final decade of the 20th century approaches, the age of digital type is firmly in place and its full potential is yet to be exhausted. There are type solutions that will take users into the future while others will merely bring the limitations of the past in tow. The caring designer will make a careful and informed decision, now aware of what to look out for. ■

Matthew Carter is founder, director and vice president of design at Bitstream, Inc., makers of digital type and related software. An internationally recognized type designer, Carter teaches at Yale's Graphic Design School and received the Frederic W. Goudy Award for outstanding contributions to the printing industry.

Typography in Hybrid Imagery

April Greiman discusses how she integrates type into her computer-generated designs.

During the 1970s, as Los Angeles-based designer April Greiman made her professional way, her work was popularly labeled "New Wave." The term no longer seems to fit. Today, Greiman refers to her brand of design as "hybrid imagery." For in combining photography, drawing, video, computer-generated images and typography in her designs, she creates a crossbreed that blends but is unlike any of its parts.

To her credit, Greiman was one of the first designers who saw potential in the "textures" of video and computer-based imagery, and was brave enough to integrate this new visual language into the mainstream design work she was creating. She was also one of the first designers to use the Macintosh computer as her primary design tool. Despite her pioneering work, she refuses the label of "experimental" designer. She prefers to say she is interested in process, in layering images to evoke both a thoughtful and emotional response.

While nature seems to have instilled in Greiman a restlessness that enables her to test the accepted visual pathways, her training at Kansas City Art Institute and the Basel School of Design gave her the discipline to bring her ideas to fruition. (For an interview with her instructor at Basel, Wolfgang Weingart, turn to the next section.) Earlier in her career, Greiman was director of visual communications at the California Institute of the Arts.

While Greiman does not consider herself a "type buff," she uses typography innovatively in the logos, signage, posters and other print materials she creates for her expanding list of international clients.

Form Follows Function "Wouldn't it be great if our signs looked like an Ed Ruscha painting—that they were beautiful yet contained the information about our properties," Greiman's clients suggested to her about the real estate signage she was creating for their Los Angeles development company, Perloff-Webster. With this in mind, she integrated the mark she had developed for the company into a square format, which she balanced with a series of horizontal bars. The most important information, the phone number, was placed in the central bar in Futura. A magnetic bar that can be changed depending upon the uses of the sign extends off the right side of the 4 x 4-foot sign. Greiman also designed smaller signs for use on other properties or in windows. The sign was designed on the Macintosh and output on the Linotronic as an 8 x 10-inch piece of artwork. The signmaker flatbed scanned the art into a computer and the sign was cut from aluminum. The colors are vinyl.

By combining traditional with bitmapped typefaces, she gives her work an unusual typographic flair.

In the following interview, she discusses the nature of hybrid imagery, how she approaches a typographically-based design, lists the typefaces, computer equipment and software she prefers and explains why corporate clients seek her communication solutions.

Q: When you work on a design that is typographically based, what procedures do you follow?

A: I would say I first look at the whole.

I get a feeling for all the parts simultaneously. There is usually one inspiration for everything, but within that are type, image, color and other elements all working together. Lately, I've been working with hybrid imagery, and I think I have a real feeling for what makes a successful hybrid expression.

Q: What do you mean by hybrid?

A: Something holistic—a design that has many origins and disparate parts yet forms something new. In that new form, it is quite unlike any of the individual parts. The hybrid becomes something

greater because it now has a unique texture, not necessarily like anything used to create it.

Q: Can you define what you mean by "texture" and explain its importance in your work and its application to type?

A: I think this idea of texture became important to me when I began working with video. In the late 1970s, my work was highly criticized by established designers. They said I was a fine artist, not a designer. At one point, I actually considered listening to their advice, leaving this business and going into fine arts.

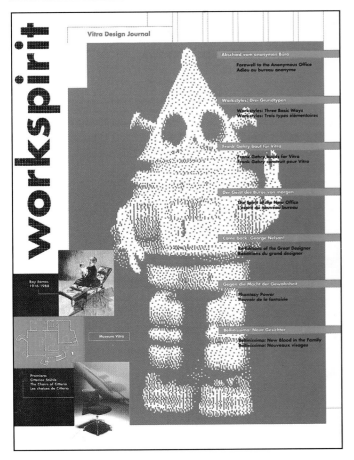

An International Effort Greiman created this 26-page oversized publication (14½ x 11-inches) for her Basel, Switzerland-based client, Vitra International, a furniture manufacturer and distributor. It is an example of international cooperation at its best. Although designed in Los Angeles, its writer was in Frankfurt and its photograper in Milan. The entire publication was produced on the Macintosh and spreads were approved via the fax machine. The focus of the magazine is on work environments, both past and present. The text is in three languages, German, English and French. Futura and Univers (available from Adobe) are used throughout. Greiman likes Futura because of its modern, geometric look. Univers, she says, is the most expressive face if different slants and weights are needed. The cover, printed in three colors, features a scanned image of a robot that was turned into a line shot.

Reflective Logo This logo, which Greiman created for *Workspirit*, is placed in a vertical position next to the fold, instead of in the traditional masthead position across the top of the publication. It was developed on the Macintosh using Futura (available from Adobe). The grid in the background suggests the name.

Simultaneously, I became the director of visual communications at Cal Arts. At that time, designers were very critical of video and computers. They said it was a tool for technicians, and certainly not for visual expression at a high level. I had a client then who produced software, and in their identity they sought an image that was friendly, soft and accessible. I was intrigued with this idea. I began playing with video and found the texture in these video images rather comforting. While other designers were saying it was ugly, hard and too technological looking, I was finding quite the opposite. When blown up, parts of the images looked like a weaving or a blanket. It was very relaxing for me. So I decided to incorporate these textures into what I was doing. I felt they evoked an emotional response. And that became a very important challenge for my design: to communicate about emotion.

Q: How do you produce these textures in your designs?

A: We're using video, digitized video, both the Quantel Video and Graphic Paintboxes and the Scitex. The video tools and the Mac provide texture and a painterly feeling. On the other hand, the Graphic Paintbox produces seamless images. The trouble with the Paintbox is that time is so expensive, I can't afford to experiment enough.

Q: Do you consider type your primary interest?

A: I don't think of myself as being a very interesting typographer. It's important to me, especially that it has quality and a spirit, because every part of a hybrid image must have its own integrity and the same level of caring and consideration. Regretfully, however, I don't feel like I take the type as far as it can go.

Q: If you were limited to just a few families of type, which would you use?

A: People have an impression of me as being very strong in typography, yet I'm just a bozo on the bus. I love it, but I don't think I'm the most interesting person using it because I see design in a much more holistic way. Type is just one of the parts. Generally, I try to imbue typography with a voice so that it's as powerful and as meaningful as a photograph, illustration or any other part of the design. In a way, hybrid imagery is a metaphor for this kind of integration.

It takes years to understand how to use a face properly and so, admittedly, I use the obvious ones—Bodoni, Garamond, Futura, Univers—because they are beautiful and well considered. Each one has a different meaning for me. Bodoni is a very tension-oriented face; it has good thick and thins. It has a sparkle and an elegance, as does Garamond. It doesn't have the hairline, but it has a more vertical axis. Futura looks contemporary because it's so geometric. For me, Univers is just wonderful because it has the possibility of being the most expressive, if you need a lot of

different slants and weights. For a long time, that was the face I found most interesting for editorial typography. It is easy to mix, combine and juxtapose. I also like mixing some of these classical faces with contemporary faces—combining a bit-mapped face with a really elegant Univers.

Q: What interests you about the look of a bitmapped face?

A: It looks technological, yet to me represents past and future. As in DNA, the more we break things down into their parts, the more we realize the infinite. For example, while the face seems to reflect this new technology, at the same time the characters look like American Indian symbols or old icons. Maybe the Egyptians, with their pictorial symbols, were way ahead of us in the communications game.

Q: Do you collect many of the digital fonts? And who are the type designers you admire?

A: Adobe has come out with an unbelievably beautiful cut of Garamond, which has been traditionally pretty bad, so we'll go out and get that. But I'm not really a type buff. I don't know that much about type designers or equipment. Hermann Zapf is obviously a fabulous type designer, but I think Zuzana Licko from *Emigre* has really done some really wonderful things that are out of left field.

Q: How many of the *Emigre* faces do you use?

A: I suppose there are about 30 with all of the variations. We use a number of them including Modular, Matrix Oakland 8, Oakland 15 and Emperor 8.

Q: How much of your work is done on the Mac now, and how has it changed the way you do business?

A: With the Mac, several disciplines —design and production—become one. In other words, you can push things around on the Mac, present that to the client, then modem the information directly to the typesetter. It removes the boundaries between design, production and typesetting.

But this does pose some problems in a business sense: How do you charge for

these services? Although you do all that in one operation, it's not fair to charge a client for all three, but it shouldn't cost them a third as much because it still requires an understanding of all three disciplines.

We've just gone through some major discussions and have gotten some outside advice on how to charge for these services. Now we keep track of our time so we can bill that to clients. We charge for computer set-up time and scanning. And, of course, designers keep a log sheet for each project. Creative endeavors are charged at a higher rate. It's a little bit complex to keep track of everything, but we're fine-tuning it and it's starting to work for us.

Q: How many Macs do you have in your office?

A: Four, one for each designer. We have two Mac II's and two Mac Pluses. And we use them for absolutely everything. The only reason we wouldn't use them is if we were short a machine, which happens when we hire freelancers for special projects. In those cases, sometimes we rent them.

Q: What other equipment do you use?

A: We use an Apple scanner, a digitizer (MacVision), video equipment (½-inch and Super 8) and we have a cartridge drive (Mass Micro Systems) for storage. The projects for our architectural clients take up so much memory that we have to store the information on cartridge. We also have an Apple laser printer and an Apple impact printer.

Q: What software best answers your needs?

A: We Use PageMaker (Aldus) because it was our first page layout software, but I know that Quark Express (Quark, Inc.) has some really nice features. We also use Ready, Set, Go! (Letraset). But when you're as busy as we are, it's really hard to stop and try to jump onto another program, even if there are some features that are obviously better. We also have Image Studio (Letraset) and Illustrator (Adobe) —both wonderful programs.

Q: You are known for your work on the Mac, yet you began your study of typography at Basel by setting type traditionally.

What did that experience teach you?

A: How to see type, how to set it. Hand-setting type allows you to look at all the possibilities. Once you've pulled all the little letters out of the job case, you can try different leading, different letterspacing and different compositions. It's like

that on the Mac; once you have it typed in, then you can arrange it in infinite ways.

For me, that is what was so brilliant about the program. Before Basel, I had never had any typography. In my undergraduate education, I went to the store and bought Letraset type. We didn't have a type shop, so we were really handi-

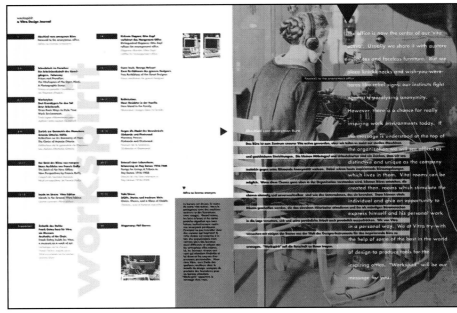

Workspirit Body On the first inside spread of *Workspirit*, the problem of the three languages is handled by specifying Futura in three different sizes. English is reversed out of the background— a photo of an office environment of the past. Greiman placed the German text in horizontal bars beginning at the middle of the page. Since French was the least important of the languages in this application, it was placed in a box on the left page. It is integrated with the other languages through the color screen. Notice, however, that the table of contents and position of the photos on the left page changes from the initial sketch. Despite the long distances, changes in the format were made up to the last minute.

capped. At Basel, I felt like I was a kid in a candy shop. Before that I didn't have a great interest in typography. I was petrified of it because I had never had any exposure to it. I remember when I walked into the type shop my first day at Basel. I literally felt faint I was so scared. It was too awesome for me.

But the way I usually deal with my fear—and this happens with anything that's really important in my life—the indicator light goes on, and I just tackle it. That light usually means there's something really important in there for me, that there is a risk involved, and it will probably be a meaningful education. So instead of backing off, I just jump in. At Basel I worked in the type shop six days a week until I got over that fear, so the learning curve was pretty steep. After that it was playtime; soon I felt very comfortable with the medium.

Q: In some ways, your designs are looked upon as experimental. How does that affect your work with corporations that may tend to be more conservative?

A: I guess I don't work with conservative corporations. Perhaps the most conservative client I have done work for is Xerox. The others include high tech, computer software, artificial intelligence, interactive video and design-related companies. Vitra (Switzerland), which makes Frank Gehry's corrugated furniture and Mario Bellini's furniture, is a current client. There are also a number of smaller corporations which import and sell furniture and lighting. Generally, about 50 percent of our work is corporate identity; another 40 percent is work with architects —including signage, interiors, fabrics. The other 10 percent is a mixed bag of things. For example, we recently did a graphic design proposal for the redevelopment of Hollywood Boulevard.

But I don't think of any of my work as experimental. I'm very interested in process, in layering ideas. There are all these different kinds of layers and agendas that make a good solution to a problem. It's a designer's job not only to get an image and put some type on it, but to imbue it with a spirit that draws people to it, that makes them want to be part of that idea.

Q: Is there a sense of risk-taking on the part of these corporations when commissioning your design?

A: Other designers perceive me as someone who is doing all of this crazy stuff and wonder how I sell it. It's not like that. There really is an audience for what I do. There are like-minded corporations who want the kinds of communication solutions that I'm able to provide. I'm not pulling the wool over their eyes. Even Xerox came to me because they were addressing a new market. The new employees of some major Fortune 500 companies are young people, so they have to communicate in their language.

I don't do any promotions, so the people who come to me have either seen or heard something about my work. There is a germ of the spirit in it that says, "That feels like what we're doing. We should get her to look at our problem." There is no deviousness, no heavy sales and no arm-twisting.

And the idea of taking risks is something that never comes up. People have been so stunned by "New Wave" ideas, especially older, established designers, who put a wet towel on this whole new movement. They seem to react to the form. Within this vocabulary, however, are solutions to problems which are contemporary, timely and appropriate.

Q: What kind of problems can your brand of design solve? And when compared to a more traditional approach, what message does it send?

A: A good example is *Workspirit*, an annual magazine in a tabloid newspaper format for Vitra. Communication with this company was done predominantly via the Macintosh computer, modem and fax machine. They approved the entire 36-page magazine, a quarter of a million dollar project, over the phone and fax. The typography, its texture and the layout expresses a global communications sensibility because the company is in Switzerland, its graphic designer is in Los Angeles, its photographer in Milan and its writer in Frankfurt.

For me, form is content. This piece possesses an eclectic, contemporary and progressive texture that is conveyed in part through the type that was used. In the publication, I was trying to represent a polarity—high-res furniture and very low-res type. On the one hand, we are showing furniture from Mario Bellini, yet we are using a typeface from a Macintosh computer.

At the same time, I want that typography to be beautiful. Although I am using inexpensive equipment, I can do that because of my background and training. We use a grid in the publication and have a nice selection of typography. Yet, I've mixed in some *Emigre* typefaces. This kind of design works because the client needs to convey the latest ergonometric kinds of research they've done, yet they also want to show prototypes for the future, which brings the furniture into the area of art.

Q: When you create a corporate identity logo for one of these companies, do you hand letter type or manipulate existing faces?

A: Even though we might use an existing face for a logo, we'll usually work with a lettering person and have her draw up some unique letters. In a sense, they're all unique when you combine different letters into a logo. You have to really redraw them because they all have a new relationship to each other. But as far as just general typography is concerned, we never modify letters or do any hand drawing because we are working primarily on the Mac.

Q: In this age of computers, do you find yourself advising in-house corporate design departments so they can produce work, for example, newsletters or brochures, themselves?

A: We do desktop publishing for clients. We're doing templates for different clients so they can do their own in-house design. Very often, when we template something, we usually do the first example of it and then let them go. But it is still too early to tell how it is working.

Q: How do you determine your client's needs? And once the design is in progress, do clients want to review your designs?

A: When I am retained, I spend an enor-

mous amount of time with the key people in the corporation and talk to them on a conceptual level. When I do strike out, if the content is what we've all agreed on, they never question me on details, like what is the typeface and how I am using it to express the content. We've come up with the concept collectively. I don't run off to Los Angeles, produce the design and shock them. The concept and the spirit of the design is a collective agreement, and the form comes from that.

Q: Is computer technology affecting the kind of typographic design being produced?

A: Typography is probably one of the toughest areas in which to do great work. Most of the work I see is good, but there is not a lot of great typography. Part of it is that because of the new tools, we're in a transition, especially with typography. People are just jumping onto equipment and imitating styles rather than coming up with authentic concepts. Some of the typographic expressions lack soulfulness. They are not perfectly matched in form and content.

Those who are producing authentic work, do so without even thinking. Really creative people are not in control of their destiny. They seem to do it until they get it right; it's in the blood, the genes, the fingertips. It's not something that can be taught. To a certain extent, I think you are either talented or you are not. With authenticity, however, you will usually find evidence of both beauty and problem-solving.

Q: How do you know when the form and content work together?

A: When it feels good in my heart. About 20-some odd years ago when I was first getting involved with symbolism and iconography, I read Carl Jung's, "Memories, Dreams and Reflections." Jung was telling a story of an encounter with an American Indian chief. In response to one of Jung's questions, the medicine man said, "White men make me nervous because you think with your minds." Carl Jung then asked, "What do you think with?" And the Indian chief responded, "We think with our

hearts." So be it.

Good communication comes through the heart, through loving your work and taking these kinds of challenges seriously. That means caring about every letterform that goes onto a design. That's what makes it a total success. When people respond

to my work, they may not even know why. They may find it interesting and somehow satisfying at an emotional level. I believe that the more love and care I put into the work, the better it is going to be for sales, but more importantly, the better it's going to be for our culture. ∎

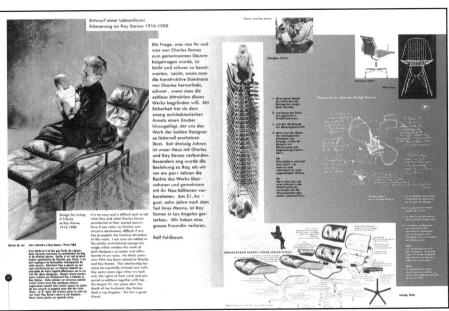

Geometric Balance The variety of geometrically balanced elements from this *Workspirit* spread makes it quite inviting to the reader. On some spreads, one language (in this case, German) takes a primary graphic position. Yet by speccing the second language in red and the third in black—although at smaller sizes—Greiman achieves balance. Again she unifies the pages through the use of background screens. At the sketch stage, designers scanned the black-and-white photos into position then rearranged the type elements.

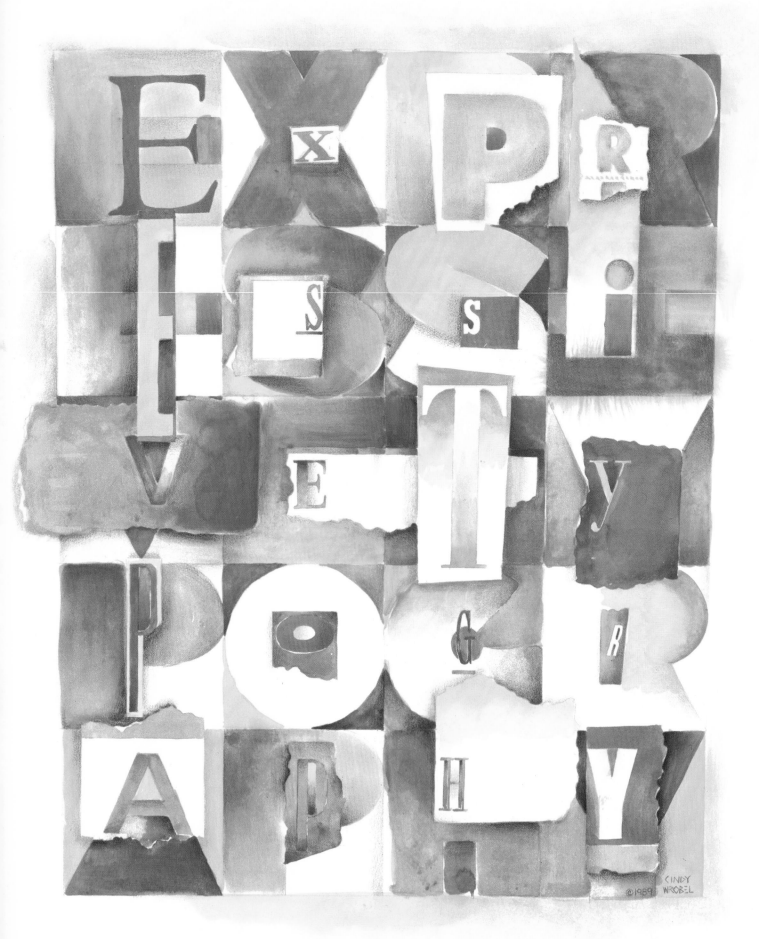

© 1989 CINDY WROBEL

TYPOGRAPHY AS INFORMATION, EXPRESSION, AND BUSINESS

This section, which has been developed to provide you with new ways of looking at and designing with type, opens with one of the most expressive and experimental users of type working today: London-based Neville Brody. The section ends with a look at some quirky typefaces of the past, and some practical tips on the business side of designing typefaces.

Designer, illustrator and freelancer Cindy Wrobel of St. Louis, Mo., used gouache, colored pencil and pastel on three-ply cold press board to create this vibrant piece. Although she says her work usually contains more flat colors, graphic shapes and clean lines, she has been trying to bring her fine art, graphic design and typography talents together of late. "It's a mesh of all my disciplines," she notes.

Neville Brody: Type As Expression

A candid interview about working methods with one of today's best-known pioneers of modern typography.

Look. Think. Question. These are just a few of the simple yet passionate words of advice offered by Neville Brody in a recent interview with *Step-By-Step Graphics*.

A shy and reserved fellow, he has achieved a kind of cult-figure status in design. Case in point: The recent AIGA National Conference in San Antonio, Texas. It was standing room only throughout a presentation he made with fellow type designers Sumner Stone of Adobe and Erik Spiekermann of MetaDesign, West Germany, both of whom are also popular advocates and practitioners of quality typography and type design.

But at the young age of 32, this kind of recognition makes Brody somewhat uneasy. "There seems to be this mystique about it all, but all my work is about, really, is trying to demystify design. What I think my work tries to show is that anyone can do it." Brody has such an aversion to analyzing his work, in fact, that he prefers not to show it when he is asked to speak at designer gatherings. "I don't like to have my work critiqued, because the work itself is a discussion."

But few would argue that his hand-lettered alphabets and unconventional layouts for magazines like *The Face* and record album covers for rock bands have, in many ways, helped to change the way we think about typography in design.

Brody's formal training includes a Fine Art foundation course at Hornsey College of Art, now called Middlesex Polytechnic. A year later, in 1976, he went on to get a three-year B.A. in graphics at the London College of Printing. And, today, he is the philosophical leader of a unique kind of design studio.

"We have a total of five designers including myself, a business manager and an administrative person, but we've decided not to form a company. I'm a sole trader [proprietor], and everyone who works for me is a sole trader. All the work comes in through me, and we work pretty much as a team. Although we are not the best paid designers—and we could be if we wanted to be—we took a decision to work on jobs creatively, which of course is sometimes not as cost effective. That's OK, though, because the ideas are more

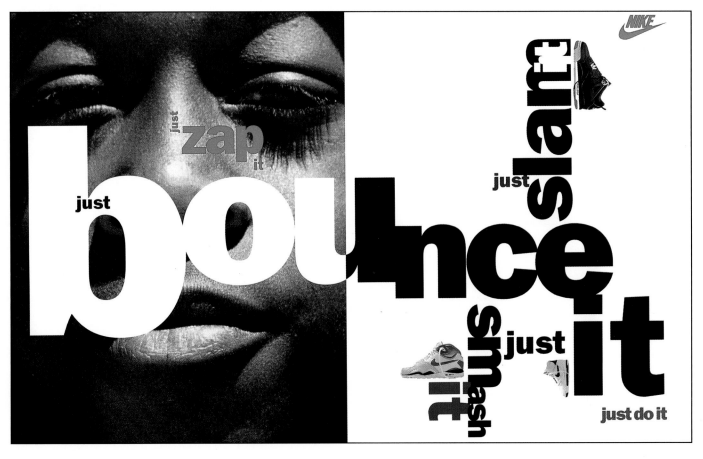

important." Brody also reports that the group made a decision at the begining of the year not to grow beyond the manageable number of seven people. "Every day we can all sit down with each other and discuss things. But there is this message in the design field today that says you have to grow to expand…"

The group does not need to expand through sheer numbers; they are expanding through fresh and new ideas. And in the following interview you will learn more about how those ideas are nurtured and brought to life.

Q: Some call it learning how to put the "dirt" back into our type to make it expressive. But whatever one chooses to call it, it means giving ourselves up to experimentation. In a practical sense, how do we begin to do that?

A: Look at things, and keep looking and thinking and questioning. The point is to look at something and ask yourself, "Why is this being designed this way?" That is extremely critical because if you ask yourself that, then you can see what the designers had in mind—and not all of them are good reasons. In a way, type design always comes out of a society's needs, and a lot of type we use now has come out of a different era, needs of a different society, a different time. Baskerville as a typeface represents little of the way in which we communicate today. And people still use it, or they use it to give the impression of something that has been around a long time. It's solid, secure.

Q: These kinds of faces are so classic, some people often call them invisible.

A: But they aren't invisible. Let's say a French person comes up to you and starts talking. The first thing you notice is that he's speaking French—not the words that he's said. Just set a piece of text, first in Baskerville, then in several different faces and observe exactly how the message changes. The choice of typeface is critical to the emotional response of the words. A piece of text set in Baskerville will read entirely different in Helvetica. Or in

script, completely different again. Designers are always making choices based on how people respond to things. This is what I mean by learning to look around you all the time.

Q: In a practical sense, though, how do we translate experimental approaches into our everyday type treatments for clients?

A: Don't let the type control you. Don't automatically go to Garamond to do a magazine. Think about it. Look at the Garamond. Maybe you need to challenge

the notion that it is an ideal face in all cases. You have to really attack type conventions, because most design today is done simply by default.

Q: Does this mean designers should abandon traditional conventions of readability as well?

A: Well, it's true that information generally is received faster if it's set in sans serif, because there are no serifs to get in the way of the message. But that is not necessarily a good or bad thing. Most books are set in serifs and there is a practical

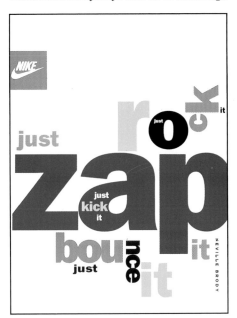

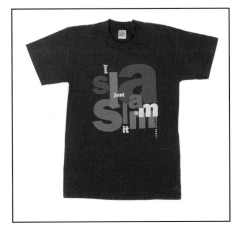

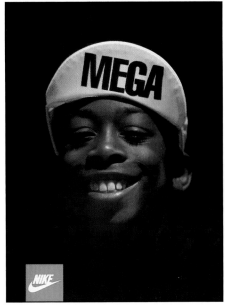

Type Can Be Fun Neville Brody designed the type for a recent NIKE kids campaign in which ads (opposite page), posters, T-shirts and hats, among other items, were created. Brody used Franklin Gothic as the primary typeface, and with the help of Aldus FreeHand he manipulated letterforms—such as reversing some letters out of other letters—on the Macintosh. His inspiration for this expressive use of type: "Definitely the idea of energy, fun and life. It came out of an intuitive response." (A.D.: Susan Hoffman, Wieden & Kennedy, Portland, Ore.)

125

HAUS DER KULTUREN DER WELT

ABC→XYZ

Organic Corporate I.D. "The organization is an organism, and communication is an organic thing," says Neville Brody of corporate identity design. And it is in this spirit that he approached the "Haus der Kulturen der Welt" project, a large West German cultural museum. He did not create a logo, but rather an original, hand-drawn alphabet, some unique shapes, a color palette and a selection of paper stock. "We gave them a language which we can develop constantly." (For the complete how-to on this project, look for the whole story in an upcoming issue of *Step-By-Step Graphics*.) (©Haus der Kulturen der Welt. Design by Neville Brody and Cornel Windlin.)

reason for that; serifs aid readability at small sizes. But they get in the way in big sizes; you don't need a serif at large display sizes.

Q: Many of your type treatments are hand drawn. Could you explain to us how you work?

A: It varies. Quite often we won't even go to the Macintosh, even though we all have terminals next to our drawing boards. Instead, we'll just use compass and ruler on a drawing pad, photocopy it and fill it in. Then we cut and paste by hand. We still find that this is sometimes a quicker way than the Mac. And, quite personally, I like to work by hand because I don't like working with bezier curves. They are too...I just don't know how to describe them. There just seems to be something artificial about drawing with bezier curves. All this technology to make something so uncomfortable to work with. I guess I agree with Erik Spiekermann and the ABCers [anti-bezier club]. I simply like rubbing things out and moving things around.

But overall, we use every means possible. For example, we often use Aldus Free-Hand on the Macintosh because it can

align elements perfectly. For speed it can't be better, but sometimes we have to come off the computer because it's just a tool like any other tool.

Q: How much of your design and production work overall is done on the Mac?

A: We use the Mac for 90 percent of our production because it gives us control, from editing to typesetting to page planning to final film output. It's really the first time we've had that control. What the computer does is give more power and speed back to the small designer, so that we have the same weapons the big design studios have.

Q: On a frivolous note, would you mind indulging our curiosity for a moment and sharing some of your likes and dislikes where typefaces are concerned?

A: I really love imperfect type. It lends an element of the human to a design. Perfect type is cold—it's Univers. I hate Univers and that's one face I'll never use. I also hate Helvetica, which is why I use it.

Q: You hate Helvetica. And yet you still use it?

A: My feeling with Helvetica is that it is there. So we try to attack Helvetica, to force it to bend, to be expressive, which is exciting. For example, we recently did the Nike Kids campaign entirely in Franklin Gothic. What we were trying to do is use sans serif type in extremely expressive ways, with a lot of size changes. The whole product was really exciting.

Q: So are you saying these blander sans serifs, as unemotional as they may be, are inherently more attackable?

A: In a way they serve a role, that they are devoid of human contact. The other role is to challenge us to make these fonts emotional and human. But I love type with personality, passion or emotion.

Q: Of course, many designers would argue that they don't have the luxury of taking risks because they don't have the kinds of progressive clients you do—that their conservative clients wouldn't accept

Arena Covers The hand-drawn logo for *Arena*, a British men's magazine launched in 1986 by the publishers of *The Face,* was created by Brody to be intentionally European in appearance. He extended elements of the letterforms for increased recognition. Photos were often specified full bleed, so that the image was the focal point of the cover designs. (Covers shown here are: left, Winter '87-'88; and right, Spring '88.)

experimental approaches. How do you feel about that attitude?

A: Well, if you leave a client alone, that client won't know what you're doing for them. You must go and talk to the client first and discuss communication and the different ways they can communicate their identities or products. There seems to be this formula today of agencies going in and saying, "OK. You need a new logo. Here are several to choose from." Then the clients pick one they feel comfortable with that many times is far removed from their own existence and the public's existence.

Q: Other more cynical typophiles might extend this argument by saying that part

of the reason why there is so little experimentation in typography today is that most graphic designers simply don't know how to work with it very well. Do you believe this? Is this why few designers have the confidence to be playful or take risks?

A: I disagree with the point that people who work with type don't know enough about it. I didn't know anything about type and my response to type was very much one of using all that I knew to find a way of expressing ideas. For example, I rejected my training in type completely because I had this feeling that if I learned the rules and traditions too much, I would not be free to use type expressively. Learning about type is more or less learning what

you are not supposed to do with type. You know, language is actually freedom— so why not be free with the way you present those words? In school, for example, most people would say, "You're not supposed to use nine point here," and I would answer "But it feels right." What I'm really saying here is that you have to get engaged in an emotional way with type design.

The key really is to trust your own instincts. You just have to believe in yourself. ∎

—Nancy Aldrich-Ruenzel

Creating Typographic Pathways

A six-step method for making printed information more accessible.

By Rob Carter

Most graphic designers enjoy an encouraging pat on the back. Hearing a supportive phrase like, "That is a beautiful piece you designed" helps them feel they are on the right track. It is also an indication that designers, in general, consider themselves to be visual people; they like to make things look good. But in making things look good, one of the essential purposes of graphic design—making information more accessible—is often overlooked. Informative design does not have to be dull and lifeless. It can communicate effectively and also reflect the individuality of a designer or a specific style. Unfortunately, in much current graphic design, style eclipses content and reduces communication to nothing more than visual babbling. We may see this babbling, for example, in some forms of deconstructivism where designers present all the typographical tricks that can be performed by a Macintosh computer. The concern here is with what things look like, not with what they say.

According to some recent statistics, the amount of information in the world doubles every five years. This staggering figure is a clear indication that there is a need for more graphic designers than ever before to responsibly and effectively organize data into usable information.

THE FOLLY OF FORMULAS
When designing information, it is important to avoid being trapped by formulas that obediently solve all design problems

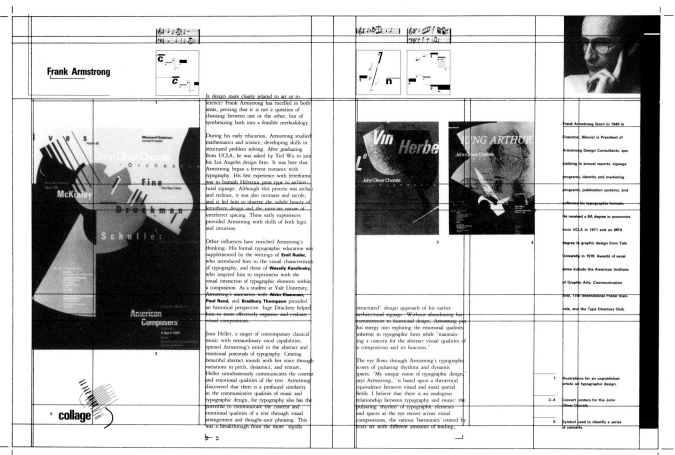

in the same way. This is a dangerous practice because all problems are different and must be considered on their own terms.

For this reason, it is best to avoid the practice of using generic one-, two-, three-, and four-column Swiss grids. These are arbitrary structures that seldom do justice to information—even though they bring visual order to a design. Another danger lies in the canned design formats provided for the desktop publishing market. These are fine for those playing make-believe designer in a corporate office, but they should be avoided at all cost by serious typographic communicators.

A more effective way of making infor-mation accessible may be found in the de-sign of typographic pathways, a process far removed from paint-by-number formulas.

TYPOGRAPHIC PATHWAYS

What are typographic pathways? Before I answer this, it is important to clarify the independent roles of information and ty-pography. Just remember that informa-tion is invisible data that has been organ-ized, and that typography is a tool used to make information visible.

Typographic pathways, then, are the visible links between different parts of in-formation. While this discussion is gear-ed specifically to designing typographic pathways for print, these guidelines can be adapted to video, film, computer gra-phics, or multi-media environments. The following is a list of suggested steps for creating typographic pathways. Remem-ber that it is not a formula. Its purpose is to provide you with an approach to typo-graphic problem-solving that you can adapt to your own needs. Even if you are comfortable with your current methods, you might find something new and of value that can be added to your typogra-phic repertoire. Remember that the de-sign process is never as clear cut as sim-ply following a sequence of steps. So as you proceed, feel free to combine or elim-

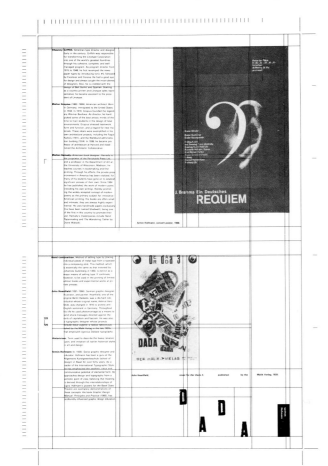

Figure 1 Spatial zones both separate and connect different parts of information and are based upon content. For example, this spatial zone system was used in the design of the book *American Typography Today*. (Book design by Rob Carter and Ben Day.) While in some ways it may look like a typical grid, it was designed for a specific use and is multi-faceted. It works either horizontally (far left) or vertically (near left) and was designed to accommodate a variety of information and design devices. In the first part of the book (profiles of top designers with samples of rep-resentative work), information is organized horizontally. The black bar identifies a new entry. Photo, biographical information and captions are always contained on the far right side. Text and visual organization can vary. Part 2 of the book is organized vertically, yet it works with the same zone system. While this spread shows one col-umn of text, other spreads have as many as three text columns with one column of visuals.

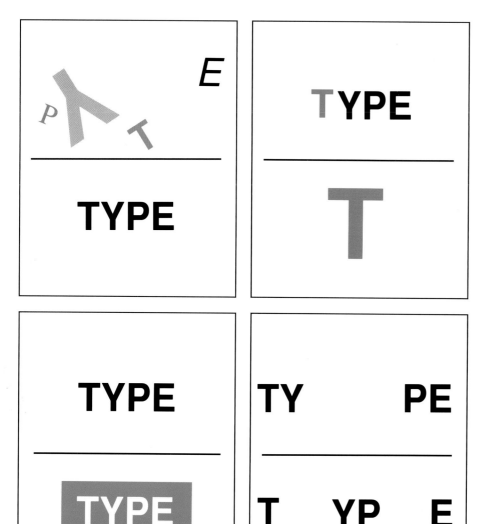

Figure 2 Typographical pathways are created by establishing relationships between typographic forms. This is done by applying the general visual principles of repetition and contrast to the following, more specific principles, which are defined in these illustrations. The top represents information as it is collected; the bottom, how to organize it into a visual pathway.

Correspondence: Forms sharing the same shape, scale, proportion, color, value, alignment or texture are organized into a unit. Here, for example, we see that different weights, sizes, styles and colors are organized into a uniform whole that makes identification easier (top left).

Amplification: Corresponding forms can be exaggerated through contrasting shape, scale, proportion, color, value or texture. In this case, the initial letter is removed from its context and enlarged. In practical terms, for example, the title of a chapter in a book can be repeated at a different size (top right).

Elaboration: Forms can be made more complex. In this case, the letters are reversed out of a blue screen. This device connects information, and at the same time separates it. This principle may be used to repeat information used in a different context (bottom left).

Proximity: The distance between visual forms can be regrouped. This changes the way in which the forms are read, and new associations can be made (bottom right).

inate steps to meet your objectives.

A SUGGESTED METHOD
1) Define the objectives of the communication
Before you can adequately solve a typographic problem, you must define the specific purpose of the communication. Who is the audience? What do you want them to get out of the communication? Are there any special constraints that must be considered? Depending upon the situation, the answers to these questions may be dictated to you by the client or they may be left entirely to you. The objectives should not be so tightly stated that they cannot be changed. Unless the designer is also the writer (with desktop publishing this is becoming more common), the problem at hand is usually to make a typographic interpretation of an existing manuscript. Never assume that the organization of the information and the writing—as it is given to you—is as clear as it should be. Make suggestions. Unless you are working with an egomaniac, your input as a designer will be greatly valued. Be a problem seeker and a problem solver.

2) Identify the parts of the information Information in any form can be broken down into smaller parts. After reading and analyzing the manuscript, you should identify—in detail—every unit of information that functions differently from all others. Consider headlines, various levels of subheads, running heads, quoted material, footnotes, tabular information, captions, sidebars, marginalia, and so on. The list can go on indefinitely. Also look for less obvious parts such as sections within text that function differently from all others. To keep track of the parts, you may want to number them or color code them on the manuscript.

This step is like putting all the cards on the table. At a glance you will be able to see everything that you have to work with. This in turn will prepare you for the critical task of establishing relationships between the various parts.

3) Design a spatial zone system After you have identified the parts of the information, you are ready to design a spatial zone system. This system is created by assigning the parts of information, depending upon their content relationships to one another, to functional areas of space. It can be compared to a map with boundary lines that separate one area from another. A

Figure 3 These scribbles are actually notational studies that reveal relationships between parts of information within the book *American Typography Today*. As a kind of visual brainstorming, they freely explore many typographical possibilities. For example, the first drawing (A) was the kind of thinking that helped to develop the book's Timeline spread. The second drawing (B) helped the designers determine how to typographically distinguish the information in the front (horizontal format with serif type, Garamond) and back of the book (vertical format with sans serif type, Univers). (Refer to Figure 1.) The third drawing (C) was used to help design the division pages between each section. (Typographic notations by Ben Day.)

Figure 4 In the next step, full-scale roughs are designed to test the system and work out details. In this stage, notations are translated into typographic forms. Once completed, the entire publication is dummied. Dummying the pages ensures a balance of unity and diversity from section to section and page to page. These guideposts allow designers to see how the spatial zone system works. Even at this stage, there is flexibility within the design. Note the mounds of transparent tape. With a page composition computer program, the production phase is accomplished automatically during the page design.

Figure 5 The cover is where readers are prepared to enter the typographical pathways of the book. It is here that the spatial zone system is first revealed as an underlying structure. Key typographical elements are introduced. The vertical black bar evolves into a device that establishes section beginnings; the space described by the three gray title bars evolve into the portrait flags of the featured designers. The pattern used on the flap is again repeated in a different way at the beginning of each section.

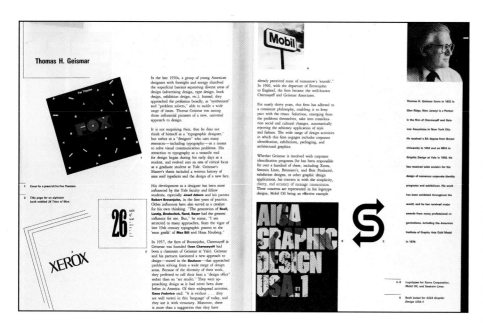

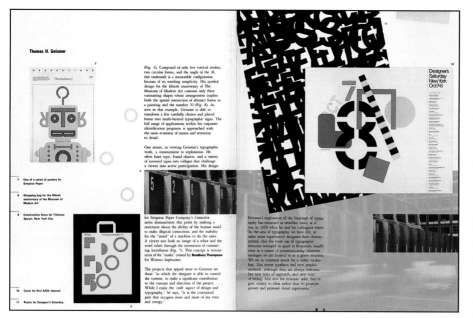

Figure 6 Many of the visual links established in the typographic pathway can be identified in these spreads. For example, the primary text, biography and captions in the 24 sections of Part 1 maintain their functional autonomy through zoned placement (always on the right side) and typographical contrast (use of Univers Bold). As the reader moves from section to section, there is no question about what each of these parts is supposed to do. Note also how the right-angled rule enclosing the headline (designer's name) corresponds to the flagged photograph of the designer, thus linking the two elements. The subhead on the second spread corresponds to the headline on the first spread in typeface and position, but the reader knows that it is a subhead because the rule is dropped and the typeface is smaller in size.

spatial zone system is a multi-dimensional system with parts relating to each other both on the same plane and on several different planes, depending upon the complexity of the information. (See Figure 1.)

Unlike the typical typographic grid, a spatial zone system is shaped by the nature of the information. It is never a predetermined structure with "x" number of columns. It is also not a stainless steel monolith; it can evolve and change throughout the design process.

If for any reason the format (size and proportion) of the communication is predetermined, the zone system will fit into this format. Otherwise, the format can evolve as the zone system evolves.

A spatial zone system will provide you with a rough idea about the orientation of type on the page. Typographic conventions such as the traditional horizontal orientation of type can be ignored for a more dynamic orientation. Do not be limited by what you think is expected.

Begin by making thumbnail sketches of several possibilities. When you feel comfortable with an approach, render it full scale. Remember that you will probably change or add something to the system later on as you determine specific ways of connecting the parts of information.

4) Create studies to visually link the parts Typographic pathways are created by establishing relationships between typographic forms. These relationships are established by applying the general visual principles of repetition and contrast to the more specific principles of correspondence, amplification, elaboration, proximity and alignment. (See Figure 2.)

The idea behind making notational studies is to discover as many information links as possible. It is a form of visual brainstorming. At first your efforts may seem scattered and random, but eventually a total scheme will evolve. These notational studies can be made through various means: by creating thumbnail sketches on tracing paper (or on a computer); by cutting paper shapes that represent typographical elements and taping them down; by working full scale with a computer program such as Pagemaker; or by using any combination of these. Regardless of your method, you will use the spatial zone system as the underlying structure. (See Figure 3.)

5) Design full-scale roughs Design full-scale

roughs to test the system and to work out the details. If the information is as complex as a book, design key sections so that you know for sure that the sections relate to each other. Do not be afraid to make changes as you go along.

This is the phase where you also translate the notations into equivalent typographic forms. Hopefully, you will have already been thinking about the use of specific typefaces and of legibility.

Designers could never again survive without copy machines. In this stage of the design process, you can copy type specimens, bars and rules, and other special support elements that you have generated and then tape them into position.

6) Dummy the entire publication You will probably want to dummy the entire publication before proceeding to the production phase. This also can be accomplished by taping down copied elements. Of course, if you are working with a page-composition computer program, the production phase is accomplished automatically during the page-by-page design of the publication. (See Figures 4 through 7.)

DESIGN IS AN ATTITUDE

According to the renowned designer László Moholy-Nagy, "Designing is not a profession but an attitude." Indeed, as the lens through which we see the world, attitude shapes our approach to design. An appropriate attitude leads to a more responsible, information-oriented approach to design. It can help us approach style with prudence and it can aid us in becoming information literate.

Information literacy is not the measure of how much we know. Rather, it is the ability to take existing information, sort out the parts, put them into a hat, shake them, pour them out, and in the randomness discover new relationships and new information. ∎

Rob Carter teaches typography and graphic design, and conducts research in computer-assisted design at Virginia Commonwealth University. He is the author of "American Typography Today" (Van Nostrand Reinhold, 1989) and is coauthor (with Ben Day and Philip Meggs) of "Typographic Design: Form and Communication" (Van Nostrand Reinhold, 1985).

Association Typographique Internationale (ATypI). Organization established in 1957 with the goal of working towards an international policy that protects type designers from the piracy and adaptation of their work by others. The first president of ATypI was Charles Peignot of Paris, and later John Dreyfus, typographical advisor to Monotype. In 1973 at the Vienna Congress on Industrial Property, an agreement was reached when ten countries signed an "Arrangement for the Protection of Typefaces." Ratification of this agreement will take place when the internal laws of these countries are altered to reflect the content of the agreement. Address: P. O. Box 611, CH4142, Muenchen, Stein, Switzerland.

Theo Ballmer (1902–1965). Swiss graphic designer. Ballmer's posters bridged the de Stijl Movement and the International Typographic Style. He used mathematical grids to construct and organize geometrical letterforms similar to those used by Theo van Doesburg in 1919. Ballmer, a former student at the Bauhaus, taught design at the Allgemeine Kunstgewerbeschule in Basel for over thirty years.

Roland Barthes (1915–1980). French critic, writer, and semiotician (analyzer of signs). Barthes' writings about the nature of signs have greatly influenced the contemporary French school of thought known as structuralism (the investigation of sign systems). His writings reveal that all systems—whether sociological, cultural, or literary—are composed of signs functioning as language. His writings include *Mythologies*, 1957; *Elements of Semiology*, 1964; and *Writing Degree Zero*, 1968.

Saul Bass (b. 1921). American graphic designer and filmmaker. Bass is able to zero in on design problems, reducing images to simple but powerful pictographic icons. In *Man with a Golden Arm*, 1955, he was first to create a comprehensive identity program for a major motion picture, unifying both printed matter and film titles. He has created many ubiquitous corporate symbols that are fused into America's consciousness—the Bell System, The United Way, and United Airlines logos are among them.

Bauhaus. Significant German design school founded in 1919 by the architect Walter Gropius. The initial aims of the school sought unification of all creative arts under the umbrella of architecture, and the restoration of craft as a fundamental. In 1923, the goals of the school shifted slightly to include a new thesis: "Art and Technology: A New Unity." This motto represented the lofty purpose of the Bauhaus before it was closed by the Nazis in 1933.

Herbert Bayer (1900–1985). American graphic designer, painter, and educator. Born in Austria, immigrated to the United States in 1938. Bayer was a student and teacher at the Bauhaus, responsible for establishing the Bauhaus style in typography. He consolidated the ideas of Dada, de Stijl, and Moholy-Nagy into a logical, but radical, approach to typography. He advocated the use of sans serif type and, after 1927, the elimination of capital letters. He also used a variety of type sizes and weights to establish hierarchy, tinted boxes to emphasize information, and type positioned at right angles. In 1925 Bayer invented his universal alphabet, an experiment that reduced the alphabet to a single "case" of geometric letterforms.

Lester Beall (1903–1969). American graphic designer. Beall was the earliest American graphic designer to infuse ideas of the Modern Movement into his work. Called the American proponent of the new typography, Beall used an amazing variety of form—old engravings, wood type, photographs, and elementary shapes—to achieve functional design with visual contrast and rhythmic patterns. He produced landmark designs for the Rural Electrification Administration, *Scope*, and *International Paper*.

Peter Behrens (1868–1940). German architect and graphic designer. Behrens, a Jugendstil designer, is credited as the first to abandon the decorativeness of the nineteenth century for a simple, geometric, and functional approach to design. His work for the Allgemeine Elektricitats-Gesellschaft (AEG) became a guidepost for modern graphic design and typography. Through his former assistant, Walter Gropius, Behrens' influence was clearly felt at the Bauhaus.

Edward Benguiat (b. 1927). American type designer and lettering artist. Benguiat is one of the most prolific American type designers of the twentieth century. As well as creating many original typeface designs, Benguiat has revived many earlier forms. ITC Souvenir, originally designed by Morris Fuller Benton in 1914 is one example. He finds inspiration in everything from period type specimens to historical architectural lettering. To his credit are ITC Tiffany, ITC Korinna, ITC Benguiat, ITC Benguiat Gothic, and many more. Benguiat currently works with Plinc (Photo-Lettering Inc.) in New York City as a type designer and editor of the company's promotional publication, *PLINC*.

Morris Fuller Benton (1872–1948). American type designer and engineer. Benton has been called the unknown father of American typeface design. He created many typefaces that formed the basis of American typography. It was quite natural that he became involved in the type industry, for his father, Linn Boyd Benton, was one of the founding members of the American Type Founders and the inventor of the pantographic punchcutting machine. Many of Morris Fuller Benton's original and revival type designs are currently in use today as they were when he first created them for American Type Founders in the first two decades of the century. A small sampling of his accomplishments includes Century Schoolbook, Cheltenham, News Gothic, Franklin Gothic, Stymie, and Alternate Gothic. He also drew many excellent versions of classic types, including Garamond, Baskerville, Bulmer, Cloister, and Bodoni.

Henryk Berlewi (1894–1967). Polish graphic designer. Berlewi developed *Mechano-faktura*, a typographic style that banished any illusion of three-dimensional space in a composition. He produced mechanical constructions using simple geometric forms that reflected mechanized society; and in 1924, he founded Reklama Mechano, an advertising firm that adhered to the principles of mechanical space.

Lucian Bernhard (1883–1972). American graphic designer. Born in Germany, immigrated to the United States in 1923. Bernhard was a self-trained graphic designer and pioneer of the modern pictorial poster. He developed a unique approach to the advertising poster by reducing it to a simple, brilliantly colored, two-part composition: a powerful image of the product composed of flat shapes and simple lettering carrying the product name. Bernhard also designed typefaces for the American Type Founders Company: Bernhard Fashion, Tango, Bernhard Gothic, and Lilith among them.

Berthold. For almost 130 years, Berthold has enjoyed the reputation of being the world's leader in all aspects of typographic quality. The company's type program comprises over 2,000 text faces with about 100 new faces added each year. The program is based upon adaptations of classical printing types that have been thoroughly researched, the Berthold Exclusiv program comprising the original designs of renowned type designers, and licensed designs from other sources such as the International Typeface Corporation (ITC). The collection is shown in a two-volume 1,500-page *Berthold Types* catalog. Address: 2 Pennsylvania Plaza, New York, NY 10121.

Charles Bigelow (b. 1945). American type and graphic designer and educator. Bigelow is a contemporary pioneer of type design who combines his knowledge of theory, history, and technology to create typefaces that meet the requirements of a new age. In collaboration with Kris Holmes he designed Lucida, the first typeface created specifically for desktop applications. For over twenty years he has helped to preserve native American languages by generating a written form of the Clackamas dialect of Chinook for the printed page. Syntax phonetic, a typeface intended specifically for Native American languages, was designed by Hans Ed. Meier, Bigelow, and Holmes.

Lester Beall, cover for *PM* magazine, 1937.

Morris Fuller Benton, Franklin Gothic, 1904.

Herbert Bayer, twenty-million mark note, 1925.

Figure 7 Although Part 2 of the book is oriented vertically—readers must turn the book on its side—instead of horizontally, typographic pathways link the two parts in form and content. For example, items called out in bold Univers type in the Garamond text of Part 1 highlight typographical influences of the featured designers. If readers wish to obtain additional information about these influences, they can flip to Part 2 (Typographic Resources) where further information is offered in an alphabetized, indexed glossary with corresponding Univers headings.

De-constructing Typography

The contemporary conflict in typographic design: Should designers seek maximum readability or maximum impact?

By Philip B. Meggs

"The Best Typography Never Gets Noticed*" proclaimed a large, elegant headline reversed from a black page in an advertising and design publication nearly three decades ago. The asterisk directed readers to a small note at the bottom of the page: "Because everyone is too busy reading the words." Readers were advised to contact Herb Lubalin, creative director of Sudler and Hennessey and creator of the ad, for some of this good typography that no one would notice because its visual style was subordinate to its verbal message. The clever copy line probably titillated clients who relished the idea of design taking a backseat to their sales pitch.

Lubalin built his career on ignoring his own advice, for he often sacrificed legibility for impact in his densely packed typographic designs. Like most graphic designers, he intuitively understood the need to juggle and sometimes sacrifice two competing typographic properties: legibility and expression. Legibility—the reader's ease in deciphering the typographic signs—results from type size and x-height size, line length, adequate leading, and clear differences in the design of characters in the font. Expression— the use of formal artistic means to convey feeling or ambience—is created by unique typographic forms and spatial arrangements. Clearly, either legibility or expression is often sacrificed for the sake of the other.

The typographic format for *Smithsonian* magazine, created by Bradbury Thompson in 1967 and still in use, is a paradigm of typographic clarity and legibility. (Refer to Figure 2.) Baskerville type is used with systematic attention to detail and care in the treatment of captions, subheads, authors' and photographers' credit, and so on. Readers find the information accessible and hardly notice the typography as it does its job quietly and efficiently. Critics of a programmatic approach to typography argue that an overall sameness results, with subjects as diverse as major Greek archaeological finds and the psychology of nightmares treated identically. Advocates of classical typography define typographic design as a service profession, presenting but not interfering with the writer's words.

CONSTRUCTION

Even though the modern design movement rejected typefaces with serifs and the traditions of fine book typography dating back to the Renaissance, it still believed the designer's principle mission was achieving typographic clarity and legibility. At the German Bauhaus school during the 1920s, a rational and functional approach to modern design evolved. The poster designed by Herbert Bayer for a guest lecturer at the Bauhaus in 1926 demonstrates their approach. (Refer to Figure 1.) Bayer carefully analyzed the message and built a clear visual hierarchy of information: 1) Professor Hans Poelzig; 2.) Architecture; 3) Slide lecture. The information on the right provides the date and location in an ordered sequence. The red circle containing the German word "vortrag" (lecture) provides a strong focal point. No element is included that does not contribute to the effectiveness of the communication, and every decision made by the designer is based on a desire for functional communication.

For all the marked differences between modern and classical design, both schools of thought agree that a typographer constructs clear and ordered arrangements of information on the page. After World War II, the Swiss school pushed order and construction to the ultimate degree. In his work and writing about design,

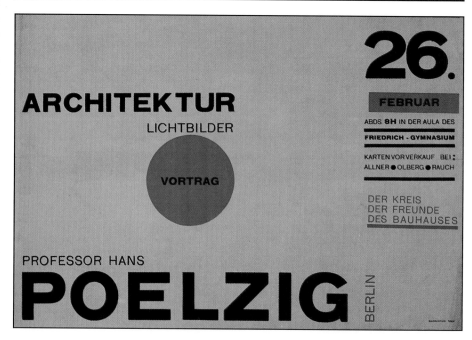

Josef Müller-Brockmann believed that the designer should only use two sizes of type in a design (one for display and one for text), organize information on a geometric grid, and exclude all decorative or textural elements unessential to the communication. (Refer to Figure 3.) Today this emphasis upon construction and clarity is being assaulted by an approach to design that scrambles, overlaps and layers words and pictures. Texture and dynamic relationships are emphasized, often at the expense of legibility.

DECONSTRUCTION

Deconstruction is a term being used a lot lately to describe these new tendencies in typographic design. This term should be in the dictionary right between *deconsecration* and *decontaminate*, but it is not there yet. The prefix *de-* means "the reverse of," and *construction* means "the act of putting parts together to make an integrated whole;" therefore, *deconstruction* must mean taking the integrated whole apart, or destroying the underlying order that holds a graphic design together.

EMIGRE A major initiator of this approach is the San Francisco magazine *Emigre*, designed and published by Rudy Vanderlans. Some of the devices associated with deconstructivist typography are: sizes and styles are mixed; type is layered and overlapped, even to the point of obscurity; computer-generated type is stretched, condensed, or expanded and sometimes left in its jagged bitmapped state. Other deconstructivist devices include using extreme letter- or linespacing, running type in different directions on the page, interlocking or overlapping text columns, and setting text columns in random or stair-step shapes. A strong tactile element is introduced by increasing typography's textural properties.

In *Emigre 8*, a special issue on alienation, a sequence of 14 full-page photographs fill the large 11 x 17-inch pages. (See Figure 4.) Several texts—poems, narratives and news accounts—begin and end as the reader progresses through the series. At the end, type and image are obscured and fade to black. Some of the typography is totally obliterated on the final pages. As

demonstrated by the cover for *Emigre 9*, typographic texture is often used with other textures such as digitized images, photographs and graphic patterns. (See Figure 5.) Macintosh typefaces for *Emigre* are designed by Zuzana Licko, including some digital faces for low resolution printers. Disks carrying fonts used in *Emigre* are marketed through the publication.

The design department of Cranbrook Academy of Art has been exploring deconstruction for several years and collaborated with Vanderlans on a special issue of *Emigre* on Holland which was designed by Cranbrook students and several Dutch designers. A presentation of the Dutch-style tourist attractions in Holland, Mich., designed by Lisa Anderson, layers and overlaps type, vignetted photographs and graphics. (See Figure 6.) The text is surprisingly easy to read, indicating that typography can take quite a bit of abuse and still function as an information carrier. **MAINSTREAM BOUND** Although deconstructivist typography is mainly found in avant garde publications such as *Emigre* and design school experiments, it is working

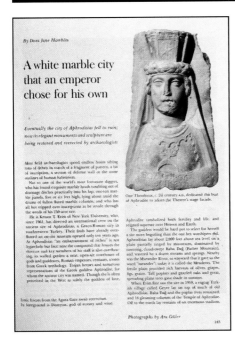

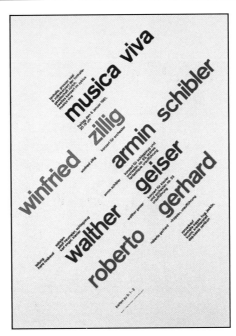

Figure 1 In this functional poster (this page, left) Herbert Bayer builds a clear hierarchy of information: 1) The professor's name, 2) Subject (architecture), 3) Purpose (lecture, "Vortrag"). The date and location is provided on the right.

Figure 2 Bradbury Thompson's format for *Smithsonian* magazine (opposite page) is a paradigm of typographic clarity and legibility. Baskerville type, used with systematic attention to detail, does its job quietly and efficiently. Until last year, the type was set with hot metal machines.

Figure 3 Josef Müller-Brockmann believed that the designer should use only two sizes of type in a design (one for display, the other for text), organize information on a geometrical grid and exclude decorative or textural elements (this page, right).

its way into the mainstream, with tamer versions cropping up on MTV titles and record ads in such magazines as *Spin* and *Rolling Stone*. English designer Neville Brody has been working with many of the deconstructivist ideas for almost a decade, and early 20th-century experimental typography within the Futurism and Dada movements made a conscious assault on the orderly syntax of typography, deconstructing the horizontal alignment and harmony of the printed page. Linear and orderly typography yields to a more chaotic and dynamic organization of space, as seen in Brody's advertisement for Torchsong with randomly placed letters forming a vigorous structure. (See Figure 7.) Over four issues of *The Face* magazine, Brody progressively degenerated the logo for the "Style" section. (See Figure 8.)

Typographic purists who immediately condemn deconstructivist typography shouldn't slam their minds closed too fast, because powerful forces are at work in high-tech culture. In addition to its inherent vitality, much deconstructivist typography is surprisingly easy to read. The phonetic alphabet permits great liberties, and a younger generation—who comprehended animated cartoons on television before they learned to talk, learned math from "The Electric Company" television program, and respond passionately to the graphic expressionism of music videos— love tactile and kinetic typography. In our over-communicated society, the power and meaning of words have been undermined. By reinventing the form and presentation of the printed word, deconstructivism is revitalizing print media.

Although some of the underlying concepts behind deconstructivist typography have been around since the Futurist and

Dada poets launched their assault upon tradition, the term is new, and it has an interesting history. "Deconstructivism" was coined by French philosopher Jacques Derrida and defines a controversial approach to literary criticism that emerged in the 1970s. Deconstructivist critics see the printed page as black marks on white paper endowed with traces of meaning, and

set out to decipher the author's meaning by carefully dismantling and analyzing the text. The structure of the literature is deconstructed or taken apart as a way to understand the work. (This is a simplistic definition, for deconstructivism also embraces an effort to "decenter" Western culture from absolute truths that do not hold up to modern knowledge, as well as

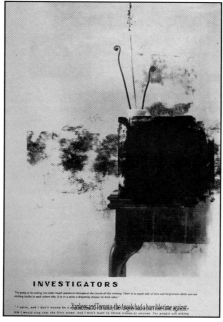

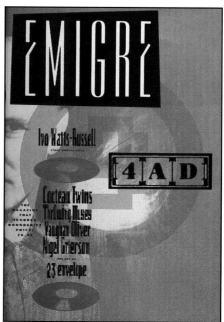

Figure 4 In *Emigre 8* (top left and right), a special issue on alienation, a sequence of 14 full-page photographs fill the large 11 x 17-inch pages. Several texts begin and end as the reader progresses through the series. At the end, type and image are obscured and fade into black. Some typography is totally obliterated on the final pages.

Figure 5 In *Emigre 9* (bottom left and right), typographic texture is often used with other textures such as digitized images, photographs and graphic patterns. Macintosh typefaces for the publication are designed by Zuzana Licko.

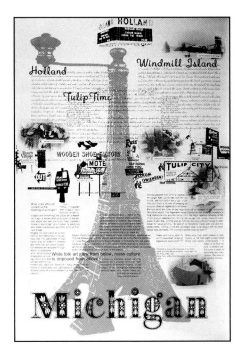

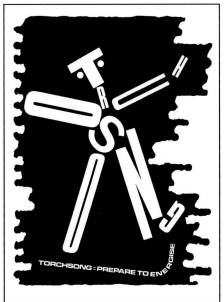

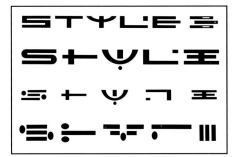

the pursuit to reverse Western culture's superior/inferior opposites such as male/female, truth/error, speech/writing, seriousness/play and so on, as a means to better understand Western ideas and literature.)

DECONSTRUCTION IN ARCHITECTURE Deconstruction might have remained an obscure term used only in university philosophy and literature departments, but last year the Museum of Modern Art in New York appropriated it for a major exhibition entitled "Deconstructivist Architecture," curated by the venerable Philip Johnson. In American architectural design, Johnson has the uncanny timing of a surfer who manages to get on the crest of a big wave and stay there, then gracefully shift to the next big one that comes along. During the 1930s, Johnson headed the Museum of Modern Art's architecture department and coined the term, "The International Style," for the then-new modern architecture of stripped-down functional simplicity. Johnson's 1948 "Glass House" and collaboration with Mies van der Rohe on the 1958 Seagram's Building established his reputation as a leading modernist architect. As the wave of modernism was overtaken by postmodern architecture with its historical allusions and eccentric personal expression, Johnson shocked purists by bolting to the postmodern camp. His 1982 American Telegraph and Telephone headquarters building in New York with a top resembling a Chippendale cabinet is an epitome of the postmodern style.

Precisely what "deconstructivist architecture" means is rather vague. The seven architects in Johnson's exhibition violate the grid structure and horizontal/vertical

geometric order of modern architecture with slashing diagonal movements, arcs and angular forms. Johnson contrasts their work with modernism, whose clarity and perfection are in opposition to deconstructivism's "violated perfection," which is disquieting, dislocated, and mysterious. Deconstructivist architecture is seen as a continuum of Russian Constructivist experiments of the 1920s, where geometry was put into restless, unstable relationships. In the exhibition catalog, Associate Curator Mark Wigley writes: "If these projects in a sense complete the [Russian Constructivist] enterprise, in so doing they also transform it: they twist Constructivism. This twist is the 'de' of 'de-constructivist.'" Deconstructivist architecture is not a style, philosophy, or cohesive movement, but tendencies present in several contemporary architects' work.

THE DICHOTOMY A segment of the graphic design profession consists of architectural groupies who borrow terminology, styles and even fads from that sister design discipline. As soon as deconstructivist architecture arrived on the scene, the "archigroupies" were scurrying around looking for deconstructivist graphic design. No problem. As mentioned above, typography that might be considered "de-constructed" has been around since the early decades of the century. In recent months, designers with computers as well as disciples of Neville Brody have been busily de-constructing typography. The term arrives just as software advances enable bitmapped computers such as the Macintosh to warp, bend, stretch, overlap and layer their type and images. This new flexibility is creating fresh and innovative work along with some of the most aesthetically obscene typography since Gutenberg pulled that first type proof. When this new graphic power is given to persons with little knowledge or sensitivity to typography, the results can be disastrous; but in the hands of imaginative designers, this new flexibility will permit typographic expressions without precedent. The Deconstructivist movement has only just begun. ∎

Figure 6 In a spread from a special issue of *Emigre* designed by Cranbrook Academy of Art students and several Dutch designers (top), type is overlapped and layered with vignetted photographs and graphics, yet the text is still easy to read.
Figure 7 In Neville Brody's ad for Torchsong (center), linear and orderly type yields to a more chaotic and dynamic organization of space. Randomly placed letters help form the vigorous structure.
Figure 8 Over four issues of *The Face* magazine (below), Brody progressively degenerated the logo for the "Style" section.

Philip B. Meggs teaches graphic design, typography, and design history at Virginia Commonwealth University. He is the author of "A History of Graphic Design," and "Type and Image."

Teaching Sensitivity to Type

Design pioneer Wolfgang Weingart discusses how typography is taught at the Basel School of Design in Switzerland.

Wolfgang Weingart has been challenging the accepted conventions in typography since 1968 when he began teaching at the Basel School of Design, an institution with an international reputation for its design program. But as a student at the school in the mid-1960s, Weingart found the typography course too dogmatic and quickly dropped it. Recognizing his potential, his instructors, Emil Ruder and Armin Hofmann, allowed him to work on his own and eventually offered him a teaching position in the advanced program for foreigners, where he still teaches today.

Immediately, Weingart set out to free himself and his students from the strict conventions of the Swiss school, which he sensed had come to the end of its dominant reign. His purpose was to enliven the subject by adding to its vocabulary. In his experiments, Weingart discarded the right angle, used wide letterspacing, changed weights, abandoned paragraph indents, reversed out headlines in rectangular forms and introduced bright colors. Even though he is considered a precursor to the "New Wave" movement in type, Weingart insists that typography must have a "hidden structure and visual order;" and despite his Dionysian reputation, he believes that all new developments in the field evolve from a thorough knowledge of the basic principles of typographic systems.

While Weingart does create posters and catalogs for a number of select clients, his first priority is teaching. In the following interview, he discusses the typography curriculum at Basel, how his ideas on typography evolved from his work with letterpress and hot metal, the role of the computer and the direction of typogra-

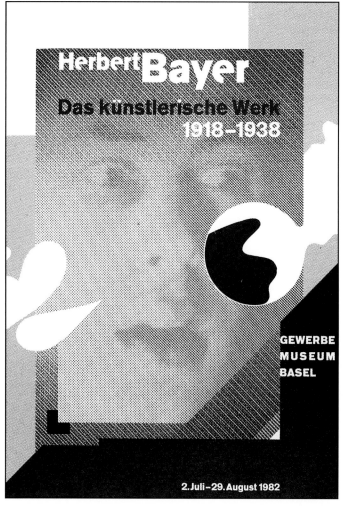

Weingart Work This 1982 poster designed by Wolfgang Weingart for a show of Herbert Bayer's work (left) combines one of Bayer's classic images with a trademark of Weingart's work—the use of halftone dots and moiré patterns as a graphic element. The carefully placed sans serif type works effectively with the organic elements in the image. In a sketch for a book jacket completed in 1985 (above), Weingart again uses film positives to create a dynamic composition that juxtaposes a variety of shapes and textures.

phy by designers working today.

Q: You have a reputation for working innovatively with type. The current history books on graphic design credit you with injecting expressiveness into the static look of Swiss design. Do you agree with that assessment? How do you view your contributions?

A: When I started teaching in 1968, the Swiss style of design and typography was being used all over the world. So many people worked in that style—Massimo Vignelli in the United States, Josef Müller-Brockmann in Switzerland. When I started teaching there, I felt it was my big chance

to break with the strict typography of the Swiss school. That became the reason for all of the experimentation in my typography class which later became known as the beginning of the so-called "New Wave," which is still very strong in America.

Q: Did you actually set out to create a new style?

A: No. Never. We started with very strict and simple exercises. Then we let loose. The purpose was to make typography more lively and to integrate it into graphic design.

For many teachers and designers all

over the world, typography was a stiff and unknown discipline. It is only now that people have learned to see it in a totally new light. Designers everywhere are creating very lively and more human typography, as if it had just been invented.

Q: Yet, you have been quoted as saying that the "New Wave" is in danger of becoming a cliché.

A: Totally, because it is very personal. The "New Wave" is a vocabulary of 20 or 30 ideas—wide spacing of letters, steps, underlining, use of negative space, varied movements, and so on. The problem is that these ideas exist in a vacuum. My ideas

 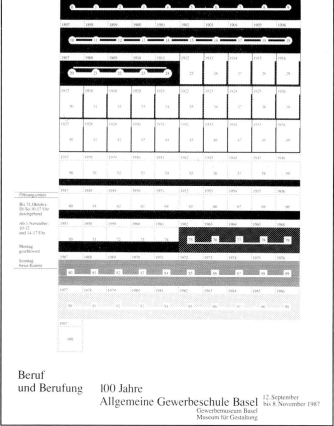

Student Designs This image (and several that follow) are examples of work completed by students in Weingart's typography class at the Basel School of Design. In this 1988 project (at left), students were asked to design a map for the city of Freiburg, Germany. R. Zilling chose to interpret the map in this semi-circular format. Circles are used to highlight areas. In the poster at right completed on the Macintosh in 1987, K. Williams creates variations in the gridded format through a variety of patterns. The serif type lends a formal elegance to the piece.

came from the typecase. All of our experiments resulted from a handcomposed technique, which I learned through an apprenticeship as a typesetter 30 years ago.

Q: The Basel School of Design has a reputation for teaching typography well. What makes its program so effective?

A: It is never one person that makes a school successful; it is the ideology of all the teachers. Most of my colleagues have the same goal for students and have the same ideas of how to achieve that goal. I think this is one of the reasons why the school has been successful for more than 40 years. Unlike other schools, the teachers do not change very often. They stay as long as 35 years, and a continuity develops.

These principles are put into practice in a very disciplined program. Students must be in school from 8:30 a.m. to 5 p.m. everyday; many even stay until 9 p.m. The big difference when compared to other schools is that teachers and students work together on a project. In America and other countries, teachers give the students an exercise. The students go home for a week, do the project, come back, hang it on the wall and critique it with the instructors. At Basel, we do everything in the classroom.

I work with students in both typography and graphic design. We work on how typography relates to the design problems and how to solve them. The students I teach also study drawing, photography, letter design, packaging, color and so on. To achieve this knowledge, there is a certain rhythm set up in the schedule every week—one day they work on packaging, another half day on color, and so on. The students come to me 12 hours a week and they bring with them all of that knowledge. Because they have landscape and object drawing, they learn to train their eyes. They then transform these experiences into the designs they create in my classroom.

Because of my experience as a typesetter and designer—when I work on my own posters, I do everything myself, from the design to the film and montages—I can help students technically. That is very important. But I also feel it is my job to inspire the students. If I can't do that,

there are no results. Typography is a very specific subject, and it can be very dry. A teacher must make it interesting, bring life into the classroom and into the subject.

Q: What kind of equipment is available for students to use in your type class?

A: When I started over 20 years ago, we only had hot metal and letterpresses. At the end of the 1970s, we installed a darkroom where we could make our own film. And four years ago, we installed Apple Macintoshes—the first in Switzerland. Everything necessary to make typography is in one room—computers, type shop and darkroom.

Q: In order to understand and use typography well, you have said students must first be given very practical tools. Is this something you still advocate? And if so, what are those tools?

A: There are two types of schools: In one school, students are allowed to do what they like, learn on their own. In the other, the philosophy is that in order for someone to learn a skill, they need a teacher.

My teaching approach is somewhere in the middle. In the beginning, I make them do elementary exercises. They must hand compose so they know what a ragged right and a ragged left is, and they must learn how to justify text. I also encourage students in the beginning to use as simple a typeface as possible, normally a sans serif. With a serif face, designs are made more complicated, more noisy, which can sometimes be confusing to students.

They start with book covers or letterhead—basic exercises in which you can control students' mistakes. From there, we build up to more complex projects. Then, after six months or a year, I am very open.

I am concerned with results. I compare the good and bad designs, so students slowly feel which way is best for them. We are not an intellectual school, and I do not take an intellectual approach in my class. Design is based on feeling, on passion. What I emphasize is that the expression in a design is what is most important, not the typeface that is used.

Q: How do you think computers and laser technology have affected the field of

graphic design and typesetting? Have they fostered a new design aesthetic?

A: Every technique is fascinating, if you know how to handle it. In my posters, I use the offset printing technique to the maximum of its potential. With offset, there is a fantastic opportunity to express yourself, perhaps in a new way. Now we have the computer. It is a wonderful tool, but I don't think the computer will bring a new visual vocabulary. What the computer gives designers is time. Everything can be done so quickly. You don't have to spend as much time doing research and creating mechanicals. With a computer, you can produce quantity—100 sketches instead of 10. With it comes the potential of creating both quantity and quality.

Q: What software programs do you use with the Mac?

A: To design magazines, we use Aldus PageMaker. We also use paint and word processing programs or draw programs like Illustrator and Aldus FreeHand to solve many different problems. But I don't really teach the computer. I know very little about it. I have the computer in my class as another tool for students.

In my own work, I use it only occasionally to draw geometric elements for posters, to create screens, to make type in different sizes and for text.

I would like to use the computer to do some painting, but in a very free way. I want to experiment more with paint programs because they are so simple. I find it fascinating to work with very simple tools, which is why I like hot metal type.

Q: What do you think of the digital fonts available for the Macintosh?

A: I don't believe you should transform 200-year-old typefaces for the computer. The language should be related to the technology. I think it is better to create totally new typefaces for a new technology.

But the real problem in design is not the typeface, it is the arrangement of the text—how it looks. Is it designed well? Is in intelligent? To me, it is stupid to have 3,000 typefaces. That will not solve the problems of design. We work with three or four families: Standard, Univers, Times,

Garamond. One family has so many cuts —hairline, italic, bold—that you have a wide range of possibilities.

Q: When you began working with offset, you became very interested in halftone dots as a design element. Why?

A: Lithography, of course, needs a system of dots to print an image. This fascinated me. Photography is a lie. And when you print images, the finer the lithography screen, the more it lies because it is an imitation. I prefer to do the opposite—to show the dots as a new graphic design element. The very rough dot is a part of a new language. In my posters, I don't like polished images; I prefer to show in a didactic way how it happens. It gives the

poster a new expression.

I believe that new expressions in design often result from production techniques. Many designers hate the technical aspects of design, but they are wrong because during the technical process of, say, making a poster, you come to new ideas, which can be added to the work.

Q: You are saying, then, that innovations evolve through the practical aspects of problem-solving. You may see interesting things happening during printing, and you use them as design elements.

A: If we were not close to the practical aspects of designs, our students would not function very well in the world. And generally, they function very well. The

best example is that students from Basel are teaching in schools all over the world. Overall, we try to have a balance between experimentation and the practical side of this business. But first we must teach student a classical approach, give them a wide range of experiences. With a basic but broad education like this, students will be ready for anything.

Q: In what direction do you see typography moving today?

A: What we need today are more sensitive, intelligent designers and typographers. I hope the future is moving toward these values. And one thing that would help would be several international graphic design schools that would get together and maintain a certain level of quality in design. We had the Bauhaus, the School of Ulm, which closed 22 years ago, and now we have Basel, which is more than 40 years old. We are not the center point of the world, but we are a school which has a very clear and healthy program.

Q: Two of your former students have said that through your work and teaching, you have opened doors for students by giving them the freedom to experiment. Isn't there more to your methodology than that?

A: Typography can be stiff and boring. In the past, students were told that they could compose only in a certain way. For hundreds of years, it was taught in that manner. Now we come along and say, be free, experiment. And it excites them. It is necessary to feel that sense of freedom to produce good work. But there must always be a strict, underlying discipline that goes along with that freedom. I believe that in the beginning, you must first go through the normal steps, learn the profession, then start to explore and experiment through long, hard work. It is a logical and historic way.

Typography must be taught in such a tricky way that when students leave they feel both secure and free. From the basics they can move on to new ideas in a wonderful, exciting visual language. ∎

—*John Fennell*

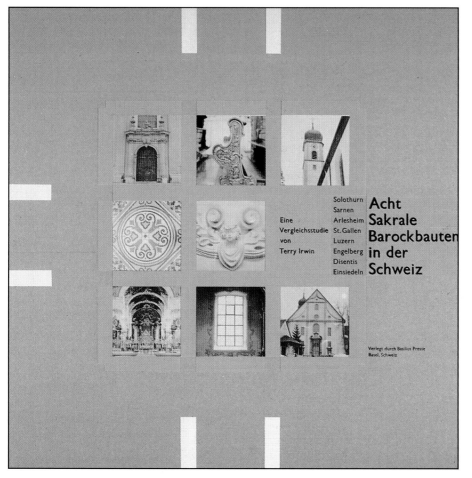

More Experiments In a book jacket project designed in 1984/85, T. Irwin creates tension in what could be a static square by placing type within gray bars that bleed off the right then repeating that element in white on the remaining sides.

Making Connections With Type

Designer William Longhauser discusses how he finds the "graphic thread" in any design problem.

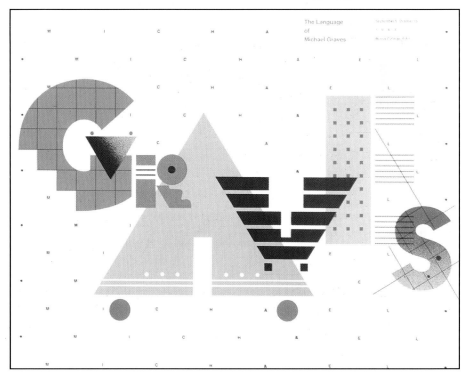

Making the "most from the least" was Philadelphia designer William Longhauser's goal in creating the cover design for this book jacket.

The entire process was one of discovery. "What was fascinating was that as I began to work, the new connections came in an expressive way, which was the whole idea," he says. "It was a wonderful opportunity to create a design that I felt would not be possible any other way."

As the basis of the image, Longhauser used a series of posters he designed, creating a collage that not only made "new connections" but sums up his feelings about typography. "What came to mind was to take existing pieces that were about expressive typography, which is the body of my work, and make a new statement that reflects what I do visually," explains the designer.

To do that, he cut up 7 of his own posters, chosen in part for their print production quality. Over a period of several weeks, he began making new "direction, color, value and size relationships" with the strongest elements from those posters. "But it was not as if any arrangement would work," explains Longhauser. "Making a new formulation integrating elements from earlier work, the final piece developed a life of its own."

Figure 1 In this gouache sketch (bottom) and final poster for an exhibition of works by the architect Michael Graves, the letters of his name are used as vehicles for expressing the vocabulary of his work. The identity of each letter is transformed into decorative geometric formulations that are then combined and integrated into a postmodern architectural landscape.

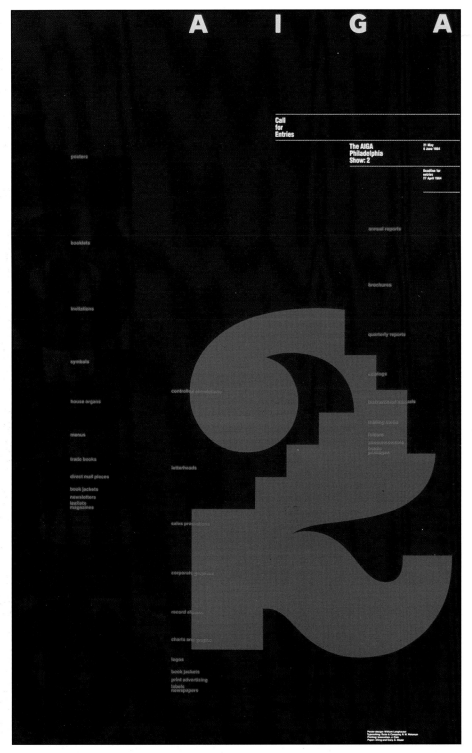

In choosing what to incorporate into the new design, Longhauser singled out what were significant elements, such as a blue numeral "2" he had used in a poster for the AIGA. "The color was significant to the whole and it was also a quiet place because there was no texture or type. The curve also provided contrast to the very straight edges of the collage," he notes. Longhauser had developed the numeral by hand for that poster.

The collage medium also became important to the process because it is one in which Longhauser is always working—if not literally, then in his mind. Here the perception of depth and the overlapping layers of information became integral to the solution. Interestingly, when the design was nearly complete, he attempted to incorporate new elements into the whole— shapes and textures that had not been used in previous posters—but discovered they did not work.

It will come as no surprise that Longhauser's chief interest is typography. He is also an advocate of type education. Although he earned both a BS and an MFA in graphic design, he felt his education, especially in typography, was lacking. To fill that gap, he became a student again, this time at the Basel School of Design in Basel, Switzerland. There, Armin Hofmann became his mentor, instilling in him an understanding of letterforms and their power to communicate.

Longhauser is now a professor at University of the Arts (formerly Philadelphia College of Art) and proprietor of his own firm. For a design to work, he says, the type must be so integrated into the struc-

Figure 2 In this Call For Entries poster, the large blue "2" is a metaphor for entering the second communications design show for AIGA's Philadelphia chapter. The various categories for entry interact with the "2" and the word "enter" at different locations, expressing the idea of various levels of achievement. "Enter" expresses the main theme of the poster and serves as a direct call for action.

ture that the piece would fall apart if it is removed.

In the following interview, Longhauser discusses the methods he has used to solve the design problems in several posters and catalogs, defines what he believes is another category of type legibility—the communication of an idea—and the necessity for getting the basic "groundwork" in typography if one does not want to be doomed to working with other designers' solutions.

Q: When you begin work on a design that is typographically based, what procedures do you normally follow?

A: Type is very much like architecture. You begin with an empty area and then begin to define the space. One line, one letter activates the potential and possibilities for other relationships. Through these walls, a structure is built.

Keeping this in mind, I generally make very small sketches with a pencil—I never work full size—and indicate type through weight and length changes in the line. Everything is there, but it doesn't look like type. It is simply a sketch composed with lines and dots.

These quick little sketches lead me to where I want to go. Then I either photocopy type from a type book or test what other type forms I might want to use. It is in this stage that the final point size and weight are chosen. Wherever there is a large letterform in any of my work, it is hand drawn.

Q: Are there certain typefaces you prefer over others?

A: There are too many typefaces. I throw away 90 percent of the type books. I generally prefer using classic typefaces—Simoncini Garamond, Bodoni, Garamond 3, Times Roman, Helvetica and Univers. I also use Serifa and Sabon. When choosing a typeface, I always go back to the basics of design: What kind of rhythm, texture and value is needed? How does it relate to the other elements on the page? Is is too heavy? Too light?

Q: Are there any specific foundries or manufacturers that you prefer?

A: Type from the Mergenthaler Type

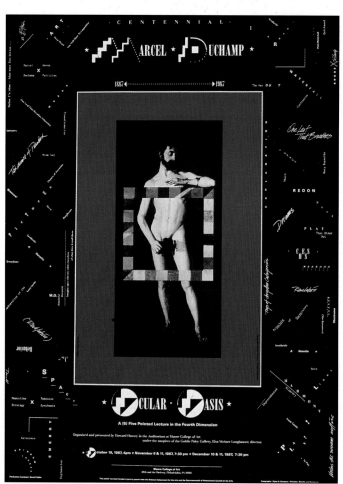 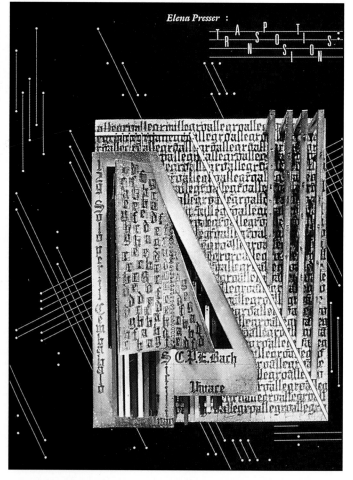

Figure 3 The poster at left, "Marcel Duchamp: Ocular Oasis," was a collaboration with artist Howard Hussey, who created the collage in the center of the piece. Using a mixture of typefaces, typewriter type, handwriting and hand-drawn letterforms, Longhauser created a typographic environment that gives expression to various names, words and phrases significant to Duchamp.

Figure 4 In the cover for an exhibition catalog for the artist Elena Presser (at right), whose work consists of visual transcriptions of Bach's Goldberg Variations, lines and dots become graphic references to actual threads used in her work. The letters in the word "Transpositions" create a rhythm with the horizontal rule lines that evoke the musical harmony resonant in Presser's work. This theme remains consistent throughout the catalog, although individual formulations vary with the characteristics and structure of each piece.

Library is the best because Mergenthaler owns the original typefaces. This guarantees that the forms of the characters are from the original design. Many faces have been altered and renamed, especially for the computer, and they no longer have the same quality.

Q: When you select the typeface for a project, what design questions do you ask yourself?

A: In many ways it is a gut instinct, but with type, I always consider the color it produces; by that I mean the range of grays on the page. If I am designing an exhibition catalog, it is important that the typeface comes in roman and italic in at least two weights, regular and bold. When working with an image, I try several variations of type to see how they work together. Again, it is basic design concerns. What is the italic of a certain face like? Galliard is a nice typeface, but the lowercase "g" in the italic is a strange form. It also depends if it is for text or display.

In a poster for an exhibition at the University of Pennsylvania's Museum of Archaeology and Anthropology titled "The Dayaks: Peoples of the Borneo Rainforest," I found a typeface in an old wood type book. The characters are tall, extremely condensed and inconsistent in weight distribution. Although the forms are raw and not particularly sophisticated, there is a unique harmony that worked well with the photographs of the masks used on the poster and reflected the spirit of the exhibition. (Refer to Figure 5.)

Q: What are the important considerations when integrating type with images, and in your own work, where is this combination most likely to appear?

A: For a design to work effectively, the type must be an integral part of the composition. If it is removed, the piece should fall apart. It doesn't matter if it's a poster, a cover design, an announcement or corporate identity. What does matter is that

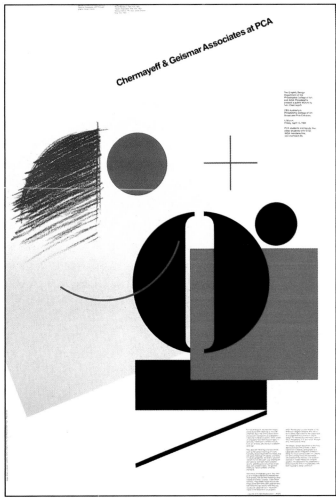

Figure 5 The original masks for the exhibition, "The Dayaks: Peoples of the Borneo Rainforest," come to life in the poster at left as the photographs (by Laurence Bach) interact with white rectangles that create visual depth and appear to cast light on the surfaces of the masks. An extremely condensed and uneven wood type, found in an old type book, projects a sculptural feeling similar to work in the exhibition.

Figure 6 In the poster at right for a workshop and lecture conducted by the firm Chermayeff and Geismar Associates, the formulation of the letterforms "C" and "G" and their interaction with two squares is used to communicate the different design approaches of the firm. Chermayeff, more the artist and illustrator, is represented with a playful hand-drawn letter with the square skewed; whereas the lower case "g" for Geismar, more a designer of corporate identities, is that of an abstracted symbol carefully integrated with a bright red square.

there is an opportunity to make an interesting formulation, to explore a combination of type and image.

Q: We are using two different terms here, letterforms and typography. What is the difference between them, and when do you use one over the other?

A: In the most obvious context, letterforms are hand drawn and used as the carrier of the central idea. Typography is text copy and small heads that are usually machine set. For example, in a poster for an exhibition of the work of architect Michael Graves, I combined large letterforms that were self-generated with machine-set type. (Refer to Figure 1.)

I use letterforms for many reasons. A good, well-designed letterform is beautiful. It is a form which everyone understands. Letterforms carry great potential

because they have an immediate identity. If you begin with a square, it means nothing. If you begin with a letter, it already has meaning. There are few things in design that are so immediately legible and understandable. Letterforms lend themselves to extensive manipulation without losing their identity, so they have a very strong expressive potential. The important factor, however, is that the integrity of the letterform is not lost in the effect to be expressive.

Q: When trying to solve a design problem, you have said that you look for a "graphic thread." What do you mean by this and how do you relate this graphic thread to typography?

A: What I mean by the term "graphic thread" is making a connection. That is what my design is all about. An example of

this is an AIGA Call For Entries poster I worked on. This was the second AIGA show in Philadelphia, so I decided to work with a large numeral two. The connection was obvious, so the key was to do something unique with the numeral "2." I tried to avoid merely creating an interesting graphic, then labeling it with typography. What I wanted people to do was enter the show. So I used the word "enter" very large and bold. The step forms in the "2" acted as a metaphor for "entering" the second show. I also listed all the categories—poster, brochure, and so on—as a progression that interacted with the number and the word "enter." It is a total typographic solution. (Refer to Figure 2.)

Another example is a catalog for an exhibition about the work of artist Elena Presser. Presser's works are visual transcriptions of Bach's Goldberg variations in

Figure 7 In the catalog cover at left for an exhibition of sculpture cast in bronze, plaster and polyester, the letters "B," "P" and "P" are given sculptural form. The resulting elements are in the process of being removed from a mold defined by the large square.

Figure 8 "Books + Books + Books" (at right) is a poster for an exhibition of recent production books by leading Philadelphia graphic designers, printmakers and illustrators. Letterforms are transformed into signs relating to various aspects of bookmaking: spiral binding, wire binding, a die-cut, a layout sketch and production notations.

which she actually uses fine threads as lines. I played off of that idea graphically using lines and dots that evoked the same musical feeling that she generates in her work. (Refer to Figure 4.)

Q: In that piece, you use the exhibition title "Transpositions" on a musical staff. This brings up the question of readability and legibility. How long did you play with the placement of the letters before you felt the word could be read?

A: That's an important point. There are really two kinds of legibility. One is automatic legibility, as in reading a text. But there is another kind of legibility which comes from communicating an idea. In this instance, I try to bring the type to the maximum level of expressive potential. It is essential that it can be read, but I play with it visually until it expresses the content of the message.

It may take a few seconds longer to recognize the word "Transpositions," but the experience of deciphering the meaning is more memorable because in communicating an idea, a new legibility is created. In a sense, I am forcing participation.

Q: Typography, then, becomes a way for you to challenge your audience.

A: I would prefer to say that it becomes a way for me to involve the audience in the message on another level than simply reading the words. After designing the Michael Graves poster, I was given the label of postmodern designer. What is postmodern *is* Michael Graves' style. This was the ultimate compliment in the sense that the poster visually communicated Graves' sensibility. If it had been another architect, the forms would have been totally different.

Q: How did the Graves poster evolve?

A: Often, I get an image in my mind. In this case, rather than just having a photograph of Michael Graves' architecture, I wondered what would happen if I created a little world of Michael Graves using the letters in his name. I observed that certain generic forms and colors appeared in many of his buildings. To recreate that world, I tried to identify the shapes and colors that were most typical and then integrate them with the letterforms. The background of the poster is composed of the letters of his first name, which creates a dot motif. But rather than a design device, this makes reference to his work. (Refer to Figure 1.)

Q: From your experience teaching at the University of the Arts, how do you instill in students an appreciation for the discipline of type?

A: In order to succeed (or just function) as a graphic designer, a person must have an in-depth understanding of typography. It is perhaps the most complicated area of design to teach because it appears as boring. Students want to design symbols and posters. However, like any foreign language, the student must learn the basic grammar and understand the structure of the language before using it effectively.

In order to avoid the pitfalls of stylistic imitation, I encourage students to seek influences in their work in artistic forms and media outside of graphic design—painting, sculpture, architecture, music, literature and theater. By recognizing how many of the basic principles are analogous to those in creating graphic design, the student begins to realize the unlimited possibilities for making new connections and creating visual metaphors that reflect an original vision.

Q: It is entirely possible to slip through design school without developing a real knowledge and appreciation for type. If you were a professional who was inexperienced about type selection, application and so on, what would you do to educate yourself?

A: In a sense, I'm the person you are talking about. I went to Basel (School of Design) when I was 28 years old. I had an undergraduate and a master's degree and had taught for a year at the Philadelphia College of Art (now University of the Arts). I was exposed to professional work with a quality that my designs lacked. I tried to acquire this understanding on my own and when I realized that it wasn't working, I went to Basel.

While it may be possible to learn certain things about typography on the job, it is my opinion that in the long run, it is better to receive additional training. If you don't understand the groundwork, the basic structure of type, then you are limited to looking at work you like from other designers. That's dangerous because it limits your growth.

Q: When looking at ineffective type treatments, what are your observations?

A: What I see the most of are missed opportunities or examples of where type has been used as a label—where it is used out of scale and hasn't been integrated into the whole. Often there is no idea behind the piece. There should always be an idea behind the type.

Q: Should students learn about typography on the computer?

A: There are so many technical idiosyncrasies inherent in understanding the operation of the computer that are totally separate from learning typography that I feel it is much too complicated to mix the two.

I still feel the best way for students to be introduced to typography is to work with letterpress. Crucial principles such as letterspacing, word spacing and line leading are experienced in a very direct way. But teaching with letterpress demands the proper space, functional equipment and a well-maintained set of good type fonts. It simply is not a viable option for most design programs.

It is important to clarify that this idea is not to reject the latest technology. To the contrary, students must have a strong foundation in the basic mechanics of typography in order to continually adapt to ever-changing technology.

Q: What are your goals with typography and, generally, with design?

A: In my own work, I want to make the familiar magical, use things that apparently have no connection to each other and create a visual thread that joins them. Combined, they communicate something new. That fascinates me. It's important for me to remain in some ways an amateur—in the true sense of the word. The word actually means "love of." With ancient Chinese calligraphy, the true artwork was done by the amateur and the mediocre work was produced by the professionals. I think that it's important that you never become so professional—so technically proficient and fast—that you stop exploring new ideas. ∎

—John Fennell

Those Quirky Novelty Faces

A brief history of ornamented typefaces and the designers who created them.

By Steven Heller

Goudy Stout was designed in 1930 by Frederic W. Goudy, one of America's otherwise premier type designers. Why the equivocation? Because Goudy Stout was a frivolous typeface which, though its "A" is reminiscent of Charlie Chaplin's clownish gait, is neither beautiful, functional or witty. Years later Goudy admitted, "In a moment of typographic weakness I attempted to produce a 'black' letter that would interest those advertisers who like the bizarre in their print. It was not the sort of a letter I cared for. . . ."

Even the luminaries blunder when they succumb to the unpredictable tastes of the marketplace; consequently, a rather long list of talented designers has perpetrated typographic high crimes and misdemeanors, placing many ugly typefaces into currency. Among them are Hermann Zapf's Sapphire, Imre Reiner's Floride, Morris F. Benton's Hobo, J. Hunter Middleton's Plastica, A.M. Cassandre's Acier Noir, Howard Trafton's Cartoon, Roger Excoffon's Calypso, and Herb Lubalin's Avant Garde. All are examples of a syndrome that should be called "when bad type happens to good designers."

The argument can be made that in many cases neither the designer nor the typeface is to blame, but rather the users are the culprits. Perhaps a large percentage of those who have used Avant Garde, for example, were simply not as adept as Lubalin at selecting ligatures or smashing letters. But it can also be argued that if the alphabet (with all its variations) is so difficult to use correctly, then why release it in the first place? Avant Garde was Lubalin's signature; how many designers

can use another's signature effectively?

Benton's Hobo, available on Typositor for many years, has aged poorly. When issued by The American Typefoundry and Intertype in 1910, Hobo had some fashionable characteristics that made it a viable advertising display face. Its vertical strokes and curved bars with the variation of stress on different letters gave it a quirky character and eye appeal; the elimination of all lower case descenders saved on space. In the right designer's hands, Hobo probably isn't half bad as a decorative alphabet or as a logo for an Eastern European newspaper, but when used incorrectly, which is usually the case,

the results are abominable.

I asked a designer at a digital type foundry which face is selling best out of all the excellent redesigns and new typefaces being offered. The answer was the package that includes Hobo and some other novelty faces. Owing to its ubiquity, Avant Garde might be assumed to be one of the most commercially popular faces in America, but who would have guessed that the presumably unfashionable Hobo retains such a large following? While the former is used as an alternative to Futura, the latter, it turns out, is primarily used for desktop newsletters, flyers and advertisements. Why? Probably for the

Palm's Patent Transfer Letters for Glass.

Color Plate III. Showing Color styles of Palm's Patent Transfer Letters for Glass. For sizes & styles of letters see the following pages.

same reason it was originally designed: It is neither formal nor wild, but eye-catching (read as "eyesoring").

DEMAND SPARKS SUPPLY With all the elegant typefaces extant today, why are so many of the ugly specialty faces used? Or more to the point, why are they designed in the first place? The answer is simple: Typography is a handmaiden to commerce, and as Goudy suggests, pleasing the advertiser or client is at least one of the typographer's raisons d'être.

It is therefore logical that "modern" decorative, ornamented or what we now call novelty typography dates back to the early 19th century and the Industrial Revolution. Commerce was expanding; its boundaries and a primitive form of print advertising replaced the tradesman as the primary hawker of goods. In his book "Printing Types: An Introduction" (Beacon Press, Boston, 1971), Alexander Lawson writes about that new typographic fashion: "Early in the nineteenth century English typefounders produced a variety of embellished types designed to emphasize their unique characteristics for the single purpose of attracting attention. Fat faces, grotesques, and Egyptians—decorative types when compared to the romans which had undergone minor changes since the Italian 15th century—were not flamboyant enough for the new requirements

Decorative Alphabets A display lettering for storefront windows, Palms Patent Transfer Letters for Glass, c. 1890 (far left). Cartoon (or Fresko in German, left top), a comic book-inspired script was designed by Howard A. Trafton in 1936. Goudy Stout was designed by Frederic W. Goudy in 1930 to appeal to those advertisers who like the bizarre in their letters (left, second from top). Calypso, designed by Roger Excoffon in 1958, was formed from shaped metal material (left, second from bottom). Hobo, designed by Morris F. Benton in 1910, was influenced by French Art Nouveau (left, bottom).

Calypso and Hobo showings courtesy Graphic Composition, Inc.

of advertising display."

Type founders discovered that virtually any unusual design would be purchased by the job printers responsible for creating advertising bills, broadsides and packages. Initially, the ornamented types were inline or outline versions of the Didot Bodoni and Egyptian styles, but designers soon switched from altering existing faces to creating more unique and outlandish inventions. Letterforms mimicked the appearance of Gothic architecture, and these letterforms were intricately designed with florid filigree, like the kind applied to many of the cast iron industrial machines of the day. Type echoed the Victorian world's penchant for extravagant decoration as a means of both displaying affluence and masking the presumably tacky nature of industrial products.

ENTER ELECTROTYPING Ornamented typography was helped along by the development of the electrotyping process for the creation of matrices. (A matrix is the mold from which the face of the type is cast.) In old-fashioned type founding, each character is formed on a separate steel punch, which is then driven into a sixteenth of an inch or more of copper to form the matrix. As the type historian Ray Nash described it: "If the punch with its matrix be of a very plain or simple character, it will have cost two dollars, and have occupied a day of one workman If the punch be of a fancy character, with scrolls and figure in it, requiring tedious engraving with much nicety and mathematical accuracy, it may occupy many days to cut it" Electrotyping, a process by which matrices can be duplicated by placing an engraving in an electrolytic bath, saved both time and money. It therefore allowed Ameri-

can typefounders, for example, to pirate a huge assortment of ornamented type designs from abroad. "Any article that is saleable, and got up in good taste by one type founder, is instantly electrotyped and cast by others," wrote the 19th century American typographer George Bruce referring to the proliferation of ornamented typefaces.

PATENTING AND IMITATION While some of these alphabets were reproduced from letters in ancient manuscripts, most were conceived by artists and produced at great expense. Therefore around the mid-century mark, type foundries began to claim the right of ownership by patenting their best designs. Since each ornamented face had such a peculiar character to begin with, it was usually difficult to imitate; hence, certain type foundries became known for their store of unique

Era of Art Deco Metropolis was designed by W. Schwerdtner in 1932 for the Stempel Foundry in Germany (left). Huxley Vertical, designed by Walter Huxley in 1935 for the American Type Foundry, was influenced by and came to symbolize Art Deco (right).

Rustic and Gong showings courtesy Solotype/Designers & Typographers
Mistral and Baby Teeth showings courtesy Graphic Composition, Inc.

Fancy Faces and Lively Scripts Log Cabin or Rustic, designed by Vincent Figgins in 1845, is still widely used for "For Rent," "Lavatory" and "Picnic" signs (top). Mistral, designed by Roger Excoffon in 1953, was an informal script. Gong, designed by J. Wagner in 1953, was used to approximate blackboard script (both faces, second from top). Baby Teeth, designed by Milton Glaser (c. 1968), was influenced by Art Deco lettering from Italy and imported to Mexico (third from top). Reiner Script was designed by Imre Reiner in 1955 for the Berthold Foundry (bottom).

typefaces. However, as the technology advanced, and more untutored job printers entered the industry, typefaces were imitated and bastardized at a prodigious rate. The bastardized versions were markedly inferior to the originals, but were nevertheless accepted by merchants who were interested in achieving an ostentatious display of their wares, not aesthetics.

During the latter half of the 19th century, the debate between art and commerce raged at a feverish pitch with the type foundries assailing the pirateers for misuse and mishandling of their inventions. The battle for quality was also fought between the letterpress printer who was being overshadowed by the lithographic printer.

A somewhat arcane, but nevertheless important distinction must be made between ornamented typefaces and the so-called fancy faces. Since designers of the latter were prone to derive inspiration from common sign painters more often than from monastic tomes, fancy faces did not resemble book illumination but rather the vernacular as derived from town- and cityscapes. One of my favorites still in currency is called Rustic (in England) and Log Cabin (in the United States) and was originally designed by Vincent Figgins in 1845. According to the late type historian Ray Nash, the reason for the popularity of fancy faces was due, in part, to the fact that most fancy faces could be rendered faster than traditional typography since they were not subjected to the same intense criticism regarding accuracy and quality. After mid-century, many of these faces were drawn by lithographic artists in an even more economical and fluid manner.

Type foundries were touting their wares in specimen books and sheets showing incomplete alphabets (to prevent theft) or lines of doggerel that gave the customer an extra treat while showing a typeface in an "artistic" application. But realistically speaking, art took a backseat to commerce, and commerce was wed, even then, to fashion. Concerning typographic vogue, an advertisement for typefaces in an 1879 issue of the *Typographic Advertiser* proffered the following: "We change, tastes change, fashions change. The special furor is now for bric-a-brac—antique pots and platters, Japanese oddities, and Chinese monstrosities. But fashion's rule is despotic, as so, yielding to her commands, we have prepared and show in this number some oddities to meet the

taste of the times As printers no doubt desire to be in fashion, we trust they will approve our course by sending in orders for them, that their patrons also may catch the infection"

A TECHNOLOGICAL VACCINE The infection eventually disappeared. And as the Victorian era came to an end, the passion for extreme ornament also faded. Two inventions in 1884, which signaled the demise of the independent type foundry by unifying the typefounding process, further sounded the death knell for the decorative preoccupation: Linn Boyd Benton's Pantograph punch-cutting machine (which was an antecedent of today's desktop computer font programs), and Ottomar Mergenthaler's Linotype machine (on which letters in the form of matrices are composed in a line). A renewed interest in typography of classic origin also contributed to the demise. In "The Practice of Typography" (1900), Theodore Low De Vinne offers this eulogy: "Printers have been surfeited with ornamented letters that did not ornament and did degrade composition, and that have been found, after many years of use, frail, expensive, and not attractive to buyers."

However, De Vinne further notes that "more changes have been made in the direction of eccentricity than in that of simplicity. Fantastic letters were never in greater request, but they rarely appear as types in books. To see the wildest freaks of fancy one must seek them not in the specimen books of type-founders, but in the lettering made for displayed advertisements and trademan's pamphlets." Although traditional typographers now eschewed ornament, a new breed of "professional"—the commercial artist—was creating hand-drawn, often one-of-a-kind, novelties for use on printed matter.

EXCESSES BANISHED? At the turn of the century, designers working in the Art Nouveau style rejected the 19th century excesses, but replaced them with a new kind of "floriated madness," which was eventually rejected by those designers who sought yet another style. Coming on the heels of "organic" Art Nouveau, a new mode of advertising eschewed the ornate, but was bold and colorful. The style, known in German as Plakatstil (poster style), presented the object being advertised without superfluous decoration and with bold, hand-drawn black letters designed to be visible and legible amidst the hustle and bustle of the urban environment. Lucian

'Retro' Designs Cochin (also called Moureau-le-Jeune) was issued by Deberny Peignot foundry in 1912 and re-issued in 1922 (left). Ohio, designed c. 1924, offered a brush letter in the Plakatstil (poster style) mode (right).

Bernhard was an exemplar of this form, whose one-of-a-kind letters for posters were later issued as complete alphabets through Monotype, Bauer and Berthold.

The vogue for the decorative letter was somewhat eclipsed during the 1920s by the canon of purity and functionalism espoused by the Bauhaus and Jan Tschichold in his book "The New Typography" (1928). However, despite the proliferation of functional sans serifs like Futura (billed as "The Type of the Future") advertisers still required eye-catching type to appeal in an increasingly competitive market.

During the 1920s and 30s—the era of Art Moderne (later termed Art Deco)—a multitude of quirky types was issued by the major German, Spanish, American, English, Dutch and French type foundries, including Stemple, Bauer, Berthold,

Deberny & Peignot, Haas and Klingspor, and were promoted through extravagant type specimen sheets that resembled art directors' annuals. Many typefaces were issued bearing names that sounded like streamlined sports cars, including Riccardo, Eclair, Femina, Golf, Mastura, Modernique, Interpol, Huxley, Resolut, and Metropolis. A few were given alternate names, like Titantypo, which was also known as Stanley, Hercules, and Titan. Many of these faces served contemporary advertising needs by symbolizing modernity, and hence eventually helped define the era in which they were produced. Some were merely stylized and souped-up versions of classical faces. And still others, such as a cursive named Time, seemed to have no aesthetic nor functional reason for being.

Wartime constraints on the design and

production of metal type put a halt to novelty typefaces. After the war, black letters were out and, as if a concerted rejection of the modern movement's disciplined austerity, lively scripts came into vogue. Among the most popular were J. Hunter Middleton's Admiral Script, Gertrude Zapf Von Hesse's Ariadane, Imre Reiner's Bazaar, Ashley Havinden's Ashley Script, Aldo Novarese and Cigno, M.F. Benton's Clipper, and Roger Excoffon's extraordinarily popular Mistral. Scripts of all kinds, from formal to freehand, made their appearance in a variety of advertising arts. In 1954, Edwin W. Shaar designed Futura Demibold Script to complement the otherwise geometric Futura family, and in 1953, J. Wagner issued Gong, a script that looked like it was written with bad chalk on a squeaky black-

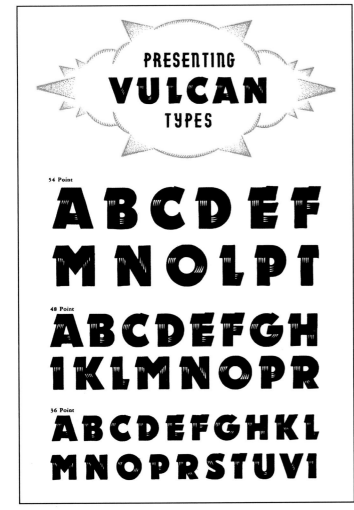

More Revivalist Faces Vulcan was designed sometime around 1930 (left). Chisel, designed by Robert Harling in 1939 (and modified in 1956), is an inline version of Latin Condensed (top right). Flash was designed by E. Crous-Vidal in 1953 (bottom right).

board. Other scripts were issued with provocative names like Agitator, Amazone, Juventud, Mecurius and Mustang. The problem with many of these scripts is that they were licenses for mediocre designers and printers to do bad typography.

REVIVALISM Univers and Helvetica were introduced in the late '50s in an apparent rationalistic reaction to rampant typographic disorder. Both types were used to help unify and clarify graphic communications, often resulting in an austerity that ignored the tastes of the marketplace and the instincts of certain designers, which fostered a counter reaction called revivalism. In the United States, Push Pin Studios and other "eclectic" designers returned to Victoriana, Art Nouveau and Art Deco for inspiration, reviving and adapting alphabets for current needs. In the same way that Lucian Bernhard developed unique lettering for special projects, designers like Milton Glaser and Seymour Chwast expanded quirky lettering done for specific posters into complete alphabets (such as the former's Baby Teeth and the latter's Buffalo, both available through Photolettering Inc.). By the early '60s, Morgan and Morgan published catalogs offering hundreds of nineteenth-century square serif and decorative woodtypes (also known as circus types) which, again, in the right hands were used effectively, and in the wrong hands, they simply mimicked the obsessively bad composition of the previous century.

Although type design has traditionally been based on past models, today many more typographers have become archaeologists digging through antique typebooks for the "perfect" faces suitable for revival or adaptation. When Roger Black, one of the leading preservationists, was art director of *Rolling Stone*, he revived the elegant, but decidedly old-fashioned Nicholas Cochin and is responsible for bringing some of the better Romans, Cursives, and even Tuscans out of retirement. It is said that the '80s was a decade stylistically defined by the reapplication of old forms, and to underscore this fact, the so-called "retro" designers (usually working on posters, book jackets and record covers) have also been mining the old specimen sheets for buried treasure, uncovering and reusing many of the quirky faces that for decades have been deemed obsolete, but are once again fashionable. In the age of the computer, the resurgence of the novelty face suggests an interregnum between photo and digital applications.

While the revivalists pay homage to the past, the computer mavens are looking toward the future. But the future of quirky typography is déjà vu. The primitive, low resolution bitmap forms have offered numerous possibilities for quirky typography equalling the worst of those produced during the nineteenth and early twentieth centuries; but at the same time, in the right designer's hands, there is also an unlimited variety of fascinating concoctions. And who can predict, maybe the bad types of today will be good types of tomorrow? ∎

Neither Functional Nor Formal Boul Mich, designed by Morris F. Benton in 1928, is an inline version of Broadway (top). Mandate, designed by R. Hunter Middleton in 1934, is a medium heavy informal script (bottom).

Steven Heller is a senior art director of The New York Times. *He is coauthor of "Graphic Style: From Victorian to Post-Modern" (Abrams), "Trylon and Perisphere: The 1939 New York World's Fair" (Abrams), and "Designing With Illustration" (Van Nostrand Reinhold).*

The Business of Typeface Design

Some business advice for those interested in drawing typefaces for profit.

By Allan Haley

Here's the bad news first. There are no rich typeface designers. No one just designs type for a living—and this includes the likes of Ed Benguiat and Hermann Zapf. It will take two to three years from the time you first get the idea for a new type design until you begin to see any consistent financial rewards. And no matter what you do, you cannot legally protect your original type design from thieves and pirates (at least in America). If you can get over these hurdles, read on.

Good type designers aren't poor. Most look upon type design as one of the more rewarding aspects of what they do for a living—and again, this includes such designers as Benguiat and Zapf. Once the revenue flow starts, and if the design is good, it will continue for a very long time. Major type foundries are not interested in stealing typefaces. If they want your design, they will license it. It's simpler.

CHOICES

It wasn't very long ago that type designers had two choices as to what they could do with their work. They could either let a major type foundry take full control of their efforts, or they could do nothing at all. There were exceptions to this norm, but they were few and far between (Fred Goudy being one of the more famous and successful). Today, type designers have other options.

If you want to draw typefaces for profit, you have three choices:

1. You can design, produce and market it yourself;

2. License it exclusively to a type foundry and let them handle the production and marketing;

3. License it non-exclusively to several type foundries and maybe increase your chances of making money.

THE WORLD OF TYPEFOUNDING

Because of products like Fontgrapher™, and Ikarus M™ designers can set up their own digital type founding business. The benefits of this option are obvious: A type designer can now not only control the initial design of his or her face, but also the font production, marketing and distribution. The end result is the potential for a product that is produced and sold exactly the way you want—with more profits.

The downside to this option is that the designer must undertake all the responsibilities and costs for production and sale of the design. And the end product, as

Independent Typefounders Peter Fraterdeus, principal and founder of Alphabets Design Group (Evanston, Ill.), promotes his typeface designs through the use of his newsletter, "Mice Type."

well as the profits, will only be as good as the designer is capable of producing.

Many designers, Peter Fraterdeus and Joe Treacy to name just two (see opening visuals), have taken this option, and by all accounts, are running a successful business and having fun in the process. If you plan to join this group, be sure that your products are finished and free of bugs before you market them. Do "beta tests" with friends and business associates.

Listen to their concerns and advice. They will be the kind of people to which you eventually expect to sell your fonts.

Don't worry about how to legally protect your new typeface design—because you can't. Currently in the United States, there is no legal protection for typeface designs. There is legislation before Congress which may turn this situation around, but for right now, anyone can copy your typeface and sell it as their own. It may not be ethical, but it's legal.

TRADEMARKING YOUR FACE'S NAME The government does, however, provide you with one form of legal protection, via trademark. The name of your designs can be registered, and should be, if you are serious about the business of producing typefaces and selling them. You can register the name yourself, but it is probably better and more efficient to have a lawyer do this for you. For around $300, you are assured that everything has been taken care of correctly. (If you want more information on typeface design protection in the United States, contact the Typeface Design Coalition. The address is at the end of this article.)

MARKET AGGRESSIVELY Once the product is ready for market, spend your time and energy on advertising and marketing—not packaging. The chances of seeing or selling your fonts in the friendly neighborhood software store are nil. The trick is to advertise and build a good mailing list for direct response marketing. Your sales will come in envelopes and over phone lines, not through channels of distribution. Get exposure; convenience magazines to write about your designs. Actually this won't take much arm-twisting; type is a hot subject these days. Buy advertising space and give something away to build a mailing list. Once you have a reasonable list, do a direct mail campaign—and continue to advertise. When you begin to sell fonts, invest your profits in the business: Advertise more, do another direct mail campaign—and start on your next type design (no business can survive on just one product).

THE BUSINESS OF LICENSING

Your other two choices involve letting other people do your productizing and marketing; these also involve contracts. You won't have to worry about constructing them; the companies you will be working with have lots. But you will have to worry

The Power of Digital Joe Treacy, the founder and name behind Treacyfaces, Inc., (Ardmore, Pa.) has created a lush catalog to promote his Postscript-compatible typeface collection.

about reading and understanding them.

Most of the type foundries' licensing contracts are straightforward. There are no hidden clauses in the fine print. They are not out to cheat you. They do, however, want just about absolute control over your design. They want to be able to market it any way they wish, with no obligation to give you, or your typeface, any special favors. They may want to name your face themselves, they may want a right of first refusal on future designs, and certainly they will want the right to sublicense the completed product. The contracts will require that you confirm the originality of the design, and will hold you responsible if it is not.

For the most part, the people you will be dealing with will be friendly and helpful, but remember that they are in the driver's seat. Substantial changes to the contract will be difficult to negotiate. If you feel strongly about a particular issue that the type foundry is apparently unwilling to budge, try to find a compromise solution, and be tenacious about your pursuit. Tenacity is an exceptionally strong tool when it comes to negotiating contracts. Finally, try to avoid lawyers negotiating with lawyers. Involving lawyers is very costly, and it is usually not a particularly friendly way to start a business relationship.

INCREASING YOUR MARKET BASE
Most type foundries still market fonts to their own customer base. With device independent fonts, this condition may change in the future. But for now, if you license your typeface to one company, you are confining yourself to a limited market. The logical way around this problem would be to license your typeface to several companies. Unfortunately, the most logical solution is also probably the most difficult. Most type foundries have an exclusivity clause in their contract. They want the marketing edge of being the only company to offer your design. Some will bend on this issue, but don't expect an easy negotiation. In fact, for many companies, this is a "deal breaker."

There is an alternative route to solving the problem of a potentially limited market: License your design to firms that are in the business of supplying other companies with typefaces and/or fonts. Companies like Adobe Systems, Bitstream Inc. and ITC will sublicense your face to other font suppliers. Here the caveat is that since these companies sublicense for a fee that approximates what you might get from any one font supplier and you receive a portion of what they get, your "unit" payment will be smaller than what you could expect from a single source supplier. The idea is that you make up for this potential shortfall in volume.

ROYALTIES
Typeface licensing is a business of royalties. For foundries, it is a simpler financial arrangement than a one-time fee and, (probably more important) they like royalties because everyone shares in the risk of the investment. Most companies, however, will provide an advance against royalties, or a "good faith" payment to help offset your initial investment in the design process. For example, ITC pays between $1,500 and $3,000 per weight or variant (italic, condensed, and so on), and this is not calculated against royalties.

Royalties can vary between eight and 12 percent of what the font foundry earns on your design. There is some room for negotiation here, but only if your design is something very special. (Again, as an example, ITC pays a 10 percent royalty.)

Royalty payments are normally made quarterly, but expect a time lag of six to nine months before you see your first check. It takes awhile to get fonts into the marketplace once they have been announced and a little more time for accountants to sort out who gets what—and how much. The royalty stream will probably start out more like a dribble (at least as far as you are concerned), but be patient. If your design is good, and if your foundry of choice is a good marketer (keep this in mind when you are hunting for outlets), then you should see a relatively large royalty check within the first year or so. This is when all the foundry's customers who are on a "subscription plan" take

possession of their versions of your design. After this big payment, one of several things could happen:
● You will see a slight drop-off in the next few royalty payments, and then see slow but continued growth in the checks that follow;
● You will enjoy continued and marked growth in each succeeding royalty check;
● The first big check will be your last. Following checks might cover dinner for you and a friend at an expensive restaurant —but little else.

The first scenario is the norm. If you start receiving increasingly bigger checks, congratulate yourself—you have created a winner! The second set of circumstances does not happen very often, but when it does, it is a sure sign of success. If this is the case for you, keep designing faces, you may be the world's first rich type designer!

Thankfully, the "one big check" scenario happens rarely. Most large companies that are in the business of licensing and selling typefaces know their business. They can spot a potentially successful typeface design and have the resources to turn potentiality into reality.

GETTING STARTED
You will need two things to conclude a successful license agreement with a type foundry: a good idea and a passionate advocate within the company.

First, the passion. Most companies that sell fonts (except those like ITC, that actively license and market designs from freelance designers) have their own staff of type designers and advance-planned production schedules. While they are always on the lookout for new original designs, they do not leave gaps in their production schedules to allow for their eventuality. This means that your design is destined to be a "back-burner" project.

That is, unless you can find someone inside the company (preferably someone reasonably influential) and sell them on your design. This will ensure that your work gets a favorable representation during any preliminary review process. Then if your typeface is licensed by the company, work with your advocate so that

your project moves through the production process with a minimum of delays. Delays? Absolutely! Even if your design becomes part of the production schedule, there are no guarantees of a smooth and orderly release process. Think about it: If the regular production for a new set of type products runs into difficulties, guess whose design suffers? If a customer wants a special order of fonts that requires additional work, which production program is postponed until the crisis passes? Should business slow down, and production people have to be laid off, which production person will be the first to go? The answer to all of the above is: Yours, unless you have done some preliminary legwork to prevent such a situation.

THE PRESENTATION

Aaron Burns, the founder of ITC, is fond of saying, "You never get a second chance to make a first impression." The first impression your typeface makes is also very important. Your presentation to a font foundry should be professional; show your typeface in real-world applications, and represent your best work. Phrases like "This is only a rough sketch" or "The design inconsistencies will be taken care of in the final rendering" do not do much to endear your type to those who would license it.

The good news is, however, that you do not have to present a completed typeface family, or even completed art for one weight of the family, for that matter. At ITC, all we require for an initial judgment on the design is the word "Hamburgerfons" set in the roman, italic and bold weights. Most other potential licensers also do not require anything more than this basic showing to start their decision-making process.

A good presentation would contain the basic "Hamburgerfons" showing at about 72 point. Photo reductions to approximately 24, 12 and 8 point would show your prospective licenser how the design would look at text sizes. (This is very important because few typefaces are profitable on a "display-only" basis.) Several examples of the typeface in use also go a long way toward selling your concept.

Remember, nobody buys an alphabet —they buy words set in type. Show your prospective client how the face looks when set in words.

GETTING TO YES

If your first impression is good, you will get a contract, maybe a check, and a request to complete all or part of the alphabet design. From here on, the process is basically the same, but it can vary slightly from one company to another. Most will require you to create a large complement of characters in one, or maybe all, of the weights of the family for additional review prior to a commitment. Some companies use design software like Ikarus™ as a production tool and will only require you to draw about 150 to 180 characters in the extreme weights of the family. Others may ask you to create everything, and this could, for your basic "four weight plus italics" type family, amount to more than 2,000 characters!

Once your design has passed a final review, the foundry will take over and convert your works of art into communications tools. Now, you may want to be included in the quality control loop as your designs are productized, but be aware that most foundries will not be favorably inclined toward this idea. By this time, your typeface has been put into their "font production machine," and most companies are more likely to compare an artist's intervention at this point (no matter how well-meaning) to a monkey wrench rather than oil to smooth the process. Some can be convinced to accept your support, but you will have to make your desires known early on.

You may also want to be involved in the advertising and marketing of your typeface. Foundries generally have a friendlier attitude here, but like the issue of quality control, you should clearly establish your level of involvement at the time of contract negotiation.

If this all sounds like a lot of hard work, that's because it is. Ask any successful typeface designer and he or she will tell you that the work is demanding, at times tedious, and always time-consuming. But the rewards are significant. ■

SOURCES FOR LICENSING
● Adobe Systems Inc. Attention: Sumner Stone, 1585 Charleston Road, P.O. Box 7900, Mountain View, CA 94039-7900.
● AGFA Compugraphic Division. Attention: Cynthia Hollandsworth, Agfa Compugraphic Corporation, 90 Industrial Way, Wilmington, MA 01887.
● H. Berthold AG. Teltowkanalstrasse 1-4, D-1000 Berlin 46, West Germany.
● Bitstream Inc. Attention: Matthew Carter, Athenaeum House, 215 First Street, Cambridge, MA 02142.
● Chartpak. One River Road, Leeds, MA 01053.
● The Font Company. Attention: Dan Barthel, 4101 East Larkspur Drive, Phoenix, AZ 85032.
● Image Club Graphics Inc. Attention: Greg Koldoziejzyk, No. 5, 1902 11th Street Southeast, Calgary, Alberta T2G 3G2, Canada.
● International Typeface Corporation. Attention: Allan Haley, 2 Hammarskjold Plaza, New York, NY 10017.
● Esselte Letraset Limited. Attention: Colin Brignall, 195-203 Waterloo Road, London SE1 8XJ, England.
● Linotype Company. Attention: Bruce Brenner, 425 Oser Avenue, Hauppauge, NY 11788.
● Mecanorma. 78610 LePerray-en-Yvelines, Paris, France.
● The Monotype Corporation Limited. Attention: Rene Kerfante, Salfords, Redhill, Surrey, England.
● Tegra/Varityper. Attention: Whedon Davis, 11 Mount Pleasant Avenue, East Hanover, NJ 07936.
● Typeface Design Coalition. Attention: Cynthia Hollandsworth, AGFA Compugraphic Division, Agfa Compugraphic Corporation, 90 Industrial Way, Wilmington, MA 01887.

A regular contributor to Step-By-Step Graphics, *Allan Haley is the author of* "Phototypography" *and the* "ABCs of Type," *a Step-By-Step Publishing book.*

Index